For Lori –
Whom 'Nana' and 'Dada'
would so much have loved
to welcome into the family.

Anita

March 2012.

Life through a Lens

Life through a Lens

Memoirs of a Cinematographer

Osmond Borradaile with Anita Borradaile Hadley

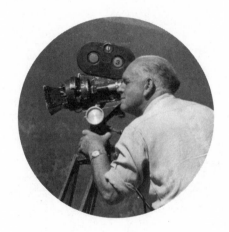

McGill-Queen's University Press
Montreal & Kingston • London • Ithaca

© McGill-Queen's University Press 2001
ISBN 0-7735-2297-2

Legal deposit fourth quarter 2001
Bibliothèque nationale du Québec

Printed in Canada on acid-free paper

McGill-Queen's University Press acknowledges the financial support of the
Government of Canada through the Book Publishing Industry Development
Program (BPIDP) for its activities. It also acknowledges the support of the
Canada Council for the Arts for its publishing program.

National Library of Canada Cataloguing in Publication Data

Borradaile, Osmond, 1898–1999
 Life through a lens : memoirs of a cinematographer

Includes bibliographical references and index.
ISBN 0-7735-2297-2

 1. Borradaile, Osmond, 1898–1999. 2. Cinematographers–
Canada–Biography. I. Hadley, Anita, 1938– II. Title

TR849.B67A3 2001 778.5'3'092 C2001-901073-7

This book was designed by David LeBlanc and typeset in 10/12.5 Palatino

Contents

Acknowledgments / vii

Editor's Preface / ix

Prologue: The Journey Begins / 3

1 Hollywood Apprentice / 11

2 Journeyman on Location / 26

3 Cameraman Abroad / 41

4 Sanders of the River / 54

5 Elephant Boy / 68

6 The Drum / 88

7 Four Feathers ... and a Thief / 102

8 Photographer in Uniform / 115

9 North African Campaigns / 129

10 The Tide Turns / 143

11 Safari Scenes and Scottish Mists / 160

12 To the Antarctic ... / 170

13 ... and Back / 182

14 Journey Home / 194

Selected Filmography / 209

Index / 213

Acknowledgments

I am indebted to many people whose knowledge and encouragement upheld me in my role as editor of Osmond Borradaile's draft memoir. Without their support its transformation from a treasured family manuscript to a book of wider appeal could not have taken place.

Of course, there would be no book at all but for Osmond Borradaile's decision, at the age of eighty, to put his life into perspective for his children and grandchildren. Nor would he have got far without his life's companion, Christiane Berthe Lippens Borradaile, who typed his manuscript on her old Underwood portable typewriter long after her failing eyesight should have discouraged such a labour of love.

I wish to express my gratitude to Canadian filmmaker Keith Cutler, who encouraged Bordie to write his memoirs, taped interviews with him, and subsequently offered helpful insights to me as the process of editing progressed. I am also indebted to British producers and film historians: Kevin Brownlow, who read my first draft, offering much-needed critical assessment, and Martin Stockham, whose ongoing help, particularly in obtaining clearance for stills, has been invaluable. I greatly appreciate their generous assistance and encouragement.

British cinematographers proved invaluable as well. Jack Cardiff advised on use of photographs; Bryan Langley offered recollections, and Alex Thomson graciously guided me through Pinewood and Shepperton Studios – with a detour to Technicolor to see the actual Technicolor three-strip camera Bordie hauled over the Himalayas when shooting *The Drum*.

Others still actively involved in different aspects of the film industry have responded generously to my persistent queries: Bill Berrios of Paramount Pictures, Sylvia Thompson, head of Rights, Carlton International Media Ltd, and John Herron of Canal + Image UK Ltd, Pinewood Studios, who graciously assisted in clearing copyright for the use of stills; Keith

Faulkner of Technicolor London who so promptly provided information on the three-strip camera and the Monopack process; Jeremy McCormack of Victory Films, Halifax, who shared with me material gathered for a documentary he plans to make on Bordie's life; Frances Russell, secretary of the British Society of Cinematographers, for her patient help in establishing valuable contacts and seeking out information on events long past. Also the staff of the British Film Institute Stills, Posters and Designs department who gathered together and promptly made available to me photographs from some of Bordie's major films. National Film Board archivist Bernard Lutz prepared valuable reference materials for me as did Dennis Duffy of the British Columbia Provincial Archives, who kindly transferred to my custody material dating from his research on Bordie in 1990.

Friends dating back to Bordie's early days in Hollywood and London Films have faithfully followed the genesis of the memoir, recalling memories or providing valuable connections: Mary Gilks Geary, daughter of Bordie's best friend and mentor, cameraman Al Gilks; the late Joan Korda, Zoltan Korda's widow; her son, producer David Korda; and Marilyn Sabu, widow of Sabu.

I also gratefully acknowledge the wise counsel and professional expertise of my dear friend, librarian Lore Brongers, and of my agent, Frances Hanna, and of McGill-Queen's coordinating editor, Joan McGilvray.

Members of my own family whose promptings have kept me going despite periods of self-doubt include my brother, George Borradaile, who entrusted to me his copies of Bordie's albums; my brother-in-law, technical producer Carl Pedersen, who patiently provided meticulous research into technical aspects of Bordie's work; my sister, film editor Lilla Pedersen, who made so much material available to me from Bordie's cases of memorabilia; my son, Dr David Hadley, for a medical perspective on the lung operation Bordie filmed; my daughter Pauline Hadley-Beauregard, who read and proposed changes to my first draft; my children Norman Hadley and Michèle Gully for their constant encouragement. But, most of all, I want to thank my husband, Michael, without whose careful, loving attention to stylistic and historical details this book would have been much the poorer. If after so much assistance there are still errors in *Life through a Lens*, the fault is entirely my own.

All photographs are from Osmond Borradaile's private collection. Stills from the early Hollywood days are reproduced with permission from Paramount Pictures. Those on pages 156 and 191 are courtesy Canal+Image UK Ltd, Pinewood Studios. Stills from London Films productions are reproduced with kind permission of Carlton International Media Ltd.

Editor's Preface

This is the story of the life and work of one of the great exterior motion-picture cameramen of the nineteen twenties, thirties, and forties. Born in Winnipeg in 1898, Osmond Hudson Borradaile travelled the world to capture on film some of the most spectacular scenery and action sequences of his day. From mopping the cutting-room floors in Jesse L. Lasky's Feature Play Company – later to combine with Famous Players and eventually become Paramount Pictures – he eventually worked his way up from film-wrapper to cameraman's assistant to cameraman and, finally, to director of photography. He left a legacy not only of classic films but also of photographic portraits of such historical figures as Emperor Haile Selassie of Ethiopia. Today, Osmond Borradaile is remembered for his location work in such well-known motion pictures as *The Scarlet Pimpernel* (1934), *Sanders of the River* (1935), *Elephant Boy* (1937), *The Drum* (1938), *Four Feathers* (1939), *The Thief of Baghdad* (1940), *The Overlanders* (1946), and *Scott of the Antarctic* (1948).

To capture the location scenes some of these productions demanded, he travelled the distant tropics, deserts and ice-packs of the world, filming sometimes in the air, sometimes beneath the surface of the sea, almost always in considerable discomfort. With his camera he crisscrossed the globe, bringing to the screen the vast expanse of distant continents. Africa, America, India, Australia and Antarctica thus formed the magnificent backdrops to many of his films.

Today these vast panoramas are familiar to us all. Yet, as earlier critics remind us, it was often Osmond Borradaile's work that introduced audiences to remote regions of the world. Describing 'Bordie,' as he was known in the industry, as "Britain's ace out-of-doors cameraman," John K. Newnham of London's *Picturegoer* recognized him in 1947 as "Britain's choice when there is a picture to be made in one of the far-flung corners of

the earth."[1] Of *Scott of the Antarctic*, Paul Dehn of the *Sunday Chronicle* wrote shortly after the 1948 premiere: "I have yet to see anything in the cinema approaching the almost unearthly loveliness of some of Osmond Borradaile's exterior photography – particularly a great, blue plain of ice with the spindrift snow scudding across its surface in faint, mackerel skeins like sand before a sea-wind."[2] And film historian George Perry, in his retrospective of *The Overlanders*, concluded: "the most impressive aspect of the film is ... the brilliantly photographed, breathtaking Australian scenery, never shown on a cinema screen before, and a revelation to British audiences."[3] Perhaps actor Raymond Massey's recollection of the shooting of *49th Parallel* (1941) in Canada offered the most direct accolade of all: "Everything was on location and the greatest exterior camera artist in the world – Osmond Borradaile – ... was brought over from England."[4]

In many ways, Bordie was a pioneer of the cinematographer's profession. He witnessed the transition from the old silent movies to sound, and from black and white to colour. Each new technical development required innovation and adaptability on the part of the cameraman, particularly when shooting on location and therefore far from all laboratory assistance.

Deliberately forsaking the controlled conditions of the studios, Bordie often defied hazardous terrain and extreme weather conditions in his search for authentic footage. *Life through a Lens* recalls the particular challenges he faced in choosing the great outdoors for his studio. In his book, he tells how he solved the problems of transporting and preserving sensitive film across the Himalayas; of persuading Acholi warriors of the Congo to stage a war dance before his camera without carrying the ceremony to its logical conclusion; of convincing Robert Flaherty that young Sabu from the stables of the Maharaja of Mysore was the obvious choice for the star of *Elephant Boy*.

Away from his country of origin for most of his professional life, Osmond Borradaile remained nonetheless a staunch Canadian, returning to his native land upon retirement from the motion-picture industry. It was therefore fitting that, in 1983, he was named a member of the Order of Canada in recognition of his life's work. Shortly before his death in March 1999 at the age of 100, Bordie was made a Chevalier de la Légion

1 John K. Newnham, "Cameraman with the wanderlust", *Picturegoer*, London, 1 February 1947.
2 Paul Dehn, "I defy you not to be moved," *Sunday Chronicle*, Manchester, 5 December 1948.
3 George Perry, *Forever Ealing*, (London: Pavilion Books Ltd., 1981).
4 Raymond Massey, *One Hundred Different Lives: An Autobiography*, (Toronto: McClelland and Stewart, 1979), 274.

d'honneur for his service to France as a member of the Canadian Expeditionary Force in the First World War.

As a child, I scarcely knew my father, for he was always away filming. But over years of listening to his stories, I delighted at the richness of his recollections. Recently, sifting through the memoirs he wrote for his family when in his eighties, I felt they should reach a wider audience. To that end, I have edited and reshaped the original text and selected from his wide collection of photographs. I have also included excerpts from film critics whose reviews help to define the mood of the times in which the films were made. That Bordie himself never referred to his collection of newspaper clippings speaks to his modesty in the face of consistent international acclaim. Although he might not have approved of letting the critics' voices be heard, I think he would have had to admit that in all else I have remained true to his original manuscript. Reminding myself that *Life through a Lens* is above all a memoir, I have resisted any temptation to embellish or seek secondary sources. My guiding principle throughout has been to let Bordie's voice be heard.

These pages therefore tell but a few of the stories that shed light on the career of a renowned cameraman. They speak of action behind the scenes and of the camera work that brought merit to so many productions. They also introduce personalities that made those early days of the film industry glamorous. But, above all, these are the memories of Bordie, whose love of photography and the outdoors combined to capture the world through his camera's lens.

<div align="right">

ANITA BORRADAILE HADLEY
"Stormhaven"
Victoria, British Columbia

</div>

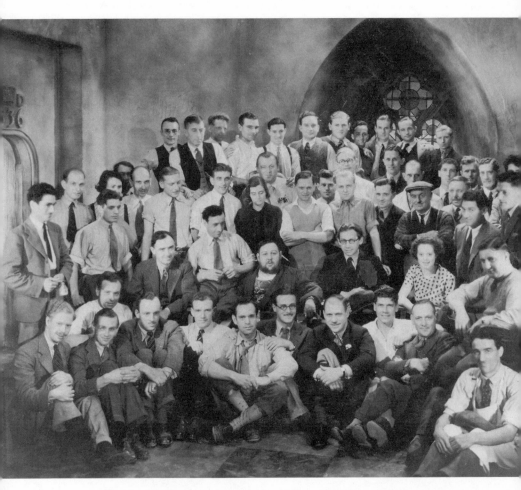

Crew and stars of *The Private Life of Henry VIII*, London Films, 1932.
I set the camera for this picture on delayed shutter and scrambled into position
in the front row (loose tie). Behind me, Charles Laughton, with Alexander
Korda and Elsa Lanchester to his left. To Laughton's right, Georges Périnal,
director of photography, and David Cunynghame, production manager.
In front of Cunynghame, Geoffery Boothby, assistant director.

Life through a Lens

Prologue:
The Journey Begins

Seeing the world through the lens of my camera defined my life in every way. If I am moved to tell my story, it is not to make revelations about the celebrities with whom I worked, but to share my discovery of the world through the medium I loved. As a young man in the 1920s, I learned the technical side of film production, later experiencing the transitions from silent film to sound and then to colour. Restless in the confines of the studios, I eventually adapted my skills to the unique conditions of filming in distant locations. For over thirty years, my camera took me to every continent and opened many doors. The memories of the places and people I knew continue to sustain me.

I saw my first motion picture as a boy in Medicine Hat, a small prairie town nestled in the valley of the South Saskatchewan River. With its abundance of natural gas, "The Hat," as it was affectionately called, kept its street lamps burning night and day. Although barely seven at the time, I was proud to be a citizen of "the best-lit town in Canada." The day that movies came to Medicine Hat for the first time, I earned myself a free ticket distributing handbills door-to-door after school. For the occasion, the local Chinese restaurant was converted into a makeshift theatre, a white sheet serving as the screen. Thinking to get the best seat in the house, I arrived early and sat in the front row.

I remember very little of the first film shown that evening, only the dimming of the gas lights, the clatter of the projector and – in what appeared to be a torrential cloudburst – dark, unrecognizable shadows flickering across the makeshift screen. Standing beside the screen and gesticulating eloquently, the travelling narrator informed us that the story concerned a beautiful milkmaid sent flying from her stool by an ill-tempered cow. "Now you see the little lady patting Betsy," his commentary ran. "She sets down her bucket and stool. She sits on the stool and

starts to milk. Ah! Betsy doesn't want to be milked! She puts her hoof into the bucket. She kicks the little lady right off her stool!" Even for a seven-year-old, the plot seemed bland.

As he changed the reels, the narrator promised us an even greater treat: a film starring the most famous of all comics, Happy Hooligan. But no sooner had the projector begun clacking again than a violent explosion rocked the building. Fire broke out simultaneously, enveloping the ceiling in a sheet of flames and shooting a huge fireball over our heads towards the screen. As the audience scrambled to escape the heat and flames, some got trampled in their wild rush for the exits. Being small, I was propelled along by the momentum: under the screen, across the kitchen, through the back door, and headlong into a barrel of stinking restaurant slop. I fled the terrifying pandemonium in a state of shock. To this day I do not remember how many people were injured – only that the projectionist suffered terrible burns to his hands and face. Certainly the combination of highly inflammable old-fashioned film and Medicine Hat's famous natural gas made for a far hotter show than the handbills could ever have promised.[1]

I look back on the days of my childhood as among the happiest of my life. I was born 17 July 1898 in Winnipeg, the youngest child of prairie pioneers. Yet I spent most of my early childhood in Medicine Hat, where my parents moved when I was about two years old. In those days before recreation centres, summer camps, or extracurricular school programs, we children were generally left to ourselves to devise our own amusement. The prairie seasons defined our activities: in summer, we splashed and dogpaddled in the muddy brown waters of the local swimming hole; in winter, we fought out our hockey fantasies on blades screwed onto a pair of hand-me-down boots. With the coming of long-awaited spring, we dared each other to ride the huge blocks of ice floating down the river at breakup time; in fall, as honking geese flew south in formation overhead, we played hookey from school to fish for goldeyes or snare rabbits. Of course, getting rid of the spoils of our adventures was always a challenge. But one elderly neighbour became a sure customer, remarking, with a twinkle in her eye, what a clever boy I was to find time to hunt and fish while diligently attending school.

My father, George Betts Borradaile, devoted his life to opening up the Canadian West. In 1876 he moved west from the Maritimes, where he was born, to join the recently formed North-West Mounted Police. Only seven-

1 Although details about it differ from Osmond Borradaile's recollections, this might have been the fire reported under the title "Mr. Charles Ness Badly Injured by the Explosion of the Film in His Moving Picture Machine," in the *Medicine Hat News* of 20 February 1908.

My father, George Betts Borradaile, in the buckskin and beadwork he wore on special occasions. Taken in 1884.

teen at the time, he smudged his age on the application form in order to be recruited. From then until his death he would cross and recross the Canadian prairies, travelling in the early days by horse and canoe, to oversee his area of responsibility in the peaceful settlement of those vast plains.

As one of Colonel Sam Steele's scouts during the North-West rebellion of 1885, he was cited for his daring in paddling his canoe two hundred miles through hostile Indian territory to establish communication between General Thomas Strange's column at Fort Pitt and General Sir Frederick Middleton at Battleford. On leaving the force, he worked first as a government surveyor, then as the Canadian commissioner in connection with the Scottish Crofter immigrants. Still later, he joined the Hudson's Bay Company, handling company lands in the district around Medicine Hat. It was here that he was appointed Justice of the Peace, a position he held for only one year until his death of tuberculosis in 1907.

I was only nine when my father died, but I believe that his influence continued to shape my life. I particularly remember his teaching me how to handle a firearm so that I could accompany him when the hunting season opened. I shall never forget our triumphant homecomings, the buggy laden with ducks which we would hang up under the veranda to freeze until needed for a meal. I was proud of my small part in these expeditions. From them I inherited a love of the outdoors which found expression, years later, in my professional work. Throughout my motion-picture career, I never enjoyed working in the studios, but preferred to be on location where I could capture on film the moods and mysteries of nature. It was as though the huge expanse of sky and prairie were to remain forever in my blood and any other roof over my head would thereafter be too confining.

My father influenced me in two other quite different ways as well. If at times he seemed stern, it was because he had a keenly developed sense of what was right and wrong. Above all, he wanted his sons to speak the truth. To this end, he never hesitated to administer a well-placed stinging reprimand with a small rawhide switch whenever I was caught telling a lie. Yet I never felt abused as a child, although many might think so today. I knew that I was loved and that the values of my parents were worthy of my respect. To this day, I am guilty of speaking the truth as I see it. In the course of a long lifetime, this habit has no doubt decisively affected my relations with others, for better or for worse.

The other paternal influence was my father's love of photography. As I leaf back through the photo albums of my childhood, I am struck by the quality of his prints. Now faded, they offer glimpses into those early days when my parents struggled to raise a young family in a harsh and unfor-

giving land. Yet the photographs also record a gentler side of life; we boys dressed for special occasions in the sailor suits or Eton collars of the time, my mother in lace, my father in formal suit, bow tie and high, starched collar, as if by dressing up we could impose a veneer of civility on the raw edges of pioneer life. Even by today's standards, I recognize that my father was a fine photographer. When I consider the primitive equipment with which he worked, I am humbled, for his photographs bear the mark of a sensitive eye for composition.

Perhaps it was the artistic side of their natures that first attracted my parents to one another. My mother, Lilla Amy Hudson, was a small, dainty woman and a gifted artist. In the course of a privileged childhood in England, she had excelled at drawing and painting lessons. At the age of fifteen, she had been the youngest artist to exhibit one of her works in the Royal Academy of London. A charcoal study of an old woman, it shows an astonishing depth of perception in so young an artist. Regrettably, mother's new life in Canada left her little time for painting. In addition to the charcoal portrait, only a few pieces of her work remain: watercolours of prairie wildflowers, a likeness of my father in ceremonial buckskin shirt and broad hat.

Instead, my mother channeled her energy to bringing up her three sons and giving them a sense of decorum. Whether in Winnipeg or Medicine Hat, she enjoyed the round of social events that added a touch of elegance to those early times. Even at home, it was understood that we changed our clothes and were neatly dressed before sitting down to the evening meal where politeness and good manners were expected. Early photographs show family members posing stiffly among the bric-a-brac and potted plants that were the fashion of the time. If there is even now a rather quaint, old-fashioned courtesy about me, it is no doubt traceable to my mother's notions of what constituted "good upbringing."

From my mother I doubtless inherited my love of travel and adventure, although earlier ancestors too left their mark. Indeed, one of our forebears was the navigator and explorer Henry Hudson, after whom the American river and huge Canadian bay were named. But on my father's side too there were adventurers. Thanks to them the name Borradaile, which traces its origins to the English Lake District of the fifteenth century, is inscribed on the map of more than one continent.

But I did not know all this when my mother read to me to while away the long winter evenings. If the titles of the books she chose now elude me, their themes do not. These were stories of adventure in far-away places: Africa, where herds of exotic animals roamed the veldt under blistering skies; India, where Maharajahs lived in palaces of ivory and gold

My mother, Lilla Amy Hudson Borradaile. The bedtime
stories she read to me made me dream of distant lands.

and rode elephants hung with silks and precious jewels; the vast polar ice-
caps, where intrepid adventurers challenged wind, snow, and ice at their
peril. All these images and more kindled my youthful imagination, and I
vowed that some day I would discover such marvels for myself. But little
could I have foreseen the extent to which my boyhood dreams would
become a reality. In the course of my long career I have visited and
worked in every continent and I count the years spent behind my camera,
capturing the panoramic splendours of this planet, to have been the most
satisfying of my life.

I can't explain why I have no recollection of my father's funeral, for his
death left me with a tremendous sense of loss. He was carried to his grave
with all the honours of the Royal North-West Mounted Police, and the
mayor of Medicine Hat was among his pall bearers. What I do remember,
however, is that father's death marked a turning point in our lives. With
my brothers Dick and Paul now working, my mother decided to move to

Dick, myself, and Paul, looking very serious.
Medicine Hat, 1904.

a more temperate part of the country. Over the years, she had experienced the extremes of prairie climate. One winter she had almost lost me as I fought my way home from school in a blinding blizzard. One summer, she had seen the railway tracks running from Winnipeg to the Red River port of Selkirk buckle and twist like snakes under shimmering heat waves. It had all been very different from the lush and clement countryside of her childhood.

Of course, there had been gentler moments too. Summer holidays at Lower Fort Garry, where our uncle was commissioner of the Hudson's Bay Company, were glorious times for us all. Once a major trading-post for the Red River Settlement, the walled fort with its sawmill, brewery, distillery, blacksmith shop, and general store was the ideal place for acting out a young boy's dreams of adventure. Indeed, it was at the Lower Fort that I took part in my first talent show. Silhouetted behind a sheet lit up by a magic lantern, I performed as a sword swallower, gulping and groaning

as I lowered the blade past my cheek and into the collar of a big coat worn for the occasion. Although much too shy to step forward afterwards to receive the applause of an appreciative audience, I was nonetheless proud of my accomplishment. Perhaps it was this small triumph that initially triggered my fascination with the world of illusion and entertainment.

It was undoubtedly with mixed feelings that my mother and I moved to Victoria on Vancouver Island shortly after my father's death. Here I enrolled as a student in the University School where, despite the discomforts of the scratchy tweed uniform and Eton collar, I settled down happily. This was the only school that I ever enjoyed, and the only one from which I did not play hookey at the local fishing hole.

From those untroubled days, one of my most memorable moments was of being taken to the clearing at the junction of Admiral and Esquimalt Roads to get a view of Halley's comet shooting across the night sky. For me, it seemed a wonderful omen. But I could not then have foreseen the path my own life would follow as I reached out in imagination to hitch my wagon to the comet's fiery tail.

Our stay in Victoria would doubtless have continued indefinitely had not my brother Dick's health begun to fail. I can only imagine my mother's fears on recognizing in her son the symptoms of tuberculosis that had taken her husband's life but a few years before. Leaving me with friends in Victoria, she took Dick south, hoping that the warmer, dryer climate of southern California would restore his health. It was not to be. When Dick died, she returned to Victoria just long enough to fetch me before moving permanently to the sunny southwest.

On New Year's night 1914, we sailed from the Inner Harbour on the ss *President*, bound for California. Our destination was the centre of a new industry whose mystique would soon captivate my imagination. But all that belonged to the future. In the course of that long, rough voyage down the west coast of North America, I was far too seasick to guess or care what lay ahead.

Hollywood Apprentice

I count my early years in California as the transition period from child-hood to manhood. Indeed, it was not long after our arrival in San Diego that I decided the days of my formal schooling were over. With the exception of University School in Victoria, I had never enjoyed school. Nor had I adapted happily to the impersonal and comparatively undisciplined atmosphere of San Diego High School. At the age of sixteen, I therefore considered myself ready to serve my apprenticeship in the school of life and, to my mother's dismay, I quit school to seek my fortune elsewhere.

My first job was at the Cave Store in La Jolla. This was the brain child of an enterprising German who had built it directly over the largest of a series of famous caves which the pounding surf had carved out of a nine-ty-foot sandstone cliff. To link the store to the cave, he had dug a tunnel through the sandstone. Into it he had built 136 steps, with a handrail on one side and four gas lamps to light the way. My job was to sell tickets, guide the tourists down the stairway, give them a ten-minute lecture on the cave and then escort them up again. Back in the store, I sold postcards, abalone jewellery, and assorted trinkets. Sometimes I made as many as ten trips a day, which is why, even now, I still remember that there were 136 steps to climb.

Yet, despite romantic encounters with lovely young visitors, my job as a tour guide was only a stepping stone to something far more exciting. The Cave Store capitalized on its popularity as a tourist attraction by handling all the photographic processing for La Jolla: developing, printing, enlarging, and so on. Well-trained by my boss, Bob Redding, I was soon able to handle the whole job on my own. It was not long before I began to seek other ways to expand my experience in this field.

In the spring of 1914, I saw a film being photographed for the first time. I think it was titled *Caprice* and it starred "America's Sweetheart," Toronto-

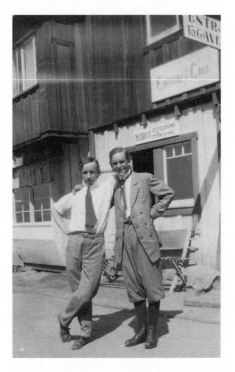

My boss, Bob Redding, and I in front of the Cave Store, 1914. Note the sign for Kodak developing.

born Mary Pickford. With her charm and projection of innocence, Mary's growing popularity was beginning to command sharp salary increases; it was the time when star status was being born. But this was not what attracted me. While on location from Hollywood, the film unit spent several days shooting sequences around the entrance to the caves. As I watched, I saw the possibility of putting my limited photographic knowledge to much more exciting use. I offered the camera assistant the use of our darkroom and we quickly became friends. It was not easy to become a member of a camera crew, he told me, for in those days it was considered necessary for a cameraman to know exactly what happened to the negative once it left the camera and entered the laboratory. Seeing that my interest in motion pictures was aroused, my new friend suggested I try to get a job in a lab.

As it happened, the movie theater in La Jolla had recently changed hands and I decided to apply there for work. To my delight, I landed a part-time job selling tickets before the show and then helping the owner in the projectionist's booth. There I took the reels out of the cases, handing them to the boss as required. After they had been projected, I rewound them and returned them to their cases. Those old hand-cranked projectors

were tiring for the operator and turned him into something of a sorceror's apprentice: he had to crank the film at a constant speed of approximately sixteen frames per second, feed the carbons to the arc lamp, and keep the picture on the screen sharp at all times. Perhaps it was the stress and heat of the work that drove my boss from the stifling booth. Before long, I found myself doing most of the projecting on my own.

It did not seem to matter that I had no license to do this work. In fact, my responsibilities multiplied. Occasionally I had to pick up the film from the Express Company, hire a girl to sell the tickets and a friend to collect them. This same friend then doubled as my assistant in the projection booth. I also paid the piano player who, in those days, was essential to creating the mood of the show. Indeed, with the clatter of the projector and the tinkling or hammering of the ivories, silent movie theaters were anything but silent!

In all, the experience represented a challenge and taught me the value of resourcefulness. I also learned to be wary of easy promises and to make sure I was paid for the services I rendered. My employers at the theater had often spoken of starting their own production company, hinting that when they did so I would be in line for a big job. But in the interim they refused to pay me a decent wage for the work I was doing. When I showed my resentment by threatening to walk out, they sat me down and offered me about half what I thought I should have. Indignant, I headed for the door a second time, and that was when they suddenly capitulated and made me an offer that surpassed my wildest expectations. My apprenticeship as jack-of-all-trades in the world of cinema was beginning to bear fruit.

About this time, fate intervened in my life when a friend of my mother became a casting director for Jesse L. Lasky Feature Plays. Knowing of my interest in films, she arranged for me to join the laboratory as an apprentice technician. Within days, I moved to Hollywood and became a member of the staff, albeit a lowly one. My work was simple and dull: mopping floors in the Vine Street laboratory, then housed in an old barn. Only my rather misleading job description, "laboratory technician," hinted at better things to come.

These uninspiring beginnings were marked by boredom, long hours, low pay, and few prospects for promotion. Yet they gave me a foot in the door to the production side of motion pictures; I was determined to use this advantage well. Furthermore, it was at the Vine Street laboratory that I first met Al Gilks. An assistant cameraman recently laid off at Universal Studios, Al was now working in the drying room at the Lasky Company, waiting for an opening in the camera department. Our mutual dislike of working

indoors led to shared fishing and hunting trips that I still remember with pleasure. In time, Al became one of my closest friends and mentors.

But before that, our lives took different directions. The year was 1916. I was nearing my eighteenth birthday. The war had not yet ended, as many had predicted, and I felt it my duty to return to Canada to enlist. Bidding farewell to my new friends and fellow workers, I travelled north, hoping to join the Royal Flying Corps. I passed my medical in Victoria, but was told there was a long list of applicants for the RFC. Since I had spent all my money returning from California, I could ill-afford to wait for my name to work its way to the top of the list. I therefore enlisted in the Canadian Expeditionary Force, hoping to transfer to the corps of my choice once overseas. I soon found myself in England as a gunner but no closer to the Flying Corps. It was as a disappointed member of a 4.5 howitzer unit that I finally arrived in France, ready for action.

During my almost three years of wartime army life, I lived with the inescapable filth of lice and mud, caught trench fever, and grew accustomed to the proximity of violent death. Through it all I learned to value the spirit of brotherhood while resigning myself to the whims of fate. Today, my most lasting impression of my wartime experience is of leading an old grey mule by night through mud and shell holes from the ammunition dump to the guns. The poor beast was heavily loaded with shells and charges. She had keen hearing and would sense an approaching shell well before I did. Then she would stop, tilt her head in the direction of the shell, and refuse to budge until it had exploded. Her sixth sense probably saved us both from being blown to bits in that wasteland of mud.

Yet nothing could prevail against the appalling lack of hygiene of the war zone. By the spring of 1918, I was back in England recovering from trench fever in a convalescent home in Epsom. There my application for transfer to the Flying Corps finally came up. But when I appeared before the medical officer, he took one look at my scrawny frame and ordered me back to bed. To my great disappointment, I never did become a soldier with wings. Disillusioned and restless, I shipped back to Canada at the end of the war to receive my discharge from the army, then headed quickly south. After the battlefieds of France, easy-going, sun-drenched California looked like the promised land. My mother tried to persuade me to take a holiday by the sea in La Jolla, but I was impatient to get on with my life and quickly turned my sights back to Hollywood.

On my return to the studios, I was surprised to find that I had not been forgotten: in fact, I was remembered as the first staff member to have enlisted in the forces "to end all wars." One of the stars on the flag of honour that hung in the foyer of the studios was, in fact, my star. Although

deeply touched, I quickly impressed upon the manager that I needed a job far more than I needed a star. Perhaps I was too irreverant. At any rate, I soon found myself back in the laboratory, once again mopping floors. Yet despite this inauspicious return to my former job, my career in the motion-picture industry was about to take off.

While I had been away many changes had taken place in the industry, and the little firm which was the Jesse Lasky Company when I left had now become the Famous Players-Lasky Production Corporation, an influential player in a rapidly expanding industry. This turned out to be a fortunate development for me, upon my return, as it meant rapid promotion from floor mopper to film wrapper. Although my new responsibilities still kept me in the lab, I was now involved in one of several stages of film processing that I would need to understand if ever I were to become a cameraman.

Initially, I worked in the darkroom, placing the exposed negative onto a wooden rack that held two hundred feet of film at a time. The rack and film were then submerged into a tank of developing solution and regularly inspected by the developer who was responsible for this part of the process. Only when he was satisfied with the quality of the development would the rack and film be removed and placed in a rinse tank, then in the hypo fixer, and finally into the wash tank. Up to this point, all of the processing took place in a dim red light. This was still in the days of orthochromatic film stock which, strongly responsive to blue and green light but blind to red, was in no danger of being fogged by the red glow. Later, by the mid-twenties, red-sensitive panchromatic film with capabilities for "day for night" filming and clear cloud definition became the standard stock. But by then I would be out of the lab.

While my time in the darkroom taught me much about film developing and the importance of good exposure on the part of the photographer, I found the darkness itself too humid and confining for my liking. So I asked to be transferred to the drying room where I could at least work in daylight and a clean, dry atmosphere. Here the film was transferred from the racks to huge, electrically driven drums in which it was revolved at high speed until dry. In an early attempt at introducing colour to achieve desired effects, some of the film was then submerged in dye tanks: amber dye for sunlight scenes; blue dye for night.

Although grateful to have work, and aware that I was learning much, I did not enjoy my time in the labs. The highlight of my days was lunchtime. Grabbing a sandwich, I would rush to the stages hoping to see a crew in action and scenes being shot. I was rarely disappointed. In those days of rapid post-war expansion, production was in full swing and I had

ample opportunity to observe the only phase of film processing that really interested me: the photography.

Whether due to zeal or blind good fortune, my days in the lab ultimately came to a quick and unexpected end when a new film unit was formed to meet growing production demands. The director was Sam Wood, up to then assistant director to Cecil B. De Mille, while the cameraman was my old friend Al Gilks. Shortly after I had left to enlist, Al had been transferred from the lab to the camera department, becoming assistant to Alvin Wycoff, chief cameraman for Cecil B. De Mille's productions. With the entry of the United States into the war in April 1917, Al too had enlisted, receiving a commission in the U.S. Navy. Upon his return to the studios at the end of the war his talents were again recognized, and he became second cameraman to De Mille's unit, the only double-camera crew in the studios. Now a full-fledged cameraman in the newly formed Sam Wood Unit, Al recalled our friendship of pre-war days and had me transferred from the lab to be his assistant. And so I exchanged the drums and dipping vats of the laboratory for the camera and tripod of the studio stage. On my chosen track at last, I could now count myself among the privileged few who love the work they do.

A camera crew in those days usually consisted of only two members: the cameraman and his assistant. The cameraman operated the camera but was also responsible for the lighting and the still photography. The assistant was accountable to the cameraman for the care of the camera. He drew the negative stock, loaded it from the tins to the camera magazines, and returned it to the tins after it had been exposed in the camera. He also kept a detailed report sheet of all the footage exposed and delivered to the lab for processing, and handled the slate used to number the scenes.

At that time, there were no motors to pass the film through the camera. It had to be cranked by hand at the standard speed for normal action of sixteen frames, or pictures, per second. Thus the cameraman had to keep turning the crank at a constant speed in order to avoid undue jerkiness of movement. At times, he also had to be able to slow his cranking down to speed the action up or, conversely, speed it up to slow the action down. Regularly he had to change the diaphragm of the lens to compensate for changing light exposure. Because there were no free-head tripods in those days, the cameraman had to bear additional pressure, using one crank to tilt the camera and another one to pan. A good assistant became critical when it was necessary to pan, tilt, change the diaphragm, and crank the camera all at the same time. Even then there never seemed to be enough hands.

After my transfer to the camera department, I spent a lot of time

acquainting myself with the camera equipment, for it would now be my responsibility to keep it all in perfect operating condition. The camera issued to us was a 400-foot Pathé made in France. Although still quite popular, the Pathé was gradually being replaced in Hollywood studios by the much more expensive Mitchell and Bell and Howell cameras. But the Pathé suited my purposes well. I spent many hours cranking away, trying to perfect my sense of speed. On becoming Al's assistant, two things struck me: I had much to learn and I could not have asked for a better instructor. Al was one of those wonderful friends who was always generous with his time and help. Throughout my career, I would owe him much. The solid training he gave me paved the way for my own eventual success. In those early days of the nineteen-twenties, we formed a good team at work and, once again, became fishing and hunting partners in our spare time. Ours was to be a lifelong friendship.

The Sam Wood Unit was successful from its very first film. Sam was open, easy-going, and pleasant to work for. He had come to Hollywood from the oil industry and was impatient to make a mark in his new career. While he concentrated on directing, he gave his cameramen free reign. It was all fast paced and exciting and a good place to serve my apprenticeship. As a unit, we had a lucky break, for our first picture was an auto-racing story called *Excuse My Dust*, starring Wallace Reid. Wally was already very popular and had all the requirements to become a great star. He was probably the most handsome man in films in those days, with a strong, graceful body and a charming personality that came through on the screen. Besides these attributes, Wally had talent and could turn in a good performance. He played many musical instruments: violin, piano, saxophone, drums, and an electric organ with which he loved to entertain his guests at home. Between scenes on location, he would produce a mouth organ and liven us up with a tune. Regrettably, his musicality did not mean much in those days of silent film. Yet with his good voice and natural grace of movement Wally was one of the few top performers who would have benefited by the advent of sound on film.

Wally was always good company. If he had a weakness, it was that he could never say no to the many hangers-on who surrounded him. He was far too generous to those he considered less fortunate than himself. Wellliked by men, adored by women and idolized by youth, Wally seemed to possess all the attributes of stardom. Yet he found it difficult to adjust to so much adulation and his life ended tragically in the torment and waste of drug abuse.

After the success of our first film, Sam Wood was asked to make others like it, starring such favourites of the silent screen as Wallace Reid, Lois

Wallace Reid in his garden with his son, Bill. Wally was one of the few silent screen stars who could have made a successful transition to sound.

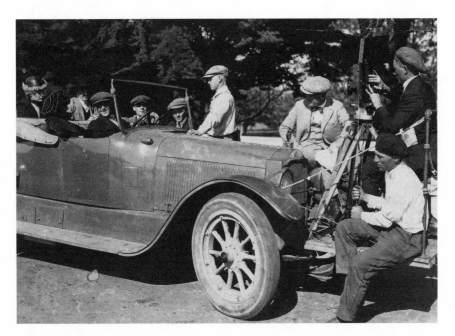

Excuse My Dust, 1919. With Wanda Hawley and Wallace Reid in the front seat, Sam Wood directing, Al Gilks photographing and me standing beside the car.

Wilson, Wanda Hawley, and Bebe Daniels. Byron Morgan of the *Saturday Evening Post* wrote most of the stories. Today, I recall the titles of only two of them: *Hippopotamus Parade* and *Sick-a-Bed*. Because his scripts were so successful, the studio eventually brought Morgan out from the East to join our unit. On one occasion, work had to begin before he had time to prepare a script. All members of the crew were given a copy of the *Saturday Evening Post* and told to work from that.

I look back on those early times as the fun days of film making. Many of the stories called for outdoor scenes, which meant that we spent much time working on different locations. The Sam Wood unit was like a happy family, moving from place to place in the beautiful sunshine of the southwest. Of course, it was the abundance of sunshine that made Hollywood the motion-picture capital of America. I remember lemon and orange groves everywhere, and you could still see mockingbirds sitting on the telephone wires.

In those days studios had no dark stages. The daylight stage was like a large greenhouse with a glass roof through which the sun shone. The natural sunlight was controlled to a certain extent by diffusers. These were

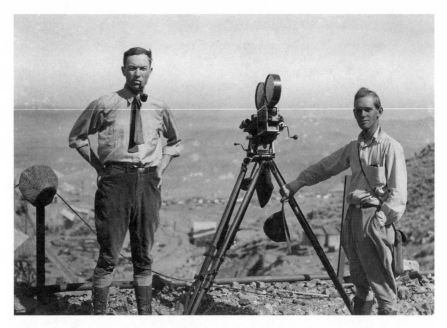

Al Gilks and I filming with a hand-cranked Bell and Howell at an old
mine site in the Mojave desert in the early 1920s.

long strips of linen that could be pulled over a guideline of wires strung
just below roof level. With the introduction of arc lights to supplement the
daylight, the work of the cameraman became easier. Nonetheless, he still
had to balance the considerable difference in the photographic value of
the two sources of light. With no light meter to assist him in arriving at a
correct exposure, a high level of expertise, possibly unappreciated by
today's photographers, was necessary.

In 1921, when production was slow during reorganization of the stu-
dio, Sam Wood received permission for his unit to make an independent
production for Sol Lesser. The film was entitled *Peck's Bad Boy*. It was a
charming little picture starring the delightfully precocious child actor
Jackie Coogan. That same year he became famous almost overnight in the
title role of Charlie Chaplin's *The Kid*. A film with a Mark Twain flavour,
Peck's Bad Boy became a great success. One memorable sequence involv-
ing several lions was filmed on a set enclosed by a wire fence through
which we could shoot. Towards the end of the day Al Gilks and I moved
the camera into the enclosure to make the most of the fading light.
Charley Gay, the trainer, came in to get the lions to perform, and he gave
Sam Wood a long spear to ward off any lion that came too close. When
Charley cracked his whip the lions bounded around the fence to a

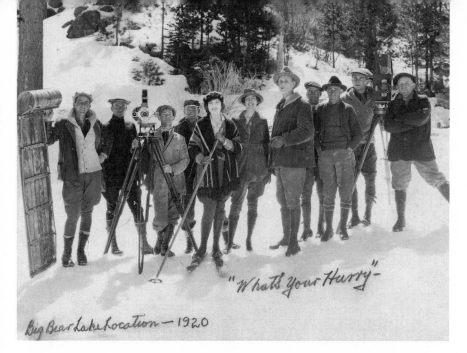

What's Your Hurry, Big Bear location, 1920. Al Gilks is second from left and I'm on the other side of the camera with Sam Wood behind me. Star Lois Wilson and script girl Louise Long are to my left.

Jackie Coogan in *Peck's Bad Boy*, 1921. Jack Coogan Sr. standing at far left of the camera crew, keeps an eye on us. Al Gilks at the camera, me beside him, Sam Wood pointing.

position behind the camera. From there one broke loose and charged straight for the crew. Whereupon Sam, instead of pointing the spear at the beast as directed, thrust the tip into the ground and used the lance as a support to swing himself out of danger's way. In the years that followed, if a scene presented any danger, Al or I would call loudly for a spear for our "protector." Sam never really appreciated the allusion.

On our return to the studio, we found that our next film would reflect the growing demand for glamorous and sexy women on the screen. We were to make a picture starring Gloria Swanson, who clearly qualified on all counts and whose talents had been evident in minor parts in Cecil B. De Mille productions. For Sam Wood's unit, this was quite a change from the rather rough-and-tumble type of films we had been making up to that time. In order to introduce an element of genteel spice into Gloria's pictures, the studio hired Elinor Glyn, the English author whose novel *Three Weeks* was considered deliciously risqué. Elinor herself exuded dramatic flare. With her theatrical sense of dress and decorum, Madame Glyn, as she became known, was a wonderful help to Sam. Besides writing good scripts for us, she also acted as a consultant, keeping an eye on costumes, manners, hair styles, sets, and practically everything else that happened before the camera. As our authority on glamour, she ensured that our productions met the increasingly daring tastes of the times.

Of the films that Elinor Glyn wrote for Gloria Swanson, the three that I remember best were *The Shulamite* (1921), *Beyond the Rocks* (1922), with Rudolph Valentino, and *The Great Moment* (1921). The latter included a much-discussed scene in which the hero and heroine ride through the rugged beauty of the Chatsworth Hills. At one point they dismount and walk over to the rock face in order to have a better view of the valley below. There, unseen by them but of course noted by the audience, a rattlesnake lies sunning itself. As the heroine leans against the rock, the startled snake strikes her breast, whereupon the hero tears off her blouse and gallantly puts his mouth to her breast to suck out the venom. In those days, the camera was not supposed to reveal the hidden charms of the female body and that constituted a daring scene. I sometimes wonder where the rattlesnake would strike if the film were remade today!

Despite all the glamour surrounding her in those days, Gloria Swanson was a warm and delightful person to work with. I was young and just breaking into the movie world myself when she started her rise to stardom. During breaks she would sometimes ask me about the war. As she began to earn good money she decided, for whatever reason, that she would like to help me get a good education. Fortunately, she first approached Sam with her idea of sending me to university. His reaction

was not encouraging: "Gloria, you'd better put on your running shoes when you speak to Bordie; I don't really see him wanting to become a school boy again." He was right, of course. But her gesture was characteristic of the kindness that permeated Hollywood in the 1920s.

Another friend was Rudolph Valentino, with whom I filmed *Beyond the Rocks* with Sam Wood's unit. This being just one year after Rudy's sensational success in *The Sheik*, women would flock around his trailor to catch a glimpse of the man reputed to be the screen's greatest lover. Although we had to chase his fans away when shooting, Rudy was always too much of a gentleman – or a star – to resent the constant invasion into his privacy. But, like me, he felt the need to escape the constraints of studio production whenever possible. While filming on Catalina Island, we used to meet right after breakfast to go hiking. In a sense we were kindred spirits, enjoying the exhilaration of the fresh morning air before rushing back to our respective jobs – he before the camera and I behind.

One day, Madame Glyn's attention was drawn to a pretty little effervescent redhead called Clara Bow. After observing her for a while, Elinor declared that Clara definitely had "it." What "it" was, she never spelled out, but we all knew it signified that elusive, mysterious something we instinctively look for in the opposite sex. Clara Bow was signed up. Elinor

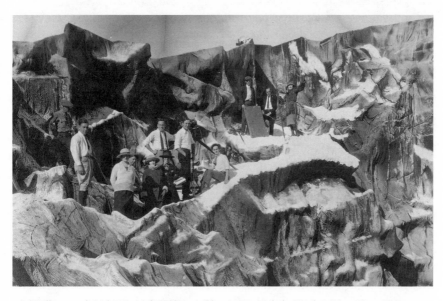

A Hollywood "Alps" set for Elinor Glyn's *Beyond the Rocks*, 1924. I'm sitting on the "snow" with Al Gilks and Sam Wood to my right. Elinor Glyn is below Sam while Gloria Swanson waves behind us.

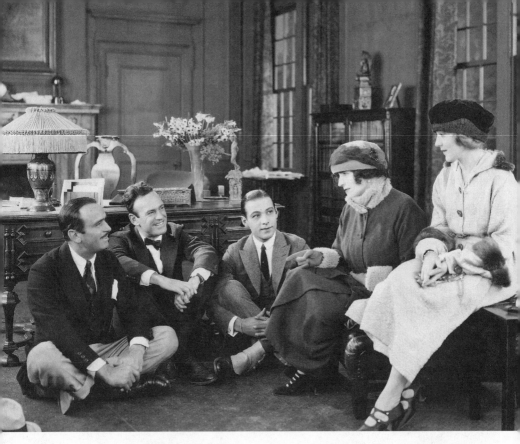

I took this photo on the spur of the moment when Mary Pickford and Douglas Fairbanks dropped by to visit during the shooting of *Beyond the Rocks*. Everyone was waiting for Gloria Swanson who had gone to change her costume. Douglas Fairbanks Sr, Sam Wood, Rudy Valentino, Elinor Glyn, Mary Pickford.

Glyn wrote a script called *It* which we filmed, and another star was born. Clara captured the buoyant confidence of the twenties and her many films sparkled with her charm.

1923 brought our unit an exciting change of location. Sam Wood was asked to direct *His Children's Children* for Paramount's New York studios. He agreed, providing he could take his camera crew and assistant director with him. We headed east to work in the sweltering discomfort of an unusually hot summer. Yet despite the heat and humidity, it was a stimulating experience. The cast consisted for the most part of well-known artists from the New York stage, including Mary Eaton, Dorothy MacKaille, Warner Oland, and Chester Conklin. We shot indoors and out: Fifth Avenue, Central Park, and the palatial Vanderbilt mansion which had been placed at our disposal. Yet for all the excitement and sophistication

of New York, I was happy to get back to the dry warmth of Southern California. Even occasional earthquakes seemed more bearable than the oppressive humidity of New York.

Upon our return to Hollywood, we found that major changes in studio management had taken place. Shortly thereafter, Sam Wood left to freelance as an independent director and his unit was disbanded. It was a sad event for us all. We had stuck together for about six years and had become known as an efficient, successful and happy crew. During this period I had risen from green assistant to camera operator and was now recognized as a potential first cameraman. All this I owed to my good friend Al Gilks, with whom I would continue to work from time to time under the Famous Players-Lasky (Paramount) banner.

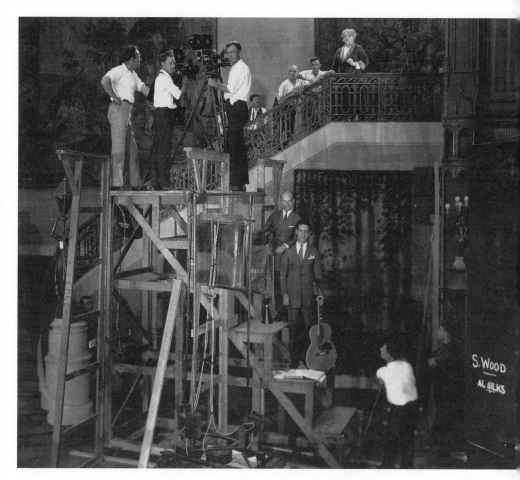

Shooting *His Children's Children* in the Vanderbilt mansion, New York, 1923

Journeyman on Location

Hollywood in the roaring twenties was both a town and a state of mind. Everywhere, optimism and audacity reflected the creative ebullience of a young, brash, and booming industry. In a milieu where everybody knew everybody else, friendliness, good-natured humour and a spirit of collaboration tempered potential rivalries. During slack moments in production, artists and technicians would visit each other from set to set, and occasionally even from studio to studio. In this manner I came to know and enjoy the companionship of Will Rogers and Eddie Cantor, although we never actually worked together on a production. However, this easy-going way of meeting and of learning from one another's work experiences did not last long. As filmmaking became more competitive, rivalry and jealousy created rifts between producers, while the introduction of production managers did away with any activity that interfered with efficient time management. A once happy-go-lucky industry was becoming highly competitive, with studios prepared to pay their stars astronomical salaries to prevent them from defecting to the competitor. In the process, something of the old sense of comradeship was gradually being lost.

Nonetheless, with the disbanding of the Sam Wood unit, I now had the opportunity of working with several other cameramen and directors: among them William de Mille, Tom Forman, Bill Wellman, Clarence Badger, and Irvin Willat.[1] When extra cameras were needed, I often joined the crew of the great Cecil B. De Mille himself. He was a well-organized producer whose productions rolled along like clockwork. No one ever said "No" to C.B., whose crew was known throughout the studio as the "yes

1 Kevin Brownlow, in *The Parade's Gone By*, (New York: Alfred A. Knopf, 1969, 187), correctly notes the differing capitalization used by Cecil B. De Mille and his older brother, William C. de Mille, for the family name.

crew." When he asked, "Are we ready to shoot?", we would call out in chorus, "Yes, C.B., Whenever you're ready!" In those heady days of the film industry's ascendance over Southern California, C.B.'s fame and influence carried unexpected weight in the community at large. I once benefitted personally from De Mille's authoritarian manner. One day I beat up and subdued a prowler who had broken into my house and threatened me with a gun. When the police arrived, the intruder was in such bad shape that they hauled both of us off to jail for questioning. Even though my victim turned out to be a much-wanted criminal, I had no luck in persuading the police that I was needed at the studios to begin the day's shooting. Only a furious phone call from C.B. De Mille demanding the release of his cameraman brought results. So great was his influence that the cops personally chauffeured me back to work in one of their own cars.

In the course of my years at Paramount Studios, I worked with most of the stars of that early period. Many I got to know quite well: Pola Negri, Ethel Clayton, Mary Miles Minter, Dorothy Davenport, Constance Talmadge, Roscoe (Fatty) Arbuckle, Billy Dove, Jeannette MacDonald, Maurice Chevalier, Jack Holt, Wally and Noah Beery, Theodore Roberts, Lon Chaney, and Harry Houdini. Indeed, as the autographed photographs in my albums attest, the list could go on and on, for the number of people employed in the industry was rapidly expanding. Rivalries, petty jealousies, and the occasional scandal notwithstanding, I must confess to having encountered more kindness and generosity than mean-spiritedness. There were no super-egos to spoil the feeling that everyone's contribution was important. Friendliness and respect made for happy working conditions.

One of my best films experiences was *North of 36*, shot in 1924. Directed by Irvin Willat, it was based on the plight of Texan ranchers who could not transport their herds to market and had to shoot them, leaving their carcasses to rot. The film told the story of one desperate rancher and his family who chose to challenge all odds and drive their cattle over six hundred miles north through hostile Indian territory to the nearest railway at Abilene, Kansas. This was a splendid western with a full cast of artists, including Jack Holt, Lois Wilson, Noah Beery, and Charles Ogle. Al Gilks and I teamed up for the photography with a small crew of five technicians.

North of 36 confronted us with new challenges, not the least of which was the fierceness of the Brahman bulls. Better able to withstand the high temperature and infestation of insects so prevalent in Texas, these beasts had recently been imported from India to improve the stock of domestic beef cattle. I could never understand why the bulls, so easily handled by cowboys on horseback, became so ferociously dangerous to anyone on

foot – including the cowboys. Years later, in India, I was astonished to see the same breed wandering freely through the crowded bazaars, where they are regarded as sacred animals. For historical accuracy in the film, we had to avoid showing the Brahman bulls which, of course, would not have arrived in Texas at the time of our story. The need to keep the ill-tempered beasts away from their cows and out of camera range required constant herding on the part of the cowboys. With five thousand cattle at our disposal – including many of the almost extinct Texas Longhorns – the herd became a major player in the production. The cowboys also had an important part to play, although the credits did not acknowledge that many of them were hardened convicts from a nearby prison ranch.

North of 36 may well have been the first film to resort to an airplane to stampede a herd of cattle. It may also have been the first to use infrared film to achieve night effect. On a personal note, it was also the production on which I finally gave up smoking, thereby possibly ensuring a long and healthy life.

Another film which I remember for personal and professional reasons was a comedy starring the team of Wally Beery and Ray Hutton. This was *Fireman, Save My Child*, and the improbable heroes struck me as the answer to an arsonist's dream. My favourite scene involved the pair answering a fire alarm. While Ray drove the big tandem-style fire engine from the driver's wheel at the front, Wally steered with the second wheel located at the back. The ensuing slapstick comedy derived from their inability to get synchronized. As the front end of the truck veered down the right side of the road, the rear end careened down the left. Whenever the hapless pair attempted to get in line, the truck zigzagged wildly from side to side. The crazy side-step that ensued triggered much merriment among film audiences, but caused me considerable grief at the time of shooting. I had set my camera on a low tripod beside the road where it was hidden by a bush. As the fire engine swerved zanily toward me, the rear end sideswiped the curb, my camera, and me. Luckily, I escaped with no more than a broken arm, but my camera was completely demolished.

A happier memory of shooting *Fireman, Save My Child* indirectly concerned Charles Lindbergh. Sometime earlier, I had visited the Ryan Company in San Diego where I had seen Lindbergh's plane, *Spirit of Saint Louis*, being built. It was a little high-wing monoplane with a two hundred twenty-five horsepower Whirlwind motor in its nose. Behind the motor was a huge gasoline compartment. Sitting behind this solid bulkhead, the pilot had no forward vision at all except through a periscope which went up through the roof. Two small windows on either side of the cockpit did little more than let in some daylight. At the time, I admired

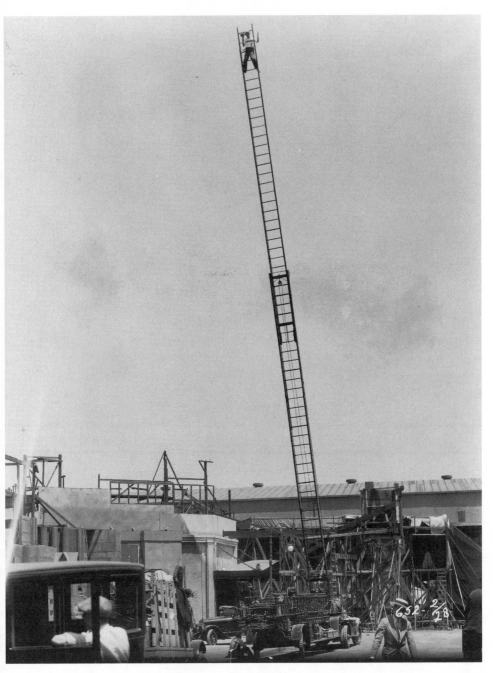

Atop Hollywood's highest fire ladder with a hand-held camera, I was shooting *Fireman, Save My Child* when I learned of Lindbergh's successful flight across the Atlantic.

the skill and courage it would take to pilot that flying gas tank, and was particularly delighted on hearing of Lindbergh's successful flight from New York to Paris. On that day, 21 May 1927, I myself was riding rather high; I was on the top of a ninety-foot fire ladder, my camera pointed to the fire engine below. It was from that lofty perch that I heard a friend on the ground call up to me, "Hey, Bordie, Lindie's made it … he's landed safely in Paris." I was very glad, for I had had my doubts about the success of that flight. Some time later, in Mexico City, I was delighted to meet Charles Lindbergh and Ann Morrow, the famous writer who later became his wife.

From my earliest days in California, I had developed an enthusiasm for airplanes and flying. What started as a hobby quickly added an exciting new dimension to my work. During my short-lived high school days, I used to skip classes with a friend to watch pioneer flyer and aircraft manufacturer, Glenn Martin, test one of his early planes at the U.S. Air Force Base on North Island in San Diego harbour. Even then, those wonderful flying machines fired my imagination. In those perhaps more innocent days, the airfield was wide open and we could walk unimpeded into the few hangars, looking at the planes and talking to the mechanics and airmen. No one ever asked us who we were or why we were there. Much later, Glenn Martin became one of the leading military aircraft manufacturers in the United States, producing such famous planes as the B-10 bomber and the China Clipper flying boat. Not in my wildest fantasies could I have foreseen that, twenty-five years later, I would fly over the western desert of Africa in a Martin B-10 bomber.

On days off, I sometimes visited the Hollywood garage where the Lockheed Vega was being built. Designed for newspaper tycoon Randolph Hearst by John Northrop and Allan Lockheed, this was an exceptionally clean and pretty plane, with its skin formed of moulded wood instead of doped canvas. Named after the brightest star in the heavens, the Vega became so successful that the expanding Lockheed business had to move to Burbank, where it still has its headquarters today.

Irrevocably bitten by the urge to fly, I met Leo Nomis, a first-rate aviator and stunt man with his own plane. Whenever he was short of money – which was most of the time – he would sell joy rides, throw handbills out over San Diego, or put on an exhibition of stunt flying. Whenever I could get away from the studio, I flew with Leo on these ventures, sometimes climbing out between the wings to attract more ticket buyers. I learned to fly sitting in the front cockpit of Leo's dual-control plane while he skippered in the rear. With one hand on the joy stick, the other on the throttle, and my toes barely reaching the rudder bar, I soon acquired the

feeling of flying. When Leo was satisfied that I had the right touch, he would tap on my shoulder for me to take over the controls of the plane. Thanks to his faith in me, I learned to fly at last. I still treasure the flight certificate Leo filled out in pencil attesting that "O.H. Borradaile of Hollywood made a 20 mile flight in a Pacific Standard Airplane from Hollywood, solo, on November 16, 1921."

My most exciting experience with Leo Nomis took place in Death Valley in 1925. He had being flying a solo stunt sequence for the film *Air Mail*, when his propeller suddenly disintegrated, causing the motor to race and the crankshaft to snap. He managed to sit his open cockpit double-winged kite skillfully down among the sand dunes. On assessing the overall damage, which was considerable, he took some water and biscuits from the plane and headed out on foot, stumbling into Rhyolite, Nevada, an old ghost town, two days later.

After procuring a re-built motor, a secondhand prop, some linen, copper wire, aircraft dope, and four willing volunteers – of which I was one

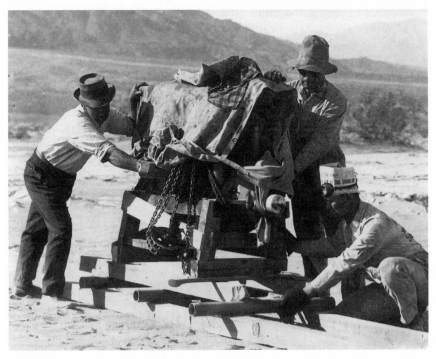

Moving a 700-pound airplane engine over the burning sands of Death Valley on improvised wooden tracks. Me, in newspaper hat, and two other vounteers, 1925.

– Leo drove us back to Death Valley. Following a rough trail over the Panamint Range, we had to abandon the car about three miles away from the plane because of drifting sand. For that last distance we pushed the seven-hundred-pound motor over the burning desert, using four planks and three or four bits of pipe as temporary tracks. It took us a full week to reach the plane, toiling by day under temperatures of 110 degrees fahrenheit. The Los Angeles *Pacific and Atlantic* recorded our adventure as follows:

> To save their plane from the fate that has befallen so many wayfarers in the famous Death Valley of California, Leo Nomis and O.H. Borradaile accomplished the almost impossible feat of transporting a 700-pound airplane engine over the shifting desert sands for 3-1/2 miles by hand. Without mechanical aid, they laid wooden rails and shoved the ponderous motor inch by inch across the burning sand dunes of the treacherous valley that has claimed so many lives. Three assistants comprised their entire aid in accomplishing the remarkable feat, which is the first airplane epic to take its place in the colorful tales of the Death Valley region. The failure of an old engine forced the plane down in the valley and the only way to save the ship was to bring in a new engine in the laborious manner Nomis and Borradaile took.[2]

Nor did that end our adventure. Before sunrise on the morning of the eighth day, Leo and I climbed into the cockpit. He gunned the motor, the plane bounced off a couple of dunes and was suddenly, miraculously, airborne. Even in the cool morning hours, we were caught in terrific up and down draughts. But the scenery was spectacular: to the east, the bleak, rugged mountains of Nevada; to the west, Mount Whitney's snow-capped crest tinged pink by the rising sun; below, the arid land carved into strange designs by wind and sudden cloudbursts. Worried that one of the struts was becoming visibly loose in all the turbulence, Leo headed for one of the white borax lakes below. Seeing a truck on its smooth, snow-like surface, he touched down nearby and persuaded the driver and his pal to fetch us some supplies from the borax plant: bolts, spikes, hacksaw, hammer, wire, tape, and gas. But when the repairs were completed to Leo's satisfaction, our new friends declined the offer of a short flight in token of our appreciation. The plane's patches had doubtless spoken too eloquently of the need for caution. Yet Leo knew what he was doing and was able to coax that wallowing old aircraft back to home base at Clover Field, Santa Monica.

2 "700 pound airplane moved," Los Angeles, *Pacific and Atlantic*, 8 April 1925.

I was filming in Europe when I heard of Leo's death in 1932. He was killed in a flying accident while doubling for actor Jack Holt in the film *Sky Bride*. Leo had lived dangerously for most of his life. He had been variously a trapeze artist, First World War flying instructor, and stunt man. Quiet and unassuming, he had excelled in all that he undertook. His achievement in the flight out of Death Valley was typical of his skill and determination. I was proud to have shared those moments with him.

During the period of re-equipping the studios for sound, I had left Paramount briefly and joined Howard Hughes. My friend, Harry Perry, was chief cameraman, but as far as I was concerned, mine was the better job. Together with Elmer Dyer and E. Burton Steene, I filmed air sequences for Hughes' famous film *Hell's Angels*, released in 1930. I already knew all the pilots and stunt men hired for the film. They were a grand, colourful bunch of fellows and damned fine pilots – they had to be good to fly some of the old aircraft we used for the movie. Even so, four pilots lost their lives during the making of *Hell's Angels*. In those early days of filmmaking the cost of achieving realism on the screen was often very high.

My first impression of Howard Hughes was of an unassuming, lean young fellow from small-town Texas. His speech was twangy and slow and he seemed to be hard of hearing. Certainly his appearance belied his success as a financial genius and builder of aircraft. As I got to know him better, I admired his zeal and determination to do things his own way. I particularly appreciated his direct manner and straightforward approach to problem-solving. I believe I was the first person to fly as a passenger in a plane piloted by Howard Hughes. All the stunt pilots bantered about the risks, calling out, "Bordie, you sure live dangerously!" "Boy, you sure take chances!" Picking up the jest "Slim Kiddix," as they called Hughes, would retort good-naturedly in his Texan drawl, "You guys get up in the air and do what you're being paid to do!" Tomfoolery had its place, but work came first.

When the shooting of *Hell's Angels* was almost finished, I received a call announcing that the adaptation to sound stages was complete and my job with Paramount was still waiting for me. I welcomed the opportunity of becoming a part of the new sound era. Yet, after weeks of flying in open cockpits through the clear California air, the dark stages had less appeal than they might. However, the mortgage on my newly built home in Benedict Canyon convinced me of the need to put fiscal responsibility before the lure of further adventure. My decision relieved my mother, who had a lifelong mistrust of flying.

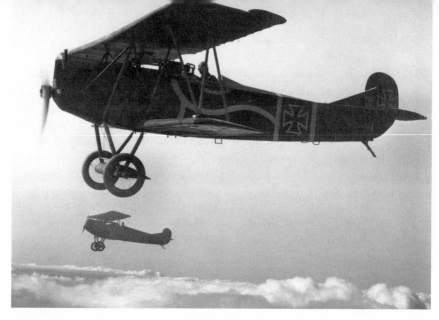

One of my air sequences for Howard Hughes' *Hell's Angels*, 1930.

Had I but known it, my days of flying were far from over. In the years ahead, both in peacetime and in war, I would again take to the air in my quest for majestic landscapes to bring to the screen. The airplane was like the magic carpet in my film *The Thief of Baghdad*. Fast and exciting, it pushed back my horizons, opening up continents for me and my camera to explore.

If 1927 was an historic year in the annals of aviation, it was also a landmark in the motion-picture industry. With the huge box office success of Al Jolson's film *The Jazz Singer*, it became abundantly clear to producers and exhibitors alike that the theatres were no longer interested in silent films. The "talkies" were here to stay.

Yet the advent of sound introduced many disruptive elements into the film industry. First, producers scrambled to obtain both the new technology and the technicians to operate it. Then studios closed down temporarily in order to soundproof their stages and install their recording equipment. With actors becoming increasingly concerned about the quality of their voices, teachers of elocution experienced a sudden bonanza. Yet with the exception of those who had begun their career on the stage, relatively few actors survived the transition from silent to sound movies. The spoken word came into its own, leaving no room for sloppy improvisation. In the silent films actors could pretty well say whatever they wanted since the dialogue was added later in the form of subtitles. I recall a charity preview of one of my early films that took place before a group

of deaf people. In a scene where a saintly hermit comforted the dejected heroine, the subtitle read "Do not despair, my child. Providence will look after you." Our audience, however, read his lips: "I'm gonna go out an' get stinkin' drunk tonight!" The scene was reshot next day.

The addition of sound meant modifications to camera equipment too. Although motorized cameras had long been available, most cameramen still preferred to crank the film by hand as this gave them greater control. The possibility of changing the speed of the action added to the cameraman's artistic licence. Now, however, the advent of sound dictated that cameras be fitted with a motor that could be synchronized with the sound recorder to turn the camera at the new constant speed of twenty-four frames per second. The introduction of motors, however, made the cameras noisy, drowning out the very sounds we were trying to record.

Early attempts at silencing the cameras were unsuccessful. First, we tried to smother the clatter by bundling the cameras in blankets and padding. When that proved awkward and ineffectual, we built huge "iceboxes," or what we cameramen more realistically called "sweat boxes." These were soundproof cases about three feet square by six feet high, with a door at the back and a heavy plate window on the front through which to film. The camera stood inside on a bench before the window; behind it was a stool for the operator. Those monstrous cases were mounted onto four large casters so that they could be moved about on the stage. There was no ventilation. After only a take or two, we would burst out, gasping. Those stifling contraptions had all the limitations of a sauna with none of the amenities! Moreover, the camera was static and lost the fluidity that was one of the great benefits of the silent film days.

Previously cameras had had the stage to themselves; now they vied for space with sound equipment and the additional lighting required to use two or more cameras at a time. In an attempt to regain ease of motion, we later placed the cameras into soundproof boxes, or "blimps" as we called them. Although more successful than padding or sweat boxes, the blimps were still awkward to operate. Indeed, from the cameraman's point of view, the coming of sound was a blow to creativity, for it was now the sound technician who dictated where cameras would be placed and moved. Everything from lighting to camera angles had to take into account the amplifiers and microphones carried along the parallels above the set.

The art of the cameraman had advanced spectacularly in the course of its brief history. As Kevin Brownlow noted: "There is hardly a camera technique in existence that did not have its origin in the silent era. Wide screens, three-dimensional pictures, Technicolor, hand-held cameras, traveling shots, crane shots, rear-projection, traveling matte, Cinerama –

all had made their appearance before the end of the twenties. Even the zoom lens had been developed by 1929."[3] After so fruitful a period of exhilirating innovation, camera crews were again reduced to basic panning and tilting, hobbled by the domination of sound equipment. Of course, as technology improved, these physical impediments were overcome, but for most cinematographers the transition to the "talkies" was fraught with frustration.

Two major systems put sound on film: the Western Electric system of variable density exposure, and the rival RCA system of variable area exposure. Not being a sound technician, I found both systems complicated. The variable density method involved stringing two taut wires over a small slot beneath which the film passed. The sound waves vibrated the wires, causing them to open and close the slot. This in turn controlled the amount of light reaching the film, thereby varying the density of exposure according to the breadth of the opening beneath the wires. The variable area system had a small mirror suspended before the aperture. This mirror vibrated according to the different strength of the sound waves. The movement of the mirror threw a sharp beam of light onto the film, sometimes covering a small area, sometimes a large one, hence exposing a variable amount of film to the light.

Once the film was processed, the light from the film projectors passing through the sound track – whether variable density or variable area – was converted into sound waves which the speakers reproduced as originally recorded. The extraneous noise and rather poor quality of early sound production, however, remained. Later techniques such as rerecording and dubbing overcame extraneous sounds, but it was really not until the introduction of the magnetic tape system in 1949 that the recording of sound for film was simplified.

One of my early sound films was *The Doctor's Secret* under the direction of Cecil De Mille's brother, William. He had been a successful stage director in New York prior to coming to Hollywood and was much more interested in exploring the psychology of his protagonists than producing action-packed spectacles. To this end he used the technique of long, uninterrupted scenes, and welcomed the one-thousand-foot film magazines that were introduced with sound. He had three cameras assigned to his productions to obtain covering, medium, and close-up shots without stopping the action. Since it was possible to cut the film but not the sound, scenes were generally filmed in their entirety. A perfectionist, de Mille would rehearse the artists for the better part of a day for a five-minute

3 Kevin Brownlow, *Parade's Gone By*, 220.

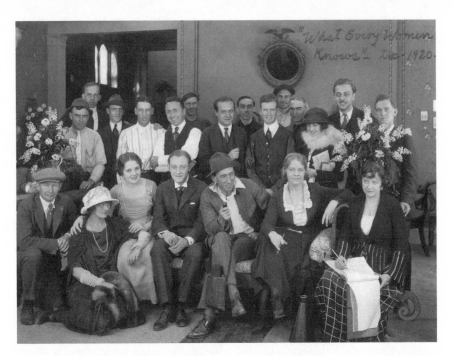

On the set of William de Mille's *What Every Woman Knows*, (1920). De Mille is in the centre, wearing the hat that became his trademark. Cameraman Guy Wilkie is front left while I'm behind the flowers on the right.

scene. When he was finally satisfied that the performers and camera operators knew what he wanted, he would announce, "Let's try and shoot it." We would then lock ourselves into the sweat boxes, hoping that everything would go as planned so that there would not be too many takes. The most de Mille could hope for with one load of film was two five-minute takes. For those of us confined in those noisy, stuffy crates on wheels, that was more than enough.

The Love Parade was the first of my films in which the actors sang. It appeared in 1929 and starred Maurice Chevalier and Jeannette MacDonald. My main recollection of the film is Chevalier's concern over his first performance in English. Although a French version was also released, he was apprehensive about the difficulties of performing in a new language. Certainly his thorough preparation was rewarded – "Louise," the song I can still hear him rehearsing over and over again, turned out to be a great hit.

Working in the sweat boxes and dark stages drove me to the conclusion that I would leave movie-making to others if I could no longer film outdoors. So I decided to specialize in location and expedition work, both of which were much more to my liking.

I was therefore pleased when the head office asked me to go to Mexico City as an advisor to an independent film maker who had been promised a Paramount release if her film met the studio's standards. Although I have forgotten the names of those involved, I do remember that the situation was delicate. The director and cameraman, being highly experienced, did not take kindly to a young greenhorn coming down from Hollywood to pass judgment on their work. Despite my efforts at working diplomatically with the crew, it was not possible to salvage the mediocre material that had been produced; my final recommendation was to stop production. Although my advice was not acted upon, it was vindicated several years later when I met the same woman producer in London. She told me then that she wished she had taken my counsel, for the film she made in Mexico was never released. For me, however, the experience was a wonderful encounter with Mexico and its people and confirmed me in my desire to see the world through the lens of my camera.

On returning to Paramount from Mexico I was assigned to the special-effects department, which was in the process of developing the back projection method. This development excited me, for I recognized it could bring more authentic backgrounds to the screen. Back, or background, or rear projection, as it was also known, made it possible to photograph actors in a studio as though they were actually on location. Once a background scene – jungle, desert, mountain peak, or passing clouds – had been shot, the print was placed in a projector with a very powerful light and projected onto the back of a translucent screen, making it clearly visible on the opposite side. With the combining camera and projector synchronized, the actors were positioned in front of the screen and lit to match the light value of the background. When all was ready, we shot the scene. The effect gave the illusion that the scene had been staged on location.

The advantages were considerable. Back projection allowed for much greater control of lighting, climate, and background noises, and saved the cost of sending actors to expensive locations. Years later, when I had joined Alexander Korda's London Films Productions, we used back projection in *Sanders of the River* to show Paul Robeson in deepest Africa. In reality, however, he had never been there at all. Do pictures lie? That depends on how they have been taken!

Having kept abreast of the latest technical developments in cinematography through my experience with sound films and rear projection, I was now given an opportunity to expand my career abroad. My next call to Paramount's front office proved to be the most exciting to date: I was offered a new one-year contract at Paramount's Joinville studios near Paris. The opportunity would allow me to get sufficient feature film cred-

My first miniature shot for background projection. The waterfalls are three feet high. Paramount, 1928.

its to be recognized as a director of photography. Needless to say, I was delighted. Little did I realize that I would never again work in Hollywood. Had I known this at the time, I might not have signed my new contract, for I had grown to love California and its friendly, generous people. Indeed, I have never known truer friends than the ones I made there so long ago. On the other hand I did have problems with an industry that was becoming increasingly big, brash, and gimmicky. Too often I felt that artistic merit was sacrificed for commercial gain. With the growing competition between studios, stars were both pampered and ruthlessly promoted. In the process they began to fall for their own publicity, took themselves far too seriously, and expected everyone else to do likewise. Of more concern to me were the producers who, to capture the growing

markets, sought innovation at all cost. One of my big disputes before leaving Paramount was against the growing convention that the camera be used as a gimmick. For a while it seemed that a worm's eye view of everything was marvellous, so you had to get your camera down on the floor and shoot up. I could never see that. I've always believed that the main thing, if you're going to tell a story, is to shoot it straight. Just like everyone else, I've created funny lighting here and there, but the picture that comes on the screen should tell the story without crying out to the world that this was done by a very smart cameraman. If the story calls for a floor shot, fine; shoot it from the floor. But only if it helps to tell the story. These views were not always popular in the Hollywood of the twenties, but eventually they resonanced with the founder of London Films, Alexander Korda. He was a rather down-to-earth guy when it came to making pictures. I think that was one of the reasons he would send me out on expeditions. He knew I would "shoot it straight" and bring back footage showing the marvellous beauty of distant locations just as they were.

But that would come later. As I prepared to leave Hollywood I was eager to face new challenges. Within days, I reported to the New York office to pick up my tickets for passage on the liner *Ile de France*. On boarding, I discovered that my ticket had originally been issued to one of Paramount's top executives who had cancelled his trip at the last minute. Once again fate smiled on me: I crossed the Atlantic in the bridal suite of one of the most luxurious ships afloat.

Camerman Abroad

On arriving at Les Studios Paramount at Joinville, France, in late 1929, I found a modern, well-established plant with five stages, a laboratory, and all the departments necessary for film making. The technicians were a cosmopolitan lot. In addition to the French crew, cameramen and soundmen had come from practically every country in Europe. Of course, there were Americans too. Three cameramen from New York, Harry Stradling Sr, Ted Pahl, and Phil Tannura, showed me around and assured me that life in France could be delightful. I was glad of their welcome. To one newly arrived from unilingual Hollywood, Joinville seemed like a veritable Tower of Babel. Nonetheless, I warmed to the international milieu of Paris. Although not a linguist, I had little difficulty communicating with my polyglot crews.

I relished the cultural diversity of studio life. For example, my young Russian assistant, Michel Kelber, invited me to celebrate New Year with his family. This introduction to Russian hospitality was beyond anything I had ever experienced. Throughout the two days of festivities an endless stream of visitors dropped by to toast the new year and partake of bounteous supplies of food and drink. Yet this community that had known deprivation. Among these White Russian émigrés were refugees from General Pyotr Wrangel's army, which had been defeated by the Bolshevik forces in 1920. Many had held high rank and enjoyed special respect among their compatriots. In greatly reduced circumstances, they considered themselves fortunate to have found refuge in France. Most of them, it seemed, had become taxi drivers. By a curious coincidence, I met several of them again when the studio engaged them as extras in *Le Général*. Dressed in their old uniforms, complete with medals and honours, they formed an impressive crowd. It must have been painful for them to leave the sound stage and resume the anonymity of their life in exile.

Filming *Le Général* at Les Studios Paramount, Joinville, France, 1930. Note the blimped cameras and the uniforms of the Russian émigrés serving as extras.

As the only technician in the studios with experience in rear projection, I was asked to assist in forming that department. Our screen was a ten-by-fourteen-foot pane of plate glass. Ordered before my arrival, it was reputed to be the largest then in existence. We had it mounted in a mobile frame and then hired glaziers to finish one side with a ground-glass finish. The result was first class and must have cost a fortune. I have often wondered what eventually happened to that screen, and whether it survived.

In expanding their operations, Paramount had ambitious plans to market their films abroad by translating American scripts and producing them in their overseas studios. At Joinville, we shot several versions of American films simultaneously, with actors of different nationalities recreating each scene in their own tongue. On paper the venture no doubt seemed economically sound. In fact, it was doomed from the start. Scripts that appealed to American audiences often seemed ludicrous when translated

into a European context. At least in France, American films were often poorly, if not scornfully, received. One of those scripts – C.B. De Mille's very successful film *Manslaughter* – had the translators shaking their heads in despair. It had appeared in 1922 and, played by Americans in an American context, had had box-office appeal – in the USA. Yet in the studio bar at Joinville, where many of us would gather for a drink and a chat after work, one heard nothing but condemnation: "It's impossible!" "There are no such people in my country!" "That would never happen where I come from!" Eventually the message reached Head Office, which announced a change. Translations of Hollywood scripts ceased and writers based their scripts on European stories, which improved production considerably.

Perhaps even more successful in reaching an international audience was a quite different approach. An Alsatian by the name of Reichman had sold Paramount the story of a small traveling circus whose multinational members each spoke in their own tongue. Entitled *Marco le Clown*, or *Camp Volant*, the script consisted of short, simple dialogue and plenty of mime. With good casting and scripting, even a non-linguist like myself had no difficulty understanding scenes spoken in three or four different languages. I thoroughly enjoyed photographing *Marco le Clown*. Our first location was Sélestat, a picturesque Alsatian town with narrow cobbled streets and old half-timbered houses. To the delight of local citizenry, our acrobats performed for several days on wires stretched from gable to gable high above the main square. The circus had come to town.

From Sélestat we moved production to the Cirque d'Hiver, or Winter Circus, in Paris. Here, considerable frustration awaited me. The building was huge, with a ninety-foot dome rising above the sawdust floor of the ring below. The script threw a twist by calling for shots directed down from the top of the dome towards the ring and audience. Good lighting was clearly essential. But, because we could only rent the building for a limited time, we had to begin production almost immediately. There was no time to wait for the studio's large portable lamps, which were then being used on location in Marseilles. Nor was it possible to rent lamps from other studios. We had arrived at an impasse. At that moment my electrician, Germain, rescued the operation. He promised to light up the Cirque d'Hiver if he could have twenty tin tubs, a few necessary fittings, and two tinsmiths. He would acquire the necessary bulbs. Despite my doubts, I gave Germain all that he asked for. In the meantime, I managed to procure a few thousand feet of the new Super X negative, which would give me a bit more speed, thereby enabling me to work at a lower light level. To everyone's amazement, Germain was as good as his word. His lamps turned out to be effective floodlights and, thanks to his ingenuity,

we delivered the required effect. No cameraman ever had a better "spark," nor a clearer reminder that good teamwork is indispensable to good filmmaking.

One of our key scenes required my scrambling up to the high trapeze hung in the lofty dome of the Cirque d'Hiver. It struck me as a precarious perch. After swinging back and forth for an hour or so to get an artiste's view of high acrobatics and the crowds below, I was very glad to return to the stability of the sawdust ring. It is one thing to enjoy the sensation of altitude from the cockpit of an airplane, but quite another to experience it from a swaying platform, no matter how securely suspended.

Despite its sensational scenes and technical acclaim, *Marco le Clown* did not enjoy the widespread success it deserved. I believe it failed because the distributors, always wanting to play dead safe, did not want to take much risk with a film whose actors were not well known and therefore hesitated to promote it to the exhibitors. Yet *Marco le Clown* received very good notices wherever it was shown – mainly in Germany and Austria – and was recognized as far ahead of its time. As far as I was concerned, director Reichman and all the cast had done an excellent piece of work. The main character was played by Samborsky, a magnificent Russian artist who had performed in the Royal Circus of Russia. Germans, French, Italians, and Spaniards played the other roles and turned in first-class performances. Like us all, they were victims of the powerful whims of the distributors.

It was in Joinville that I first met Alexander Korda, just returning from location in Marseilles. He had gone there for Paramount to direct *Marius*, a film based on the delightful story by Marcel Pagnol. Set in Provence with an all-French cast, *Marius* marked the end of Paramount's failed experiment at shooting American stories in translation. Rich in local colour and talent, and directed with close collaboration between Korda and Pagnol, *Marius* became one of the few successful films made at Joinville at that time. Korda laughed when I told him of the headaches he had caused me when his crew pinched all the lamps I needed for the Cirque d'Hiver. By the time he brought them back to Joinville in order to light the sets his brother Vincent had made for *Maruis*, it was too late for me. This brief encounter gave no hint at the time of the extraordinary influence he would exert on my future in the industry.

On a more personal note, it was also at Joinville that I met Christiane Lippens, later to become my dear life's companion. She was a lovely, charming continuity girl whose English sparkled with a delightful French accent. We met while working on a production whose name surprisingly eludes us both; presumably, our thoughts gravitated towards more important matters! Initially, I would ask for her help when I needed an

interpreter, particularly in arranging my dates by telephone with a French actress who had attracted my attention. However, I soon realized that my interpreter was fast becoming much more interesting to me than my date. It was not long before Christiane and I both knew that we wanted to make a life together. So on 10 September 1931, with four friends as witnesses, we stood before the mayor of the eighth arrondissement in Paris to be married. Not understanding the questions he directed toward me in French, I simply answered "Oui" whenever Christiane squeezed my hand. It would not be the last time she would guide and reassure me.

Although I understood little of my own wedding ceremony, it transformed my life. Our union has held together despite the cultural, political, and religious differences that seem to destroy so many marriages. We have survived long separations and a world war and have learned to live together in harmony, based often on a willingness to compromise when we do not agree. As we approach our twilight years, we derive our greatest joy from our three children and their families and are secure in the realization that our life together has indeed been bountiful. Our lives are blessed with many happy memories.

Due to internal policies in New York, Paramount decided to close their French studios. I was among those asked to go over to England to carry on production there. Regretfully leaving our newly established home, Christiane and I bade farewell to our Parisian friends and moved to London. The day following our arrival we journeyed out to Elstree to see the British and Dominion Studios where Paramount had leased space. It was after looking over the studios that fate struck us an unkind blow on our return ride to London.

We were riding in a hired limousine with Alexander Korda and Ted Lawrence, the soundman. Dusk was falling and a notorious English fog was rolling in. In almost zero visibility, we crashed into a large steam-driven truck. Even at slow speed, the shock was considerable. Christiane and Korda, in the back seat, were thrown forward while Ted and I, sitting on jump seats, were catapulted through the window separating the driver from the passengers. Christiane had a cut knee, Ted and I, both knocked unconscious, suffered fractured skulls, and Alex Korda was severely concussed. Yet, ever the gentleman, he stepped gingerly from the crumpled wreckage, tipped his hat, and with a gallant, "My dear Christiane, I must be off," disappeared shakily into the murk.

Following the accident I spent about three months in hospital, during which I came down with scarlet fever and had to be transferred to the Isolation Hospital in Islington, North London. When I was discharged at last, the doctor advised me to leave the cold weather of England and take a

year off. Determined to restore my health as soon as possible, Christiane and I packed our bags and booked passage on a ship bound for Gibraltar.

For the next three months we enjoyed the sort of carefree travel known only to the young and unencumbered. With no fixed destination but a clear sense of adventure, we often went out of our way to stop at small towns that, in those days at least, were off the beaten tourist routes. In choosing the less-travelled paths we discovered enchanted places that seemed to have been forgotten with the passing of time. From colourful, bustling Gibraltar, with its ancient and modern fortifications, we took the ferry to Algeciras, then traveled up the coast by bus to the ancient port of Malaga. In this place of many contrasts we feasted on local seafood, fruit, and wine, and turned our pockets inside-out for cave-dwelling gypsy children pitifully pleading for alms. As we moved away from the coast and up into the hills, the weather turned very cold. On arriving at our inn in Ronda just in time for the evening meal, we joined our fellow guests seated around a huge, baronial table. It was covered with a heavy woolen cloth reaching down to the floor and slit from top to bottom at each chair. The reason for the slits became clear when we were shown two large brass pots underneath the table filled with crushed olive stones glowing like charcoal. By slipping our legs into the slits and wrapping the woolen cloth around us, we kept the warmth in and the drafts out. I was reminded of childhood sleigh rides on the Canadian prairies, with a hot brick at my feet and heavy buffalo robes pulled up to my chin.

Returning to Algeciras, we boarded a vessel bound for Ceuta in Spanish Morocco. If the miserable, storm-tossed crossing of the Strait of Gibraltar reminded us of the English Channel at its worst, the bus ride up through the mountains to Chechaouene was just as perilous. Crowded to overflowing with men, women, children and babes at the breast, crammed with odd-shaped bundles and baskets of live fowl, our speeding bus swerved continuously to avoid donkeys, goats, ducks, and chickens that darted out in front of us with no apparent sense of danger. With each sway and lurch our bus threatened to roll over on to its side with catastrophic results. As evening fell and we climbed high up into the mountains, the road became a series of narrow hairpin curves with no retaining walls between us and the murky void below. We tried hard to convince ourselves that our vehicle was perfectly safe, but only when we sighted the lights of Chechaouene ahead did we begin to breathe more easily.

Having reached the end of the route, the driver was the first to disembark. Leaving Christiane with firm directions to wait for me on the bus, I ran after him to ask for directions to our hotel. When words got me nowhere, I tried through mime and snoring sounds to communicate that I

wanted a place to sleep. A bright young lad nearby seemed understand my need, and signalled me to follow him down a dimly lit street. This nearly got me into a lot of trouble. Turning into an uninviting entranceway, he led me up a flight of stairs and knocked at the door of a room where a woman lay in bed under a blanket covering her from head to toe. After an animated exchange with my young guide, she beckoned me to join her in bed. Confused and apologetic, I lost no time in backing my way out and scurried back to the bus where Christiane waited patiently, besieged by people gesturing eloquently for her to get off. After that disconcerting incident, I pocketed my pride and relied on Christiane's superior communicative skills to lead us through the potential minefields of local culture.

Hidden away two thousand feet up in the Rif Mountains, Chechaouene was founded in 1470 as a Moorish fortress against invasion from Portugal and Spain. But in that winter of 1931 it seemed that only migrating storks from the low-lands of Europe nested within the shelter of its high stone walls and buttresses. However, in response to growing interest in the region, the Spanish government had recently opened up a comfortable and spotless hotel to encourage tourism. Judging from the flurry our arrival caused, we must have been among its first guests. With the exception of the manager, who knew a little Spanish and French, all the staff spoke only Berber. Meaningful conversation was almost impossible, but gesture and mime served us well. When our waiter, wearing the full baggy trousers of Berber national dress, served us splendid meals before a crackling fire, our murmers of appreciation sufficed to express our pleasure. Nor did we need to know the words when awakened each morning by the muezzin's call to prayer from a nearby minaret. I only regretted that, at so early an hour, there was never enough light to photograph this early ritual. To this day, his summoning the faithful of Chechaouene remains a vivid memory our journey.

Conscious of our dwindling resources, we slowly made our way back to the coast, stopping first at historic Tétouan where the Moors had fled when driven out of Spain in the fifteenth century. The narrow, cobble-stoned alleys struck our imagination as bearing witness to the suffering of those troubled times. By contrast, Tangiers, the great seaport commanding the entrance to the Mediterranean, pulsed with life and pleasure. With its splendid palace, promenades, fine sandy beaches and excellent restaurants, Tangiers was the perfect place to end our extended holiday. With a mixture of regret and anticipation, we made our way back to Gibraltar and thence home by ship to London.

Our diminished financial circumstances forced us to travel third class where, due to my lack of discretion, we were ostracized by our fellow-

passengers from the first day out of port. Since tourist cabins did not have their own ensuite facilities, Christiane and I took soap and towels and wandered off in our housecoats to the public bathrooms: women's on the port side, men's on the starboard. As luck would have it, there was already a line-up on the men's side. Not being the most patient of men, I went back to knock on the women's door where Christiane was about to step into the tub; she invited me to join her. We enjoyed a leisurely hot bath together while a queue of missionary women returning home from the Far East, patiently formed outside. So astonished was Christiane when we eventually opened the door, that she tripped on the sill and stumbled right into their arms. They were clearly unimpressed by my intrusion into female territory. Not even my cheerful "Good morning, ladies" could ease their consternation, and the good souls avoided us for the remainder of the journey. Undoubtedly we were beyond redemption.

We had now been gone for three months. Our stay in the sunshine had restored both my health and my memory, which the accident had also affected. I was ready to report to work again and fully anticipated that the directors at Paramount would send me back to Hollywood to fulfill my contract with them. Such was not to be. During our absence, developments in the film industry had taken place in London which would soon drastically change the course of our lives.

Alexander Korda had regained his health more quickly than I after our unfortunate car accident. While I had enjoyed an extended convalescence in the South, he had been busy forming his own company, London Film Productions. I had great respect for Korda as a film-maker and was delighted when he asked me to join his organization. Convinced that we could make good pictures together, I ended my contract with Paramount, joined London Films, and settled down in England. It was to become my base of operations for many years.

The Korda brothers had come from a small village on the Hungarian Plains. The eldest, Alexander, became a journalist before moving on to the theatre and then films. He was a voracious reader and had studied several languages. If his mastery of French, German, and Italian, (all of which I have heard him use at work) was as picturesque as his English, it must have added greatly to his charm and contributed to his success. I always enjoyed working with Alex, for he had an excellent understanding of all aspects of film making. He trusted his technicians and gave them freedom to operate as they saw fit, praising and criticizing as warranted. His talents ranged from the artistic to the financial. At first, I regretted his involvement in the financial side of production, for I felt he was more creative artist than financier. Yet without his business acumen there would

have been no London Films and many fine productions would not have come into being.

In his long struggle for success, Alex always included his brothers in whatever he undertook. Although living in Alex's shadow, they became successful artists in their own right – Zoltan as a director and Vincent as an art director. Despite their mercurial temperaments and the huge arguments that erupted in Hungarian whenever the brothers (specially Alex and Zoltan) disagreed on anything, they were magnificently loyal to each other and to their friends. I experienced their generous friendship on numerous occasions, but was particularly moved during the war when Zoltan (Zoli) and his wife Joan opened their home to my wife and daughter while I was with the British Army in North Africa. Their kindness during those difficult days did much to help Christiane adapt to her new status of "war guest" in a distant land. At about the same time I was delighted to learn that King George VI had bestowed a knighthood on Alex in well-earned recognition of his contribution to British films.

When Alexander Korda formed London Film Productions, he brought to England an artist whose work he had much admired in France. Georges Périnal was a great cameraman with many excellent productions to his credit, including most of René Clair's highly successful films. Although Korda recruited both Péri and me as directors of photography, Péri arrived first and was senior to me. Since London Films produced only one film at a time in those early days, I usually drew the second units and exterior work, a circumstance that suited my taste. Over the years Péri and his wife, Lucette, became very good friends, with Péri eventually becoming godfather to our daughter Anita. He was a gentle man of infinite patience, whose saintly smile was tinged with sadness and who never recovered from the premature death of his beloved only son. With the perfectionist's attention to detail, he could take hours in setting up camera shots. His beautiful, exquisitely lighted scenes remain unsurpassed. Because Péri's mood-creating artistry relied on the availability of full studio facilities, I believe we made a good team: he on the sound stages (where I sometimes operated the camera for him), I, increasingly and much more happily, on location.

My first assignment for Alex Korda was to film the exterior scenes in Oxford for a comedy-drama called *Men of Tomorrow*, starring Merle Oberon and Robert Donat. A story of undergraduate disillusionment with university life, it was the first of the British "quota" films that Korda produced for Paramount. Intended to protect the British industry from American domination, these films were often cheaply made and sparsely distributed. As far as quota films went, *Men of Tomorrow* was probably one of

the better. Although it enjoyed only limited success, it gave me a marvellous opportunity to bring to the screen the beautiful old quads and playing fields of historic Oxford. Such settings are a cameraman's gift, and I was gratified that the location shooting was generally well received.

London Film's next production, *The Private Life of Henry VIII*, proved an important one for us all and a landmark for the British film industry. A lighthearted period piece with principal actors of international appeal, it became the first British film to captivate American audiences. Vincent's imaginative sets and John Armstrong's rich costumes, while no doubt unpretentious by today's standards, were nonetheless splendid. I have often thought they would have been glorious filmed in colour. Be that as it may, Péri's studio work with black-and-white stock was masterful, while my exterior sequences at locations such as Hampton Court added the authentic dimension the subject required. But Charles Laughton, in the title role, could be difficult. Often, when a scene was finally ready for shooting, he would wave his hand and declare himself no longer "in the mood." This was hard on a new crew and one day I decided to try to ease the tension. Seeing that Charles was about to signal he was ready, I began swinging the camera from side to side. When poor Alex exclaimed in bewilderment: "Bordie, what is the matter? Are you ready?" I replied, "Not yet, I am just getting into the mood!" Well, Laughton exploded and Alex, for once, was speechless. Only the production manager, David Cunynghame, saved the day by yelling for a tea break. I learned to be more diplomatic thereafter, and Charles, just possibly, made an effort to be less moody. Certainly he gave a fine performance as Henry VIII, a part for which he won an Academy award. Other artists meriting acclaim included Robert Donat, Merle Oberon, Elsa Lanchester, Lady Tree, and Joan Gardner, later to become Zoltan's wife and godmother to our second daughter, Lilla. Merle Oberon, always a challenge to the lighting cameraman, was a beautiful Anne Boleyn.

All of us who had put so much faith into Alex's production of *The Private Life of Henry VIII* were gratified when it was released to huge international acclaim. In the United States, it made a significant impression on Douglas Fairbanks Sr, a familiar face from my Hollywood days. He saw potential for collaboration between United Artists and London Films and persuaded Alex that both companies would stand to benefit. Within this new alliance, Alex at last received the funding and distribution he needed to realize his filmmaking dreams.

As part of the new collaboration Douglas Fairbanks Sr came over to England to play the lead role in *The Private Life of Don Juan*, a cloak-and-dagger adventure tailored to his swashbuckling reputation. He wore ele-

vator shoes and used ingenious springboards hidden around the set to bound about in a manner denied to ordinary men. Although visitors to the studios were awestruck by Fairbank's agility, his twangy, uncultured voice and terrible grammar (often patiently corrected by Alex, of all people) detracted from his portrayal of the dissolute Spanish nobleman. For whatever reason, *Don Juan* never achieved the renown of *Henry VIII*. Nevertheless, it was fun to work on. Fairbank's dashing high jinks – leaping unscathed through huge palace windows confected of sugar candy – no doubt brought out the boy in us all.

Equally engaging from a cinematic viewpoint was *The Scarlet Pimpernel*, described years later by the *New Yorker* as "one of the most romantic and durable of all swashbucklers." Based on the popular novel by Baroness Orczy, it took place during the French Revolution and was the perfect foil for the talents of Leslie Howard, as the elusive Pimpernel, and Raymond Massey, playing the villanous Chauvin. I had the greatest regard for Leslie Howard, who usually directed the second unit. A talented artist, he would have made a great director had he not been shot down in enemy action in 1943. His passing was a great loss to the film industry.

Hoping to increase the film's appeal to American audiences, Alex had put together a mostly American crew and brought Harold Rosson from Hollywood as director of photography. Once again, I was in charge of photography for the second unit. Instead of using huge sets, we shot the exterior scenes with large hanging miniatures depicting the roof-tops and skylines of old Paris. The result was surprisingly effective.

No doubt inspired by the catchy titles of earlier successes, Korda now conceived the idea of making a series of documentaries on the "private life" of different animals. To this short-lived ambition I attribute one of my most engrossing assignments, the brief documentary entitled *The Private Life of the Gannets*. Very different from anything I had done before, it presented me with considerable challenge. The film was the brainchild of biologist Julian Huxley, curator of the London zoo, and showed the life cycle of the handsome, goose-like gannets living on Grassholm Island, a bleak, wind-swept rock off the southwest coast of Wales. Although an effective writer and broadcaster in his field, Julian had no experience in filmmaking. But Alex told him not to worry; if he would just write and narrate the script, I would look after the technical side of things, such as setting up angles and selecting material worth photographing.

We reached Grassholm Island aboard the supply ship serving the lighthouse keepers along that section of the coast. As we unpacked our gear, the captain told us he would pick us up on the return trip about ten days later. Besides Julian Huxley, our crew consisted of myself as director of

photography, my assistant Hatchard, and Ronald Lockley, a naturalist and friend of Huxley. Mrs Lockley nobly undertook to cook for us all under the most primitive conditions. We camped in two bell tents, one for the Lockleys, the other for Huxley, Hatchard, myself, the camera, a high-speed accessory for slow-motion sequences, several thousand feet of negative, scientific notebooks and test tubes, sleeping bags, and changes of clothing.

Despite cramped and crude living conditions, this location turned out to be among the most instructive that I have ever known. How could it have been otherwise, with Julian Huxley as a close companion? At night, in that crowded tent, we would bat ideas back and forth about a marvellous little film to be shot at the London zoo. Although it would begin with foreground shots of the different animals, the angle would soon shift to what the animals saw: visitors of every description peering into the cages. From this new perspective, an audience might well wonder just who was behind bars after all. Although our film was never made, it did fill our evenings on Grassholm with much irreverent merriment!

A more serious side to Julian had less endearing results. Ever the avid scientist, he collected parasites such as fleas and lice from the nests of the gannets and placed them into test tubes which he insisted on keeping warm in our sleeping bags until he could get them to London for further study. Of course, the inevitable happened. One night the gauze cover came off one of the test tubes nestled at the foot of my sleeping bag and its nasty little inhabitants began to nibble at my legs, no doubt mistaking me for a gannet. Thereafter I insisted the bottles be sealed with reliable camera tape.

The only regular inhabitants of Grassholm Island were sea birds. Their habitations ranged from a large rookery of gannets to puffin burrows and cragged rocky ledges on which razor bills and guillemots perched precariously to lay their eggs and raise their chicks. Flocks of gulls and smaller birds also abounded. The main subject of our film was the gannets – and they seemed to know it. Graceful when soaring and flying, breathtaking when diving straight down into the water from great heights, they put on a splendid performance. They even managed to look dignified when sitting protectively on their cone-shaped nests.

We faced enormous technical difficulties in shooting this film without the advantages of zoom lenses and speed cameras. What today has become commonplace was still state of the art in 1934. Among the shots of life in the nest, we showed the gannets feeding their young by regurgitating their catch of fish into the mouth of each chick. For sequences of the birds in flight, we used the high-speed attachment to slow down the graceful wing action and show more clearly this miracle of natural aerodynamics.

Yet from the ground we couldn't capture the visual experience of flight. When Alex saw the footage, he became so enthusiastic that he pulled strings to help us overcome our limitations. Contacting the RAF, he arranged for me to ride in the nose hatch of a Stranraer flying boat to simulate the effect of a gannet returning to its nest. When all was ready, the "Stranny" manoeuvered into position, then power dived toward the rookery. As we pulled out of the dive – lower than I had intended and just in time to clear the rock – we were surrounded by startled gannets flapping in all directions. Through the eye of the camera, they looked like snowflakes in a driving storm. The result, though not without its victims since we hit a few birds in our descent, was a beautiful, exciting shot, quite avant-garde for its time.

I later learned that documentary filmmaker John Grierson, an old friend of Julien's, hired a fishboat to shoot the closing scenes of the film – a beautiful slow motion sequence of gannets diving for fish. By then I had moved on to another production, but I met Grierson years later in Ottawa after he had become commissioner of the National Film Board of Canada. Although I suspect we shared many filmmaking values in common, regrettably we never did manage to develop a particularly good working relationship.

When *The Private Life of the Gannets* was shown at the premiere of *The Scarlet Pimpernel* on 21 December 1934, I was gratified to see that it received as much critical acclaim as the feature film. Six years later in Hollywood I learned that it had just won an Oscar for the best film of its class. Yet when I went to the theater where the winners were being shown, I was disgusted to see that our little short had been given a new set of credits and that an American voice had replaced Julian Huxley as narrator. A distributing firm had tinkered with the film and presented it as its own product. I lost no time in complaining to the Academy officials. Once satisfied that my claim was correct, they recovered the Oscar and had it re-engraved. On my return to England I took great pleasure in presenting the coveted award to Julian Huxley – a fitting testimonial to successful collaboration between science and cinematography.

Sanders of the River

My lifelong dream of visiting Africa was realized in 1933–34 with the shooting of *Sanders of the River*. This marked the first time London Films had sent a crew to a distant location to shoot background footage for a feature film. By today's standards, Edgar Wallace's story of the trials and tribulations of a colonial administrator is dated and politically suspect. But at the time it reflected British pride in the Empire and struck a sympathetic note with audiences. Certainly, critics were quick to praise Alexander Korda, the anglophile Hungarian, for his sympathetic portrayal of the "unsung heroes" administering "Britain's far-flung" interests. Indeed, Korda was a keen admirer of British colonialism and *Sanders of the River* became the first in his series of very popular "Empire films."

Alex entrusted the direction of the film to his brother Zoltan, who shared Alex's vision and developed a deep love of the African continent and its people. Significantly, the film derived its authenticity from the supporting cast of hundreds of African extras. The principal stars, Paul Robeson, Leslie Banks, and Nina Mae McKinney, never joined us on location. Yet it was the location work that made *Sanders of the River* something of a trailblazer. This was the first Korda production to include footage of remote, spectacular, and inaccessible locations largely unknown to motion-picture audiences of the day. While Georges Périnal directed the studio photography in England, I, as director of the African camera unit, shot all the location scenes that were later used for background projection. The challenges were considerable: I had to ensure the safe transportation of heavy camera and sound equipment over rugged terrain with few roads, and protect the film from sweltering heat and humidity. Furthermore, all exposed negative had to be shipped back to London for processing, leaving us to continue shooting without knowing whether our footage was good or bad.

The logistics of setting up a distant location are complex. Equipment must be transported, lines of communication established, and local assistance recruited. To preserve our film from the devastating effects of equatorial high temperature and humidity, we sealed it in special tins placed in larger containers with little sacks of chemicals to absorb any moisture. In Africa these containers were transported from location to location in heavy wooden chests built for that purpose in Kampala, the capital of Uganda. On transferring stock from tin to camera for exposure, we were careful not to subject it to the heat for longer than necessary. Once having shot the film, we returned it to the containers as soon as possible for shipping to England. All these precautions paid off, for we never lost any film footage to climatic conditions.

In mid-September we flew from London to Entebbe, Uganda, and thence to Kampala, which became our headquarters. On arriving at our hotel, Zoltan Korda, together with Bernard "Brownie" Browne, my assistant, and other members of the crew were warmly welcomed by the Armenian owner. Years earlier he had been a trader in the region. As it turned out, he and I shared a remote connection. Once in the bush, he had become so seriously ill with blackwater fever that he was unable to walk. Dangerously close to perishing alone, he was rescued by a patrol of the African Rifles led by Jack Borradaile, a cousin of mine. The future hotelier thereafter credited the African Rifles with saving his life. When I arrived at his hotel years later, he remembered the name and showered our party with special considerations. (Before my globetrotting days were over, unsuspected family connections would open other doors for me when I least expected it.)

At Kampala, we engaged the services of "Squash" Lemon, an English planter living in Uganda, who knew the country and its people well. Proficient in Swahili and several local dialects, he helped us acquire staff and supplies: cooks, hunters, camp helpers, bearers, and drivers, together with trucks, cars, food and drink. Although not a professional guide, Squash had fallen in love with Africa and knew the landscape intimately: I'm not sure we would have fared very well without him.

From Kampala, we drove about 150 miles north through swamp country to Gulu, where we established our first camp. This was to be the location for some of the most exciting sequences of the film: war and ceremonial dances and battle scenes featuring the Acholi tribe. Here, the local district commissioner established contacts for us. Despite his own busy round of duties, he arranged for the shooting and generally acted as intermediary between us and the local performers. He rendered us invaluable service, for the cultural gap between us and the Acholi was wide and our

Blooded Acholi warriors – those who had won honour
in battle by killing a man.

purpose was incomprehensible to a people who had never seen a motion
picture. To help reconcile the cultural expectations of both parties, the dis-
trict commissioner promised the dancers not only pay but a good feast
both before and after filming their performance. The headman accepted
the offer, although it was clear that the warriors regarded the whole busi-
ness as proof that we were mad.

Next day, warriors and their women began to arrive, loaded with
spears, shields, battle-axes, drums, and ostrich-feather headdresses. As
the cameras began to roll, they threw themselves into a traditional war
dance intended to arouse them to a frenzied state of readiness for battle.
This was obviously a serious matter, a ritual not to be cut short and
restarted at the whim of strangers. When the time came to reload and
change the positions of the cameras, the district commissioner found it
almost impossible to convince the warriors to stop dancing and take a
break. It proved even more difficult to start them up again once they had
stopped. So we gave up trying. While a thousand dancers worked them-
selves into a ten-day frenzy, we ran the cameras intermittently, capturing
only a manageable portion of that incredible marathon.

Several times during the dance a warrior, with only his eyes and ostrich
feathers showing above his buffalo-hide shield, would break ranks and
charge up to the camera, shaking his quivering spear. Twenty yards or so
behind him stood his woman. Beautiful, almost naked, she wore a huge
necklace and a tiny skirt hanging from a cord around her waist. Bran-

dishing a war hatchet, she poised for her traditional role: dashing in once the man's spear had found its target and delivering the coup de grâce by splitting open the victim's skull. Given my vantage point behind the lens, the couple's target appeared to be the camera or myself. I was relieved when sharp yells from the district commissioner arrested their advance.

Before completing our shooting at Gulu we received word that the prints from the negatives we had sent back to London for processing had arrived in Kampala. These prints, or "rushes," consisted mainly of the war dance and we were most anxious to see them. So when Zoltan Korda called a halt to shooting for a couple of days, we loaded cars and trucks with crew and warriors and headed off in a colourful cavalcade along the dirt road leading to the capital. Crowding the front half of Uganda's only theatre that evening, the warriors' in their traditional garb contrasted sharply with the European dress of the remainder of the audience.

The rushes were preceded by a comedy-thriller called *High and Dizzy* starring Harold Lloyd. Scenes of Lloyd clinging to the outside of a sky-scraper with traffic hundreds of feet below completely baffled our war-riors. That men should build such huge houses with no easy way of get-ting into them confirmed the Acholi's low opinion of our culture.

The real excitement of the evening came with the rushes. The audience was hushed for the first few seconds. Then shrieks of delight and laugh-ter broke out as the warriors recognized their fellow dancers on the screen. Never having seen their own likeness in either mirror or photo-graph, they recognized everyone but themselves – even when someone pointed out their own image to them. My own attention was divided between assessing my photography and watching the reactions of our delighted artists. On the whole, the quality of the footage pleased me and gave me confidence that we could continue to produce good results.

As I watched the Acholi's reaction to the rushes, I was aware of how dif-ferently people from diverse cultures perceive their world. Africa showed me value systems that were quite different from my own, and caused me to reflect on how easily we convince ourselves that our own truth is the only truth. This struck me once again when I had driven to a tiny village near Gulu with Louka, my bearer and interpreter, and a couple of the cam-era crew. While we were there, the quiet was broken by the weekly Lon-don-to-Capetown plane with its four noisy motors flying overhead. While the crew and I were excited to see this link with the outside world, the vil-lagers reacted with indifference. Children shaded their eyes, looked up, then went back to their games, while their elders simply continued what they were doing without so much as an upward glance. Surprised at such nonchalance, I asked an old man through my interpretor what he thought

about a mode of travel that could carry people so far in so short a time. He smiled and replied he was not interested in traveling that far. Indeed, neither airplanes nor automobiles held the least attraction for him. Yet when asked which invention he prized the most, he answered with a broad grin: "Matches!" The gift of a box of matches gave him more joy than anything else I could have imagined.

Louka was a member of the Kikuyu tribe from Kenya. He spoke Swahili and English besides his own tongue. Always neat in spotless shirt, shorts, and sandals, he prided himself on keeping my kit impeccable. Every morning he would put out freshly washed and ironed clothes for me – even when we were traveling on the road. And at the end of a hot day's work he would escort me back to my tent where the tin bathtub would be filled and waiting, together with a change of fresh clothes. When I complained that I would like to have a drink before changing, Louka persisted that the bath must come first: "Bwana, you smell so bad!"

Although we worked long days, our time in Africa was not all sweat and toil. We soon found that our African co-workers possessed a wonderful sense of humour and we often joined in their contagious laughter without knowing the reason for the outburst. It was usually directed at ourselves, as when Zoltan Korda tried to speak Swahili or throw a spear. Whatever the occasion, laughter was an endearing quality that lightened our endeavours. Catching the spirit, my camera operator, Brownie, and I put on brief stand-up-comedy acts involving sleight of hand and plenty of slapstick – all to the boundless mirth of our impromptu audiences. Their laughter encouraged the ham actor that lurks in us all.

Before leaving London it had been decided that we would go to the Congo River to photograph huge war canoes in action. Arrangements had been made with the authorities in Brussels for us to enter the Congo via the southern route to Stanleyville (now Kisangani). All seemed straightforward until we realized that the ferry across Lake Edward was too small to carry our five-ton trucks. This was a serious setback, for one of the trucks had been adapted to accommodate the fragile Western Electric studio-channel sound-recording equipment. No portable channels were available in those days.

Typically, the district commissioner came up with a solution: the camera crew should follow a trail running north from Gulu into the Sudan which would avoid Lake Edward altogether and allow us to enter the Congo from the north instead of the south. Although reluctant to break up the crew, we acted on the recommendation. Taking the lighter passenger vehicles and most of the crew with him, Zoli returned to Kampala to ship the exposed film and make arrangements for our new border crossing. I

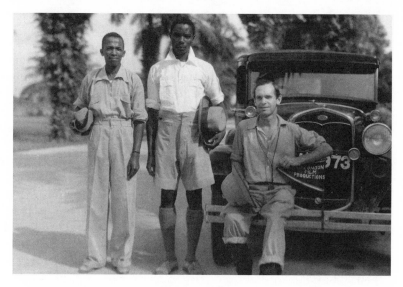

Myself with Louka, who kept me neat and well-groomed, and his friend, Joso (left).

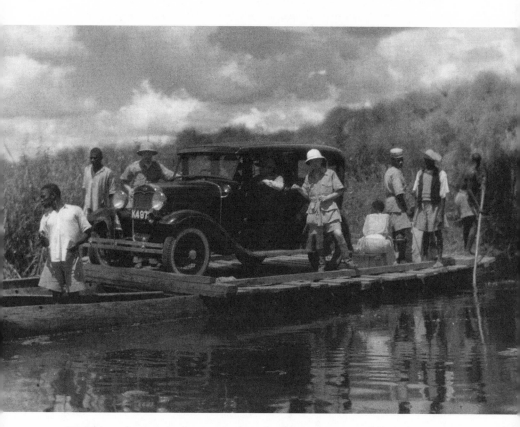

An African ferry: two dugouts, a few planks, and some paddlers. It was too small to carry the trucks and equipment.

headed north with two cars and two trucks transporting the equipment, the gasoline, and my entourage: the assistant manager, members of the sound and camera crews, my bearer Louka, and the cook with all his gear.

Our separate routes led to quite different experiences. Zoli's journey from Kampala was unexceptional. He cleared customs, requested authorization for our party to enter the Congo from the North, crossed Lake Edward, and proceeded without hindrance, reaching Stanleyville after a pleasant trip of about one week. There he immediately made arrangements for filming the war canoes – and then sat back to await our arrival. He waited several days before sending an anxious cable to Alexander Korda in London: "Where is my cameraman, Bordie? I haven't seen him for more than two weeks." Of course, nobody at London Films knew what had befallen us and the cable merely increased the level of anxiety for all concerned.

While uneasy messages were being exchanged between Stanleyville and London, our journey was proceeding by fits and starts. North of Gulu we crossed open scrub country, land of rhinos and lions. The trail was scarcely more than bush road with little paths branching off to small settlements. Unlike other parts of Africa, where roads and pack trails facilitated trade and commerce, most travel here took place on foot.

On reaching the Sudan, we discovered that earlier torrential rains had coursed down the little gulleys, sluicing away all soil and vegetation. Where once a trail had existed now lay only an arid stream of boulders, about half a mile wide. Working in scorching heat, we managed to manhandle the trucks around the boulders. The going was slow. By the time we had finally cleared the storm area and relocated the trail, Brownie had developed a bad bout of fever and fallen into delirium. Anxious to get him to hospital, we wrapped him in blankets and pushed on to Juba.

To my regret, we had no time to stop among the Nilotic Dinka people who inhabit the region. Tall and slender, they have been called the stork people because of their custom of standing on one foot with the sole of the other resting just above the knee. They can hold this position for long periods at a time while grazing their cattle or waiting patiently by a slough for fish to spear. I would have liked to learn more about their customs, but Brownie's fever kept us hurrying on.

The hospital at Juba was run by young English doctors and nurses who, with their local staff, carried out the virtually impossible task of providing health care for the whole region. Among the patients a long queue of lepers awaited their weekly treatment. As for Brownie, he was immediately admitted for four days to a room with cool, white sheets. We almost envied him.

On leaving Juba with fresh supplies, we headed for Aba, the border crossing into the Belgian Congo. Despite Zoli's efforts at Kampala, the officials here had received no word of our arrival – and a recent spate of gold smuggling and killings by the notorious Leopard Society had made them particularly cautious. They viewed us, our vehicles, and our equipment with great suspicion and delayed our onward journey until permission for us to enter the Congo arrived from Stanleyville three days later. Even then, they directed us to proceed quickly and directly to Stanleyville, stopping only at authorized places along the way. They had me take the cars and go ahead with Brownie to arrange for the night stops. The trucks would follow once their contents had been inspected and repacked.

Further difficulties arose. A broken clutch on the camera car forced me to break the rules and stop to ask a group of native hunters to help me push the car to the nearest village. Although they initially ran away in fright, their curiosity soon coaxed them back. The promise of cigarettes and a ride in the car apparently proved too tempting to pass up. I steered, while a good-natured team of eight pushed from behind, and we were soon underway. All went well until we came to the crest of a small hill. As the car began to gather momentum, six of our squad eventually had to drop back. But two hopped onto the tailgate and enjoyed a bracing ride until, overcome by sudden panic, they leaped off and landed in a writhing heap on the gravel road. Jamming on the brakes, I ran back in alarm, only to find both victims sitting up surrounded by their laughing mates. Liberal applications of mercurachrome to their various scrapes and bruises was all the first aid they needed. Soon everyone wanted a daub, and the misadventure ended in general merriment.

The trucks caught up with us in the village, where Brownie and I had been offered hospitality and shelter in the headman's hut. From there to Stanleyville we proceeded in convoy, I nursing the car along to avoid being towed on that dusty road.

Stopping to eat and replenish supplies at the trading post of Gombari, we came across a hunting party of Pygmies. They carried bows, a large assortment of arrows, and coarse nets made from vines. Although extremely shy, they allowed me to examine their bows and arrows and showed me how to take aim. My first shot fell wide of the mark, felling an amorous bantam rooster hotly pursuing a fleeing hen. Appalled at what I had done, I prepared to make reparation to the owners. To my great relief, my gauche shot caused much merriment among my new hunting friends. Breaking the ice, it enabled me to buy a selection of arrows from them which I treasure to this day.

We reached Stanleyville at last, where Zoltan Korda despaired of ever

seeing us again. Although our party of "truants" would have welcomed a day off, Zoli needed to make up for lost time. Prior to our arrival he had arranged for the use of an old paddle-wheel steamer and about thirty of the big canoes that we had come to photograph. These dugouts were formidable war machines: each one was carved from a single tree-trunk and carried up to forty-four men, who stood up to paddle. The hardwood oars, eight feet long and pointed at the end of the blade, also served as spears. Once the canoe was underway, a drummer beat out the rhythm of the stroke from the centre of the craft, while a warrior in the bow chanted and threatened the enemy with his upraised spear.

The Canoe People of the Congo differed from other Africans with whom we had worked. Whereas the Acholi were tall and lean, the Canoe People were broad chested, with strong shoulders and arms and short legs. Their attitude to work differed as well, for they saw no point in earning more than what they required to pay their taxes. Whether their lethargy was due to the heat and humidity of the region or to a set of values wiser than our own, I do not know. But their nonchalance made it difficult to convincingly shoot a fast-action scene in which several hundred armed warriors race down the river bank to their canoes and push off to do battle downstream. Even Zoli's single-handed demonstration of the scene, with waving spear and blood-curdling yells, had little effect. Though regaled by his performance, the would-be warriors continued to saunter down to the river in a slow-motion emulation of Zoli's brilliant one-man show.

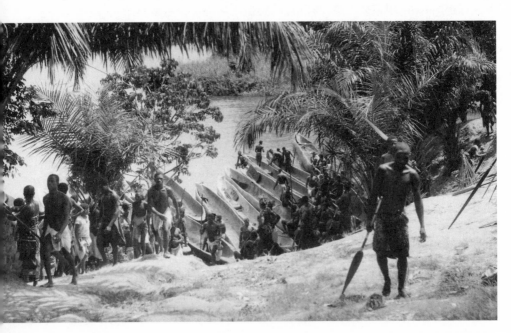

Dugouts on the Congo River.

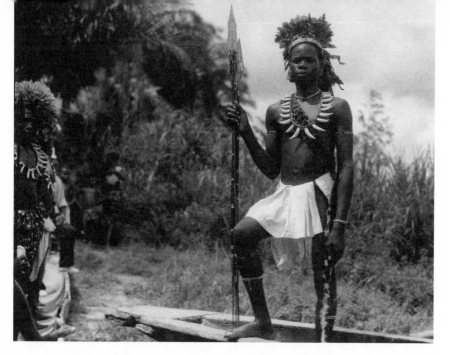

A young Ituri chief wearing a necklace of leopard's teeth.

Ultimately we had to be satisfied with a slow jog to the canoes which I then speeded up by adjusting the camera.

Our work each day with the big canoes took us many miles downstream. Not surprisingly this displeased our cast, who then faced a long paddle back to the village at the end of the day. In a gesture of reconciliation we invited the headman of each canoe to ride back to Stanleyville in the paddle-wheeler with us and the equipment. To make the most of any available breeze in that sweltering heat, I used to invite some of the headmen to join me in climbing onto the flat roof of the pilot house, hoping it would not collapse under our weight. Although communication with these stoic men was difficult, our return trips together enabled us to get to know them a bit better and catch glimpses into their lives. One Saturday I hit the right note by saying, "Well, fellas, it's been a tough day, but tomorrow will be a good day. Tomorrow is Sunday, and we don't work tomorrow!" As the interpretor translated, the men beamed in approval. One village chief, the toughest of them all, concurred that Sunday was indeed the best day of the week. I was astonished, and asked him why this was so. Was he perhaps a Christian? "Not at all!," he replied: "A Catholic!" He had been converted several years before and had insisted on his whole village being converted with him. "And now", he continued, "Sunday is the best day of all, because every Sunday I send all the women

and children to early morning Mass; then the village is quiet and I can sleep in peace!"

Nowhere else in the world have I experienced such suffocating humidity as in Stanleyville. The sheer act of breathing was like trying to inhale a bowl of thick pea soup. By the end of the day I had spent most of my energy. I remember lying on my bed on Christmas night, drenched in perspiration but too weary to fan myself, listening to the messages being drummed up and down the river. Drumbeat was a vital force of African life, undergirding communication, dance, religious ceremonies, and war rituals. The messages were despatched up and down the river by means of the lokele. This was a log about five feet long with a slit approximately six inches wide all along the top. The log had been partially hollowed out through this slot. When beaten with clubs covered with raw rubber, the lokele emitted a two-tone note that could be heard several miles away. It was said that a good sender and receiver could communicate with the speed of Morse code. Once heard, the haunting beat of the lokele can never be forgotten. Certainly, it was used to dramatic effect in *Sanders of the River*. We also relied on drummers to keep in touch with our widely dispersed cast. Each evening the drumbeat would go out, reminding village headmen that we needed the same artists back for the next day's shoot and that they should wear the same clothes and ornaments. Within moments, the messages would come back from up and down the river, confirming that all would be as we requested. And indeed, it was.

Because of the heat and humidity, we were glad to leave the Congo, although we did manage to obtain beautiful footage there. With the ferry problem now resolved, we all returned to Uganda by the southern route through Central Africa. With its variety of climate, vegetation, and animal life, and its mix of arid deserts, snow-clad mountains, dense forests, and mighty rivers, this was surely one of the most beautiful regions of our planet. Equally fascinating was the variety of human beings, be they of Nilotic or Bantu origins. Acholi, Pygmies, Canoe People, Stork People, Tutsi, or Hutu – each tribe had its own language and traditions. Some customs were difficult to appreciate: the Mangbettu binding their babies' heads into a horizontal egg shape, or the Ubangi stretching women's lips by inserting wooden disks. I saw one woman who had a full-sized soup plate inserted into her upper lip. Originally intended to protect the women from slave hunters, the extended lips had become symbols of beauty – an example of how one man's deterrent can become another's enchantment.

With the completion of the location work, we returned to England. At Shepperton Studios we oversaw the building of sets to match some of our African footage and pulled prints from the negatives so the sets depart-

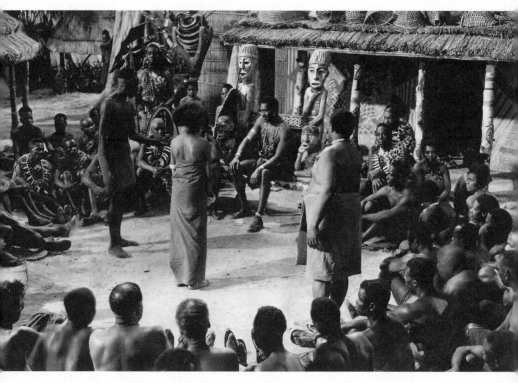

Paul Robeson, seated centre, in the set at Shepperton Studios. This was as close as he got to Africa for *Sanders of the River*.

ment could compare camera angles of the location footage. In our scramble for realism, we faced such awkward and improbable tasks as tying cabbage leaves to weeping willows in order to recreate lush jungle scenes. When finished, I did a lot of foreground work to match what I had shot in Africa.

At that time there was still no back projection in England. However while in the Congo, knowing that Paul Robeson was supposed to be part of a canoe sequence, I had taken my camera out on one of the canoes to get some footage of warriors paddling. I used a double to indicate where Robeson would stand, knowing from experience that this would make it easier to match his image against the background. When we got back to England, we fixed up a projection machine that gave us enough light to throw our footage onto a screen. We then had to synchronize this with the combining camera. This awkward arrangement with improper equipment was something of an ordeal for me but somehow I brought it off. From my perspective, however, this was not particularly good back projection, even though audiences were convinced that Paul Robeson and the

rest of the cast had actually been with us on location. My task would have been much more effective had this actually been the case. I used to have ongoing arguments with Alex: "Why the hell didn't you send your damned actors, and let me shoot the whole thing out there and do a good job." But I never could get him to accept that point. With the exception of *Four Feathers*, I was always shipped off beforehand to bring back footage for others to match up. It was a source of great frustration for me.

In fact, there was much about our methods of production that infuriated me. For one thing, I rarely had a detailed script to guide me. In the case of *Sanders*, I knew that we had a story by Edgar Wallace, but not much more. With the exception of Robeson, we didn't know who our cast would be, nor what to expect on location. For example, we had no idea beforehand of the extent of the Acholi's marathon war dances, nor of the size of the dugout war canoes big enough to carry forty warriors. In other words, we always went in cold: no script, no doubles, no speaking parts, no dialogue, not much idea of what to expect. Before leaving England, I used to plead for time to research so that we could do a decent job, if not with the actors, at least with doubles and proper costumes. But nobody ever listened to me.

The music for *Sanders of the River* was originally recorded in Africa. Melodious and rhythmic, it sprang from tiny villages scattered over a vast territory. Often we would travel several hours to film and record songs and dances unknown beyond their communities. But in one village we discovered a traditional girls' dance that appeared to have had widespread influence – it exactly resembled the Charleston, so popular in America since the 1920s. We immediately assumed it must have been imported to Africa from across the Atlantic, but our young artists hotly denied this was so. In all liklihood the reverse was true, the Charleston owing its success to the steps and rhythms of traditional African dance. In England, Mischa Spoliansky orchestrated much of the music we brought back, and Arthur Wimperis wrote lyrics for some of the songs. Of the authentic music recorded in Africa, I thought the war dance and the canoe-paddling songs particularly beautiful.

Of course, the Africa we experienced in 1933 no longer exists. The British and Belgian empires have come to an end, and the present map of Africa reflects very different political realities. Attitudes have changed too, and that fact no doubt dates the film more than any other. It is probably difficult for audiences today to appreciate how eagerly *Sanders of the River* was received when released in 1935. Yet, writing for the illustrated magazine *Film Pictorial* under the title "Britain Puts Her Empire on the Screen at Last," lead actor Leslie Banks echoed public enthusiasm:

Underlying the grandeur of the spectacle and the swiftly moving events that go to make up the story, however, there is a spirit of quiet heroism characteristic of Britain's Empire Builders and which, until now, has been left to Hollywood to immortalize on the screen.

We who live comfortably in our brick and mortar houses, with central heating and other modern conveniences, are apt to lose sight of the fact that we would not have all these modern conveniences without the help of Sanders and his colleagues in other parts of the Empire.[1]

Of far greater personal satisfaction to me was praise in the *London Times* for the "marvellously efficient camera" that had shown commercial audiences for the first time the magnificence and diversity of African landscapes, wildlife, peoples and cultures.[2] All in all, I believe our African expedition was successful. We brought back authentic, exciting footage and set a pattern for more such films to follow. With *Sanders of the River*, the world had become our stage.

1 Leslie Banks, "Britain Puts Her Empire on the Screen at Last," *Film Pictorial*, British Film Section, 6 April 1935, 42–3. See also Zoltan Korda, "Filming in Africa," *Film Weekly*, 5 April 1935, 52.
2 Sydney W. Carroll, "A Wonderful Week: Korda as Imperialist," *The Sunday Times*, 7 April 1935.

Elephant Boy

I almost didn't make it to India to shoot *Elephant Boy*. Prior to its production in 1935–36, I had been preparing camera mounts for aerial sequences to serve as back-projection plates for *Conquest of the Air*, a film on aviation. That was when I met the American director Robert Flaherty, famous for putting the documentary film on the map with his 1922 tour de force *Nanook of the North*. Now he had interested Alexander Korda in a story based on the trusting relationship between a boy and his elephant. Although Flaherty and Korda were different in so many ways, I think the theme appealed to a sentimental streak in both men: the documentary film maker who believed the best way to tell a story on film is to show it through the eyes of a child, and the producer who recognized commercial value in the dramatic tension between a boy and his beast.

The appeal of Flaherty's films lay in their authenticity. In both *Nanook of the North* and *Man of Aran* (1934), he had brought to the screen man's enduring struggle for survival against the inexorable forces of nature. I had long admired his work and was excited when he asked me if I would like to go to India to film with him. But the timing seemed wrong. With Alex away in New York, his staff informed me that work with Flaherty was out of the question: London Films had other plans for me, including the shooting of *Conquest of the Air*. Furious at losing the opportunity of filming on the subcontinent, I hotly announced that I was terminating my contract with London Films forthwith. Turning on my heel, I stormed out of the office and spent that entire evening poring over maps with Christiane as we began to plan a long-overdue holiday together. We could have saved ourselves the trouble. Late that night, the telephone rang; it was someone from Alex's office asking if I would come in the next morning to select the equipment I wanted to take to India with me. Still smarting over our earlier exchange, I retorted that I was not available; I was leaving the

country and taking my wife on a trip. "Of course you are;" came the reply, "with you – to India!"

Although the original story for *Elephant Boy* was Flaherty's brainchild, Korda soon insisted that Rudyard Kipling's *Toomai of the Elephants* be incorporated into the script. Although this last-minute change may have broadened the appeal of the film, it complicated Flaherty's task by adding a new dimension to his purpose. He had intended to show the importance of elephants to Indian life, and the skill of the mahouts who trained and handled the magnificent beasts. Pivotal to his story were the relationship between a boy, his elephant, and the beautiful, varied landscapes of the state of Mysore. The Kipling story was more fanciful. It told of a young boy who saw what no one else had ever seen, the dance of wild elephants deep in the jungle. Ultimately, Flaherty combined the two themes quite satisfactorily. Yet when all was said and done, the film owed much of its success to the dynamics between its two star performers: Sabu, son of a mahout, and Irawatha, prize tusker from the elephant stables of the Maharaja of Mysore. The production of *Elephant Boy* was unique in that virtually everything – from photography to processing to editing – took place on location in Southern India. Only the regrettable last-minute change of one of the principal actors made us reshoot scenes at Denham Studios on our return to England.

My memories of Robert Flaherty are of a genial character whose large frame easily accommodated his vitality, generosity, and love of life. Playful as a boy, he would invite us to his farm for boisterous games of kick-the-can, or enthrall us over a good scotch with his gift of storytelling. His respect for all people, regardless of race, rank, or religion, won him many friends who counted it a privilege to help him in his work. For him, all of life – people in their various cultures, flora and fauna in their natural habitat – were worthy of being recorded on film. He had an excellent eye and an innate sense of what would interest motion-picture audiences. I'll never forget one shot in which Bob taught me how to look at things in a new way. In the scene, as an elephant begins to eat from a huge pile of greens at his feet, he gradually uncovers Sabu lying in the fodder. I planned to open with a long shot of the elephant against a jungle background. But Bob directed me to put the camera on the tip of the elephant's trunk. Then, as the animal ate, to open up and back slowly to reveal Sabu and finally the whole scene. Bob's natural instinct proved unerring, and the unorthodox opening shot worked beautifully.

But as a director, Bob had weaknesses too. Athough he acomplished the incredible feat of processing the negative of *Nanook of the North* by himself in the Arctic, he was not really a great technician. There were times when

his lack of technical knowledge limited his ability to translate his inspiration to the screen. Similarly, he found it difficult to communicate his vision to his actors. I well remember Bob trying to show Sabu how to cry. The whole episode collapsed as Sabu responded – with howls of laughter.

Nor did Flaherty's impracticality endear his methods to producers. Totally innocent as far as money and time were concerned, deadlines and budgets meant nothing to him. Indeed, for all his greatness as a filmmaker, I believe he never worked for the same producer twice. His rambling, marvelling, unconventional way of filming made them far too nervous. Even on a much smaller scale, Bob seemed to be broke most of the time. I remember once in London he asked if I could lend him some money to tide him over to his next cheque. With only about five pounds in my pocket, I said I would be glad to go to the bank when it opened. Bob said that would be just fine and suggested in the meantime we pick up some pastries for tea at a small shop around the corner. Passing a florist on the way, his eye was caught by a huge bouquet of sweetpeas in the window. He ducked in to sniff them – and bought the whole lot for four pounds. Which left us exactly one pound for our tea.

What Bob valued above all was his freedom to make films without interference. He dreamed of working as he had in producing *Nanook*: with neither script nor schedule, and especially without regulations. Of course, this was rarely possible. Although producers recognized Bob's talents, they couldn't give him the total independence he wanted. Like business-

Filmmaking on the banks of the Cauvery: Frances Flaherty, Robert Flaherty, myself, Christiane.

men everywhere, they had to work within the constraints of deadlines and financial accountability. Yet Bob was able to achieve much on his own terms; on location in India, his way of doing things generally prevailed. Only when time and Alex's patience finally ran out were production changes introduced: filming of *Elephant Boy* was completed in England with Zoltan Korda directing a cast of professional actors. If commercially sound, this change of direction seriously compromised Flaherty's vision of creative authenticity which had been described by Harold Hobson in the *Christian Science Monitor* prior to our departure:

> All the photography will be done in India; there will be no 'faked' studio scenery; everything will have on it the absolute stamp of authenticity. But only the raw material will be provided in India. The cutting will be done in England. It is in London, within easy reach of the most modern appliances and adjuncts of the cinema world, that Mr. Flaherty will assemble his picture, and bring to bear upon it that process of imaginative selection which is a constituting factor of art, but especially of the art of the film.[1]

Preparations for the filming of *Elephant Boy* were complicated by Bob's insistence that all processing be done on the job. He never wanted anyone else to see the processed film before he did. This approach created considerable worry for both his producer and his crew. At that time, portable developing machines were unavailable but, prior to leaving England, we scouted around and managed to procure some antiquated developing racks and tanks, a printer, a projector, rewinds and so on. I felt that this pile of junk should have gone to the British Museum instead of to India, but Bob was much more optimistic and hired an experienced lab technician to look after all the processing. For my own equipment I selected a Vinten camera, rather heavy but fairly quiet, and a spring-wound and rather noisy Newman Sinclair with two-hundred-foot magazines and a large assortment of lenses of different focal length. Both cameras proved very reliable.

On arrival in Southern India, we chose the city of Mysore as our base of operations. The Maharaja of Mysore placed many facilities at our disposal, including a small, unused palace which became both our headquarters and the Flahertys' home. As Bob and his wife were settling in, he noticed two men making music in a corner of the compound. On closer inspection, he discovered to his horror that they were professional snake-charmers

1 Harold Hobson, "Man of Films," *Christian Science Monitor*, Supplement, 6 November 1935.

trying to coax a couple of cobras from their den. With an Irishman's deep mistrust of snakes, Bob backed away hastily and thereafter became the most cautious of men when skirting that section of the compound.

Throughout the filming we were indebted to the Maharaja, a most gracious prince without whose approval and support our project would have been impossible. He was a man of vision, dedicated to improving the well-being of his subjects; in return, they loved and respected him. It was our good fortune that his imagination was fired by the possibility of bringing his beautiful state to the screen.

We built our laboratory in a large bungalow that was situated in the compound and had once housed the palace servants. It soon became clear that dust, pest, and temperature control were going to cause problems. To create our own air conditioning, we covered all openings – verandahs, doors, and windows – with cotton material which we hosed down regularly. Water was obviously the key to success if conditions inside the laboratory were to remain constant. We spent much time experimenting with filters and ice before the lab met our specifications. To this day I still marvel at the quality of work we eventuality produced there. Much of our success was due to the first-class work of the lab man, a young Bengali named Sayne. He had been recommended to Bob by Kodak when it became clear that the man hired in England was not up to the job. Yet even with Sayne's expertise, our rack-and-tank method was primitive at best. Although we got fairly consistent prints, we knew it would be impossible to have sufficient control to process sound. To Bob's disappointment, we arranged to send all the sound-recording film to a lab in Bombay.[2]

In those pre-production days I spent a great deal of time driving around with an interpreter looking for visually striking sites. Each day I shot a couple of hundred feet of film to use as lab tests and to offer Bob a choice of possible locations. While I roamed the countryside, the Flahertys struggled to cobble a new script together incorporating the Kipling story.

My search for suitable locations led me to discover the beauty of the region. Our home for the duration of the production of *Elephant Boy* was Mysore City, over 500 miles south of Bombay and 250 miles northwest of Madras. With an elevation of 2,400 feet above sea level, it enjoyed a healthy climate and was much greener than the semi-arid land of Northern Madras, which reminded me of some parts of Mexico.

2 The Western Electric Noiseless Recording Sound System used by London Films was particularly sensitive. It required stricter processing control than would have been possible in the laboratory made up on location in Mysore.

Much of our work would take place in the Karapur forest, where the Maharaja put his hunting lodge at our disposal. Beautifully situated on the banks of the sacred Cauvery River, this was a magnificent place to study nature. The forest abounded in teak, rosewood, giant bamboo, and other exotic species of trees. It swarmed with animal life: elephants, tigers, bisons, panthers, bears, sambhurs, cheetals, barking deer, pigs, monkeys, jungle dogs, jackals, pythons, and small creatures such as squirrels, rats, mice, lorris, and mongooses. Wondrous birds – peacocks, jungle fowl, green pigeons, and mynahs – nested among the leafy branches, while exotic mahseer fish coexisted with the wily crocodile in the Cauvery. Night and day, forest animals visited the river to slake their thirst and cool themselves in the waters.

Only a sprinkling of human settlements clung to the jungle stretch of the Cauvery, their inhabitants dependent on the river for their own needs and those of their few domestic animals: a goat, a sheep, a cow or two. But where the river emerged from the forest, it teemed with activity. Bordered by temples, shrines, and burning ghats, the Cauvery, like the Ganges to the North, drew to its healing waters all those in need of physical and spiritual cleansing.

One of my location-seeking trips took me to Melkote, a charming little town situated high on a plateau overlooking a vast plain of ever-changing hues. Home weaving was the principal industry of this peaceful community with its many sacred tanks, shrines, and temples. In the main square sat an ancient Juggernaut wagon. Fashioned from beautiful carved teak, it had endured blistering heat and torrential monsoons for over 150 years. Originally mounted on wheels, it had been used on holy days to pull a statue of the goddess through the town square. The wagon had remained immobile since Mohammedan invaders had removed the four huge wheels to prevent zealots from throwing themselves under them.

When I met the chief priest of the temple to make arrangements for shooting at Melkote, I casually mentioned through my interpreter that it was a shame the old Juggernaut wagon should remain unprotected from the weather. Great was my dismay on returning the following week, to discover that my concern for the wagon had been completely misunderstood; the magnificent artifact had been dismantled and piled up for firewood to get it out of the way of our production. The loss of so fine an example of ancient workmanship sickened me. From then on I took particular care to communicate as clearly as possible whenever translation was required.

Bob Flaherty came with me on this return visit. Much taken by the beauty of Melkote, he chose it for the sequence showing the recruitment

of the hunters and their elephants. Although artistically sound, this decision caused considerable extra work for Melkote lies in a semi-arid district with no nearby forest to supply the huge amount of greens that elephants eat. With each elephant requiring about 500 pounds of fodder a day, the logistics of transporting both the beasts and their food the thirty miles from Mysore City were considerable.

Our film unit at first consisted of Bob and Frances Flaherty, Bob's brother David, production manager Fred Ellis, sound recordist George Cape, his assistant Bill Bland, machinist Sidney King, and myself. Others were later recruited in India. With the exception of Sayne, the laboratory chief, and Ranga Rao, who had served for a short time as an assistant cameraman in Bombay, none of the assistants had ever been involved in film-making. Yet despite their lack of experience and the delicate caste restrictions to be respected, we never lost any footage of film through mishandling, either in the lab or in camera departments. This was a remarkable achievement for an untried crew.

I first encountered Sabu on visiting the Maharaja's stables to see some of the elephants and mahouts who would be taking part in the film. Up to then, Bob had been unsuccessful in finding a suitable lad for the role of the elephant boy. All the young candidates he had interviewed were shy and frightened by Irawatha, the huge tusker who would play the part of Kala Nag, the boy's best friend. On seeing Sabu's fine physique and grace of movement, I asked Yalavatti, my interpreter, to bring the boy over so that I could talk with him. When Sabu came up to me, we saluted each other with a salaam. His alert eyes, ready smile, strong body, and forthright manner made him a most attractive youngster. He told me his father had been a mahout who had died in the service of the Maharaja, and that he had come to the stables to collect his father's pension in the form of food for the family. When I asked if he would like to work for me, he almost exploded with excitement and pleasure. It only remained for me to convince Bob Flaherty that I had found the elephant boy at last. Anticipating the importance of their encounter, I gave Sabu a few rupees and told him to throw away the rags he was wearing, buy a new dhoti, have a bath, and report to me at the hotel in the morning.

The next day Christiane and I were awakened by a huge commotion on the verandah behind our room. By now spruced up and resplendent in a new dhoti and crimson puggaree or turban, Sabu was tussling with our regular servant, David, as he prepared to bring us our early-morning tea. According to Sabu, it was alright for David to take Christiane's tea to her, but only he, Sabu, was to bring my tea in to me. Although only about half David's size, Sabu soon prevailed, appearing triumphantly at our door

with my morning tea and an infectiously broad grin that would endear him to film audiences everywhere.

But for reasons I could never understand, Bob was initially unconvinced that Sabu should play the elephant boy. Although Sabu soon dominated the other candidates and handled huge Irawatha with ease, it took a fairly dramatic incident to make Bob change his mind. The Jemadar, or head mahout, was an old friend of Sabu's father who often allowed the boy to feed and exercise Irawatha. One day when the Cauvery was surging in full flood, he invited Sabu to cross the river with him on the back of Lakshmi, another huge tusker. As we watched anxiously, they entered the swift-flowing water holding onto a rope tied around the elephant's girth, just behind its forelegs. The current caught Lakshmi at once, spinning him around like a cork. As the elephant swam, he would sometimes raise his head above the surface to see where he was going, then sink down again with only the tip of his trunk showing. Up to their shoulders in swirling water, it seemed that Sabu and the Jemadar would surely be washed away. Just as we despaired for their safety, Lakshmi hit shallow water two or three hundred yards downstream and ambled ashore on the opposite bank. Bob yelled for them to stay where they were, but to no avail. Lakshmi moved upstream about three hundred yards then re-entered the river and swam back, landing just below us. As he fought his way up the bank into our midst, we showered him with praise and tid-bits. It was a decisive moment. Although visibly shaking and overcome by his anguish for the boy's safety, Bob nonetheless managed to blurt out, "That settles it. Sabu will be the elephant boy!" It was a decision he never regretted.

The second star of the film was Irawatha, reputedly the largest elephant in Southern India. Loaned to us by the Maharaja, this magnificent beast was at our disposal throughout our stay in India. Each morning a bell would ring and Irawatha would appear under Flaherty's window, curling up his trunk to salute "the boss." Then, unless otherwise required, he would spend the day in the compound under the shade of a great spreading tree. Whenever he suffered from indigestion, as sometimes happened, his mahout would feed him pills of opium, big as cricket balls. Mighty Irawatha was the perfect partner for young Sabu. *Elephant Boy* owed much of its charm and success to the dramatic bond they created so effortlessly between them.

The third main character in the story was a European hunter, Petersen Sahib and this time it was the Flahertys who discovered the right person to play the part. Captain Fremlin owned a coffee plantation and was respected as a good "shikaree" or hunter. He knew and loved the jungle and felt perfectly at home with its people. Moreover Sabu and the crew

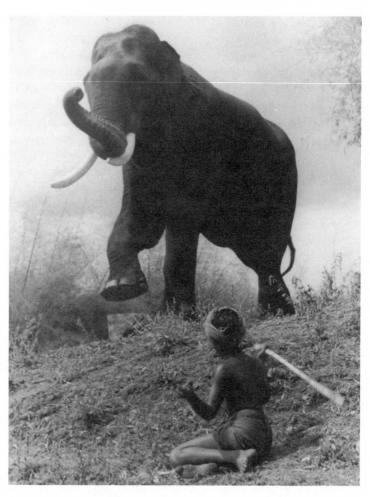

Sabu teaches Irawatha to dance: "Left! Right! Left! Right!"

liked him and worked easily with him. We considered ourselves fortunate to have found an authentic hunter who was such a natural before the camera. Yet ultimately the film distributors insisted on replacing Captain Fremlin with a well-known actor. It was an unfortunate decision that spoiled a very good film. Other studio aberrations would follow.

Of course, the elephants were just as important to the film as the human actors. I spent much time observing these magnificent creatures and developed a deep appreciation of them. Despite their huge size and strength, elephants can be gentle and even affectionate. They are proud

creatures that respond to being treated kindly and spoken to softly. Those I filmed were mostly tame, but whenever I had an opportunity to observe wild herds in the forest or at the river, I gained the impression they formed a disciplined, considerate society that could well be the envy of our own.

One example of the intelligence of elephants occurred during the filming of an early scene in which our train of elephants passed through a small village on their way to the jungle. As the big beasts ambled by, a baby crawled out into the road, right in front of the leading tusker. We all gasped as the huge foot came down. Yet, scarcely had the beast touched the baby, than it threw its weight onto its other front leg and, without missing a step, continued on its way, carefully avoiding the infant with its hind legs. As the mother rushed out to pick up her unharmed child, the rest of the elephant train passed majestically by. The incident had lasted only a few seconds, but it became a memorable scene in the film and increased my affection for these magnificent creatures.

There were times when our four-legged stars were not so cooperative. In a sequence showing the recruitment of mahouts and elephants, Captain Fremlin and Sabu stood behind a string of tethered elephants, talking about the upcoming hunt. As the camera turned, one of the tuskers suddenly began dumping grapefruit-sized balls of dung right behind the actors. Against such animated background distraction no artist could possibly compete. Stopping the camera, I called for someone to remove the steaming mound. Nobody moved. With an eye to the caste system, everyone started calling for someone else. When I asked why there was so much calling but so little action, I was told that such a menial job could only be performed by a sweeper from the lower echelons. At that point I exploded, went over to the balls of dung, and kicked them clear of the scene. At the end of the day's shooting, I gathered the crew to inform them that, in future, I would tolerate no such delays in remedying simple matters. If I could clear the set of elephant droppings, so could anyone else!

Minor misunderstandings aside, one of the joys India afforded me was the opportunity to learn about new cultures. One Hindu ceremony particularly moved me. Before production finally began, we all gathered together for a "puja," or ceremonial blessing of our venture. On this occasion the priests garlanded and blessed all those taking part in the project, as well as the equipment to be used. Symbolically, it was as though our fragrant jasmine wreaths bound us together in our seriousness of purpose. I only hoped that Alex, despairing of any footage ever coming out of India, would hear of the "puja" and know that it augured well.

Another wonderful celebration was the great Dasara Festival that took place in Mysore City during our stay. I believe it was one of the finest displays of pageantry to be seen anywhere. Richly clad and bejewelled, the Maharajah rode through the streets in a howdah of gold, his magnificent elephants painted and decked with precious ornaments. Later that day, when I was presented to His Highness sitting on a throne of gold inlaid with precious gems, stories from my childhood flashed through my memory.

On several occasions the Yuvaraja, younger brother of the Maharaja, invited Christiane and myself to his palace for an evening of entertainment. An avid patron of the arts, he introduced us to some of India's finest musicians and dancers. Although my appreciation of music is limited, my photographer's eye was captivated by the beauty of the scene with its graceful artists, exquisite saris, rich carpets, and delicate, many-stringed instruments. These evenings appealed to all the senses, lifting us, however briefly, into a realm of enchantment. Our host could not have been more gracious. Whether at his palace in India or his hotel suites in London, to which he frequently invited Christiane and me after our return to England, his bountiful hospitality gave us memorable, happy times.

Religious tolerance seemed to be a fact of life in the state of Mysore. Although the majority of the population was Hindu, other faiths appeared to be welcomed and respected. I saw one example of this soon after our arrival. In our hotel I met a wealthy Parsee, or Zoroastrian, and his nephew who, together with their Australian jockey and string of purebred horses, had come south for the racing season. One morning I heard a great commotion. On going to awaken his uncle, the unfortunate nephew discovered his relative had died in the night. Quite apart from the shock, the young man now had to arrange for his uncle's corpse to be committed to a "dakhma" or stone tower of silence in keeping with Zoroastrian doctrine. This was a daunting task. The nearest dakhma being in Bombay, some 500 miles away, it was decided that the quickest and simplest way of getting there would be by car. A Muslim taxi driver named Malcolm agreed to make the round trip. With the nephew in the back to steady the shrouded corpse, laid out on a stretcher across the top of the front and rear seats, Malcolm drove steadily for two days and nights. Rough roads, punctures, and stifling heat added a nightmarish quality to the trip, but the destination was reached at last. Here family members were waiting at the entrance to the dakhma. A brief service was held, then the deceased taken up into the tower to be left on an iron grating for vultures to come and devour the flesh, picking the bones clean. In that way the body, no longer pure after death, could not contaminate the sacred elements of earth, fire, and water. On hearing of Malcolm's jour-

ney, I was moved to reflect on the irony of fate that had brought these people of different faiths together. Many Zoroastrians had fled to India when Persia became Muslim in the 7th century. Yet in this instance, adherents of these two opposing faiths had shared a common mission with understanding, tolerance and mutual respect.

Bob Flaherty was by no means an easy man to work for, but he was always fair. Only on one occasion did I have a serious dispute with him. I had found a small grass-covered knoll surrounded by fine bamboos that was ideal for a short sequence we had in mind. I warned Bob that we would have to start early while the sun was right. By the time Bob had arrived on the appointed day and positioned everyone to his satisfaction, the sun was too high to achieve the desired effect. Bob gave orders to shoot. I refused and a heated argument ensued. We finally agreed that Bob would rehearse the scene then and there while I went back to camp to place an early crew call and order breakfast for all.

I had no sooner done this, than an elderly "Koruba," or jungle man, named Bomo came running to tell me that a tiger had killed a sambhur not far from camp. If I wanted to shoot the tiger, I should come along at once. By the time we reached the site of the kill, light was beginning to fade. Finding no tree nearby for shelter, I sat down with my back against a small termite hill, facing the kill about fifty feet away which had a path leading up to it. Soon I heard the tiger cough. With my rifle at the ready, I waited for it to come down the path. To my dismay, it approached from the opposite direction and began tearing at the meat of the prey that now separated us. My only chance for an easy shot lay in waiting for the tiger to get up from his feed. But a hunt is never a static scenario and the longer the tiger took to savage its kill, the more the tactical scene changed. For now I sat exposed in full moonlight, while the tiger crouched in the shadow of bamboo. Hoping to create a diversion, I shone my flashlight at the cat. Startled but cautious it stood up, presenting me with a good heart shot. But just as I fired the tiger leapt high into the air, charging straight at me before I could fire again. I dove under the beast as it crashed into the bamboo behind me. The expected second charge never came. Realizing the potential danger of my situation, I made my way cautiously back to the car and home.

An unwritten law requires that a wounded tiger be hunted down and killed. Accordingly, before dawn the next morning, I returned with a forest officer to make sure the tiger was dead. We found it lying just a few yards beyond where I had been sitting, felled by the single shot. We tied

it onto the rack at the back of the car and sped off, for I was already late for my own location call. As we approached, I could see everyone waiting, with Bob pacing furiously up and down like some cross between a rogue elephant and a lion. Before he could utter a word, I spun the car around, almost dumping the tiger at his feet. Instead of tearing a strip off me as he had clearly intended, he let out a yell of surprise and congratulation. Without further delay, we set about our business and shot the sequence as good friends. Flaherty was far too big a man to bear a grudge.

The most spectacular sequence of *Elephant Boy* shows wild elephants being captured and held in a stockade. An authentic shot, it involved a great deal of preparation. Once the Maharaja had given his permission to stage a keddah, or elephant hunt, we had to muster help from all the nearby villages to build a strong pen. The structure required thousands of large teak logs and no less than nine tons of heavy homemade rope. Villagers laboured day and night. While teams of builders provided the supplies and erected the stockade, a thousand other men kept watch to prevent the elephants from dispersing before the filming could begin. This they did by building fires and using clappers to frighten the poor beasts into docility. Each night I would ride out on an elephant with a forest officer to see that the fires – all of them about fifty feet apart – were kept burning. The memory of those eerie rides through the wild beauty of the jungle still fills me with excitement.

The keddah was a great success. We captured over eighty wild elephants and kept them for two days before releasing them. We obtained marvellous footage of their crashing through the jungle, chased and harassed by men with flaming torches and noisy clappers. The most daring beaters took incredible risks, closing in to within prodding distance of the beasts. Shots of elephant herds swimming the river, surging into the stockade, and becoming trapped in the huge pen as the heavy gate crashed down captured authentic, exciting action that had never been seen on the screen before. As soon as the terrified elephants realized they were trapped, they surrounded their young and pushed them towards the center in order to protect them from being crushed against the corral when the big bulls tried to break away to freedom.

When at last we had enough footage, the drivers raised the stockade gate to release the captives. Contrary to my expectations, we witnessed no wild rush to liberty but rather a dignified march towards the river. It was as though the spirit of the herd had been broken. I watched them go with mixed feelings: guilt because we humans had inflicted so much degradation and anguish upon those poor, noble creatures; joy as they crossed the river and disappeared once more into their lovely forest home.

Building the stockade for the keddah with tons of village-made rope
and thousands of teak logs.

By now, we had been in India for almost a year and Flaherty still refused
to send any footage back to London. Only some of Mrs Flaherty's stills
proved to Alex that we really had an elephant and an elephant boy. Not
surprisingly, he decided to send observers to India to evaluate the state of
the production. The first to arrive was Monta Bell, a Hollywood director
who had heard of a book about a ghost elephant. He had convinced Alex
that inclusion of this story would breathe new life into our film. Shocked
by his arrival, and particularly by his account of the ghost elephant, Bob im-
mediately sent for a copy of the book. While we waited for it to arrive, the
new director ordered us to shoot a ghost-elephant sequence. We wasted

three or four days playing around with whitewash and an unlikely "ghost" that – to the dismay of our American friend – aroused more curiosity than fear among its fellow beasts. As it turned out, the book bore almost no resemblance to what Bell had described. While it did tell of a man called White and his adventures among elephants in Siam, it made no mention at all of a white elephant, much less a phantom one. After this fiasco, Monta Bell returned to London and we continued our work as before.

Still in the dark as to what we had achieved in India, Alex next dispatched his brother Zoltan to view the footage and make recommendations. After many hours of screening, Zoli came to the conclusion that, except for a few short sequences to tie the story together, we already had enough film for at least two features. Despite our plea to remain longer to complete the required footage on location, Alex ordered us to return to London, taking Sabu and Captain Fremlin with us.

We left India with regret and the feeling that our project was incomplete. Yet when Alex finally saw a rough cut of the footage, he was enthusiastic. Unfortunately Louis Silverton, the United Artists distributor, saw things differently. For him, the film was fatally flawed because it featured no famous stars. At his insistence, Alex agreed to replace Captain Fremlin. When a matinee idol named Clive Brook declined the part because of a tight shooting schedule, Alex chose Walter Hudd, acclaimed for his stage performance in Bernard Shaw's play *Too Good to Be True*. Poor Hudd was miscast in the role of great white hunter. He neither liked his part nor felt comfortable in front of the camera. In my estimation, his performance was largely responsible for spoiling what should have been a beautiful, top-notch film.

The decision to replace Captain Fremlin as Petersen Sahib was heartbreaking for Flaherty, and indeed for all of us who had worked with him in India. Yet the work went on. Zoltan replaced Flaherty for the Denham phase of production, and parts of the script were re-written. By now, autumn was upon us. We had to hurry to replace the scenes shot with Captain Fremlin before winter would make it impossible to work in England. Members of the props department rushed around hiring elephants from circuses and zoos and buying up bamboos and any other tropical plants they could find. It was a wonder that Kew Gardens survived the onslaught.

Most of the reshooting of the white-hunter sequences was done at night. This was to make the newly acquired bamboos appear convincing as a jungle. With the frosts of Fall upon us, it was cold work for the elephants and a scantily clad Sabu. However, despite the discomfort and the phoniness of the setting, we did manage enough footage to replace the

original Petersen Sahib. To my mind they were afterthoughts that never quite worked out. Yet, despite all the obstacles, *Elephant Boy* turned out a success, both financially and as a prestige film. We had worked hard to make it so.

Yet, upon our return to England, Alex greeted as though we were returning from a long, lazy holiday in the sunshine. In fact, we had been far from idle. We had written a story, built and operated a laboratory in which all the visuals were processed, trained a complete crew, found and cast the characters, and captured more than eighty wild elephants. All this in a community where no such films had ever been made before and with no help from the studios back in England. Producers sitting in their comfortable offices with all requirements at their fingertips can never understand why it takes time to organize a location production such as *Elephant Boy*. I used to think that if Alex were to join us at the scene of action he would be more sympathetic to our needs. But, of course, he had his own production problems to deal with.

One of the joys of our time in India was close contact with the animal life of the region. In addition to the elephants who played such a central part in our film, I encountered majestic beasts of prey and shy, gentle creatures of the forest. Eventually, some became trophies; others, pets. All of them I acquired through my friend and guide, Bomo, who kept me informed about the comings and goings of wild game. I often followed Bomo along forest trails and noticed how quickly he moved despite being almost blind. His compensator senses of hearing and smell were acute. By sniffing a stem of grass or a leaf by the side of the trail, or by placing his toe into the droppings of animals, he could tell which beast or beasts had last passed by, how long before us they had been there, and even where they were going. Knowing of my passion for hunting, Bomo showed me how to surprise wild game in its natural habitat. Thanks to his deep knowledge of animal ways, the walls of my den are hung with trophies from two tigers, two pythons, and a crocodile.

Among my pets was Maglou, a Malabar squirrel that had been smoked from a hollow tree by some Korubas and came to me pitifully singed. Yet he eventually recovered his beautiful orange-and-yellow coat and became a wonderful companion. He developed the delightful vice of expecting his share of my evening drink on completion of each day's shooting! Other pets included a mongoose, a lorris, a baby panther, a pair of civet cats, and two twelve-foot pythons who refused to become domesticated. But the others became great friends. Rickie the mongoose loved to shoot up the trouser-legs of unsuspecting guests, causing quite a commotion at more than one social gathering. The little lorris, a primitive species of

monkey, was quite a ham too. He appeared in a short sequence in the film with Sabu and Irawatha and later, on the boat journey home, enchanted fellow-passengers by decapitating cockroaches caught by an obliging cabin boy and despatching them with gusto in our bathtub. Once home, however, he came to a sad end. Although I had made a cozy box to keep the lorris warm, he escaped one night and caught a fatal chill. That episode taught me the error of bringing such creatures away from their natural environment. I never attempted to do it again.

I suppose my favourite pet was Puss, the panther cub I acquired soon after arriving in Mysore. I bottle-fed that wee, spotted orphan until he was old enough to be weaned. As he grew up, Puss would allow nobody else to handle him. With me, however, he would gambol and purr when playing games. I would pretend to be another animal, even stalking him on my hands and knees. We would approach each other slowly, then, when I came within his reach, he would charge. Locked together, we would roll over and over on the grass. Not once did Puss bite or scratch me intentionally, although others would give us a wide berth when I walked him down to the river for his evening bath. This special companionship with a wonderful, wild creature, came to a sad end when Puss contracted rabies, probably from the pie dogs who used to visit our camp at night to steal his food. Heavyhearted, I fetched my rifle to kill my dear pet. As a demented Puss strained to attack me with teeth and claws ready for action, the shot entered one ear, went out the other, and cut the chain restraining him. In one last magnificent motion, his body sprang forward almost knocking me to the ground.

As a consequence of Puss's rabies, I underwent a two-week treatment consisting of daily injections of the Pasteur serum. This was administered to me in the jungle by a doctor who rode out each day from Mysore City with the thick white substance in a metal cooler. Following the injection into my abdomen from a huge syringe the size of a banana, I was supposed to remain immobile for the remainder of the day. But we were shooting the keddah at the time and rest was out of the question. When the doctor failed to appear at the appointed time one day toward the end of my treatment, Christiane grew anxious. Deeply fearful that my exposure to rabies would lead to madness if left untreated, she urgently sent for him. He arrived towards the end of the day, and eyed Christiane with unfeigned resentment. "Madam," he enquired wearily, "do you mean to tell me this is a standing order?"

Nobody's life was more affected by the filming of *Elephant Boy* than Sabu's. From our chance meeting at the Maharajah's elephant stables, he became an international star, equally at home in the bazaars of Mysore or

The doctor from
Mysore injecting me
with the Pasteur serum
after my pet leopard
Puss contracted rabies.

the glittering film premieres of Paris or London. With his many talents, he would have been successful in any society.

Christiane and I felt very responsible for Sabu when he began working for London Films. Each evening he would come to our hotel to rehearse his lines for the next day. Not knowing a word of English, he simply parroted after us. But with determination and much good humour, he learned his lines quickly. Christiane used to say that if the elephant boy spoke with a French accent, it would be thanks to her tuition. Once back in England we enroled Sabu in a private school near us in Beaconsfield, and he would join us for the weekends. His older brother, Sheik, came too, ostensibly to look after him, though I always suspected the roles were actually reversed. Although only thirteen, Sabu had a strong will and knew what he wanted from life. Indeed, his firmness of purpose sometimes needed guidance. Each payday I used to march him, dragging his heels, to the local post office to send a money order home to his mother. Although a devoted son, Sabu found the temptation of squirreling his money away in the bank all but irrestible – an understandable reflex in one who had known deprivation from an early age. Yet he rose quickly to

Back in England. I was dressed for the climate, Sabu for the film!

star status. Chaperoning him to Paris for the glittering premiere of *Elephant Boy*, we stayed at the prestigious Hôtel Georges V. Unfazed by so fashionable a milieu, Sabu's natural grace and charm quickly made him the toast of the town. Although Sabu never did return to India, I don't believe he ever regretted his decision to leave his homeland for an international acting career. Certainly, he took Hollywood in his stride, combining acting with business acumen. Decorated for his services in the American Air Force during World War II, he also became a member of the Hollywood Masonic Lodge. Sabu married a charming American actress, Marilyn Cooper, and to them were born a son, Paul, and a daughter, Jasmine. Tragically, Sabu died of a heart attack in 1963 at the age of thirty-six.

Reflecting on such a promising young life, I have often wondered whether introducing him to the mad pace of the film industry indirectly contributed to his early death. He was a brilliant, natural actor who brought joy to many. He certainly enriched my life, and I shall always remember him with deep affection and admiration.

For all of us, the production of *Elephant Boy* was a momentous experience. Despite its shortcomings, the film met wide acclaim. European critics particularly appreciated the performances of Sabu and the elephants. They praised the photography showing the beauty of India, the splendour of the elephants bathing and swimming in the river, the excitement of the hunt and the corral. British critics generally echoed these sentiments, but they were also quick to pan the somewhat stilted script, particularly the implausible Oxford accents of the unconvincing studio sequences. Today, I am gratified by the generous praise my camera work received. And I agree with the critics' negative reaction to the studio shots. Their rejection of the artificial elements which had been added for the consumer market vindicated Flaherty's commitment to filming authentic situations. I've always felt that if we'd been allowed to finish that picture the way we shot it in India, it would have been a much finer film. I think Alex knew that. Had he been in complete charge of production, including casting and story line, and free of the dictates of the distributors, *Elephant Boy* would have been delightfully, consistently authentic. How regrettable that in film making, artistic merit is so often sacrificed to commercial values.

For me, my time on the subcontinent fulfilled childhood dreams and professional aspirations. When I left the sunshine of Mysore to return to the autumn mists of England, I did so with the conviction that, like so many before me, I had received rich blessings on the banks of the Cauvery River. Wherever life would take me in the future, the haunting, plaintive beauty of India would forever remain a cherished part of my experience.

The Drum

The success of *Elephant Boy* and the appeal of its lead character triggered demands for more films starring Sabu. Seeking to capitalize on so promising a career, Alexander Korda bought the rights to A.E.W. Mason's *The Drum*. It was an improbable tale of the British army backing a young oriental prince pitted against a treasonous uncle. As in *Sanders of the River* and *Elephant Boy*, Korda's ideals of Empire and personal courage found expression against a backdrop of wild and romantic places. Yet *The Drum* remained above all a rousing adventure of heroes and villains – a sort of oriental version of the ever-popular western motif. As such it appealed to audiences on both sides of the Atlantic, but caused clashes in India over its colonial stance.

After the costly experience of *Elephant Boy*, Korda introduced major changes. He anticipated the demands of exhibitors by hiring a cast of well known actors and regained considerable production control by greatly reducing authentic location photography. There can be little doubt that the roster of famous names enhanced box-office appeal. Strong performances by Sabu and Raymond Massey added charm and suspense to an otherwise trite revisiting of the conflict between the very good and the very bad. Likewise Valerie Hobson, Robert Livesay, David Tree, and Desmond Tester did professional justice to their rather stereotyped roles. As usual, however, not one of the stars of *The Drum* set foot on the authentic locations forming the backdrop for their unlikely adventures. To bring this tale of Himalayan intrigue to the screen, only four of us actually braved the wild mountain passes of Northern India: production manager Geoffrey Boothby, myself as director of location photography, my assistant Christopher Challis, and Henry Imus, a technician from Technicolor. The harsh, rocky territory that awaited us proved to be the antithesis of the lush jungle of Mysore.

Although published accounts have suggested that *The Drum* was filmed entirely in Wales and at Denham Studios in the interests of economy,[1] headlines in May 1937 correctly announced otherwise. From *The Times* of London to the *Madras Mail*, our imminent departure for the north Indian frontier was widely reported in response to public interest following the success of *Elephant Boy*: "Technicolor Unit Leaves for India," "Peshawar and *The Drum*," "Indian Unit Leaves," "A Film of the North-West Frontier," "Filming in Delhi"... The fact that London Films' latest production would be in colour added to its appeal.

For me, too, the colour dimension of *The Drum* marked a professional watershed: so far I had only filmed in black-and-white. I looked forward to mastering the new technology, little realizing the particular obstacles it would present in our unique location. Prior to my departure for India, Technicolor arranged a one-week crash course for me at their laboratory. This, followed by three days of shooting in Westminster Abbey for the coronation of King George VI, constituted my only experience with colour prior to leaving for north-west India. With our camera freed-up as soon as the coronation was over, Challis and I departed from Southampton on 16 May 1937 aboard the Imperial Airways flying boat *Canopus* for the first leg of our journey. In the hold we carried 60,000 feet of negatives packed in special refrigeration tanks. Owing to the weight of our gear, Imus was to follow on the next flight with a Technicolor three-strip camera. In all we transported over half a ton of film and equipment – including special refrigeration tanks for film storage – that would eventually accompany us over rugged mountain terrain.

Most cumbersome to carry was the seventy-seven-pound three-strip camera whose triple 1,000 foot magazine gave approximately ten minutes of filming. The camera exposed three black and white negatives through a single lens with up to seven focal lengths, while a double prism beam splitter allowed the separate recording of red, green, and blue information. With its metallic finish of "Technicolor blue," the camera looked very pretty – but it was a brute to transport up and down Himalayan mountain passes, and I longed for the lighter equipment of earlier locations.

Although the camera was cumbersome, it was the film that constituted my greatest concern. In those days film stock was much more sensitive to temperature changes than it is today. Indeed, my final instructions from Technicolor had warned me that the stock would deteriorate quickly if

1 Among those who have claimed *The Drum* was not filmed in India are Karol Kulik, *Alexander Korda: The Man Who Could Work Miracles* (London: W.H. Allen, 1975); David Shipman, *The Story of Cinema: An Illustrated History* (London: Hodder and Stoughton, 1982).

submitted to intense heat. Scarcely were we underway, when our difficulties began. Our flight to Karachi, which in those days was still part of India, stopped en route at Brindisi, Alexandria, Ar Rutbah, Baghdad, Kuwait, and Bahrain. Everywhere we touched down the heat was intense, but personal discomfort paled before my concern for the film stock, particularly since the freight compartment had no air conditioning at all. Whenever possible throughout the journey I took advantage of refueling stops to buy ice and pack it around the film. On arrival in Karachi, I was relieved to hand this particular responsibility over to someone else. We hired a bearer, Syed Hassin, whose main job was to keep the film surrounded by ice at all times. Given the sensitivity of the stock, his task proved vital to the success of our expedition.

For the train journey to Delhi we placed a big tin bathtub into our compartment, packed the negative inside, surrounded it with mounds of ice (each mound weighing eighteen pounds), and covered the lot with two layers of heavy canvas. We kept another mound uncovered on a tray, directing three electric fans on it in an attempt to cool the atmosphere. By renewing our ice every two or three hours, we crossed the burning Sind Desert while successfully keeping our film within the safety margin prescribed by Technicolor.

Leaving Challis and Syed Hassin to await the arrival of Imus, I boarded a train the next day for Peshawar, where our production manager, Geoffrey Boothby, had already established our headquarters. Once the camera crew was complete, they would follow with the film and equipment. At Peshawar we arranged for the film stock to be kept in a refrigerated room of the hotel. We also had a heavy teak chest built for transporting each day's supply of stock to and from location. By adding a few bottles of beer and topping the case up with ice, we satisfied a major concern: the protection of both the film and ourselves from the ravages of excessive heat.

We began shooting trial footage as soon as possible in the old bazaar of Peshawar and around the Khyber Pass, but we dared not ship the exposed film back to London for processing because we could not protect it from the blistering heat. My decision to keep the film under our control provoked angry cables from the studios. I would ship the footage, I replied, only if Alex would assume full responsibility for its condition. Since I never received any such guarantee, the exposed film remained with me – as did my deep anxiety. Without the possibility of reports from the rushes, I would have to await until return to England three months later to know the result of the expedition. For all the time we were on location in India, I had no idea whether my work was successful or not.

As we began to shoot, the contrast between northern and southern India struck us. The gentle greenness of Mysore had not prepared us for the arid and hostile land we found around the Khyber Pass. Here the tough Afridis tribesmen of the region never left their homes without their Jazails – locally made rifles. Their houses of hardened mud and stones served as individual forts grouped around a small plaza or compound. A lookout tower commanded the surrounding area and no man ever left the compound without first climbing the tower to make sure there were no enemies in sight. A family cemetery nearby attested to the fierceness of long-standing feuds: it seemed only one man in three had died from natural causes. How far we had come from the peaceful Korubas of the Mysore jungle!

We spent our early days in northern India on such things as spotting locations, getting permits, arranging for troops, hiring a car and truck, and having reflectors made. To say that it was hot would be an understatement. On our first day of test-shooting in the area surrounding Peshawar the temperature broke all records by reaching 120 degrees in the shade. The Indian troops working with us had already nicknamed us "bioscope wallahs," "bioscope" meaning motion-picture, and "wallah" being a general term for people. As they watched us persist in our incomprehensible habit of working long hours in the blazing sun, they quickly pronounced us the "*mad* bioscope wallahs." The epithet remained with us for the duration of our stay.

One of our excursions took us to Parachinar, whose solitary mountain, Safid Koh, rose some 15,600 feet above the arid land below. Tribal feuding was rampant and a couple of stray bullets whistling past our heads convinced us that this location did not suit our purposes. Indeed, with so much armed hostility, we were not surprised to discover firearms being produced locally. The police chief of the city of Peshawar, an Englishman by the name of Finch, arranged for the camera crew to visit an illicit rifle factory in tribal territory near the Kohat Pass. The invitation was something of an honour, for we were the first Europeans to be invited to enter the precincts of this clandestine operation.

We left Peshawar one morning under a blazing sun. Our escort, one of Finch's men, rode in the truck carrying the film and equipment. We followed in a passenger vehicle. Upon entering tribal territory, we saw that every man and boy carried at least one gun, the preferred arms being the long-barrelled, awkward-looking Jazail and the British Army pistol. On arriving at the factory under secret escort, we drove through a gateway leading to a stifling courtyard where the three or four stern-looking men awaited us. As our interpreter introduced us, we greeted our hosts with a

slight bow. From the first they made it clear they would like pictures of the factory. I explained I would not be able to give them a print from the motion-picture camera, but would leave them photographs from the still camera. I then requested to see the whole factory, explaining I would decide afterwards what I could photograph.

Using the most primitive machines and tools, untrained technicians in that little mud factory were producing rifles indistinguishable in appearance from the stolen British Army Enfield which served as their model. Piles of cut-up railway tracks provided the basic metal. Woodworkers made stocks and guards. One man operated a contraption made of bicycle parts – wheels, gears, pedals, bits of frames and goodness knows what else – to drill the rifling into the barrel. He executed this most exacting operation without the benefit of precision tooling. On firing one of the rifles, I found it no different from the regular army issue. But unlike their legal counterparts, these guns lost their accuracy after only fifty rounds of ammunition. Their short lifespan was due to insufficient knowledge of how to temper the metals correctly.

In the courtyard of that incredible little factory, with our test-kit thermometer registering one hundred degrees Fahrenheit in the shade, I sat down to one of the hottest, spiciest curries I have ever enjoyed. While other crew members opted for the familiar beer and sandwiches we regularly carried with us, I indulged my love of Indian food and experienced one of the best, most memorable, meals of my life. Indeed memories are all I have left of that extraordinary day. With poor light and excessive heat, I failed to record anything worthwhile of that remarkable operation. Although I hoped to return one day to do a better job, the opportunity never arose. Yet, recalling the precision craftsmanship of those rebel mechanics, I still marvel at the tenacity of human determination in the face of great odds.

Realizing we were not in the right part of the country for the scenes the story required, we decided to move on. Our search for location took us to Srinagar in Kashmir where we discovered the most beautiful land I had ever seen: lush growth, well-cultivated soil, tree-lined roads and waterways, a placid lake dotted with sumptuous houseboats, a beautiful, bountiful marketplace. Beyond rose the magnificent Himalaya Mountains with their crowns of perpetual snow and ice glistening in the clear air. Yet it was all too peaceful to be used as a background for the angry, mutinous scenes we wished to stage. In pursuit of a more dramatic background, we reluctantly returned to Peshawar and the heat of the plains. Following local advice, we drove through Kohat and on to Parachinar on the Afghan border. But here, too, we failed to find the conditions we

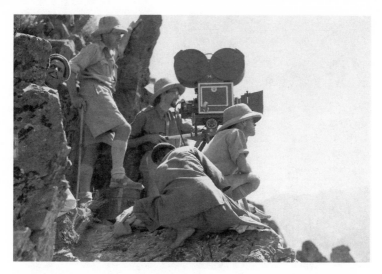

Shooting in rugged Chitral. The Technicolour three-strip camera
was cumbersome to move around.

required and at last set our sights on the mountain outpost of Chitral
beyond the frontier. With the help of the governor at Peshawar, we final-
ly received permission to cross over the Lowari Pass to Chitral. As the
first civilian expedition to enter that isolated region, we required a mili-
tary escort to ensure our safety.

Under military protection, we crossed the State of Swat in army trucks.
At one point the Wali, or ruler, came to greet us in his armour-plated Rolls
Royce but time would not permit us to accept his kind invitation to visit
his palace. Instead we pressed on to the end of the road at Dir. Here we
bade farewell to the escorts and trucks that had escorted us the eighty
miles from Peshawar, and took to the trail. We were now in the State of
Dir whose ruler, the Nawab, insisted on arranging for a pack-train to
carry our equipment and supplies through his territory. Forty pack mules
and half a dozen riding ponies as sure-footed as mountain goats made up
our cavalcade. While the ponies were fitted with riding saddles, the mules
carried yakdans – leather-covered boxes, thirty by eighteen inches in size.
These hung by hooks on each side of the saddles and carried two drums
of film surrounded by straw and ice. They constituted the best method of
packing I had ever seen.

Our expedition made an impressive sight as we filed past the fort at Dir
and took to the trail. Over the next few days we covered rugged moun-
tain terrain, experiencing a wide range of temperature. Our first march
was a warm, short one, climbing over 4,000 feet to make camp at Gujar

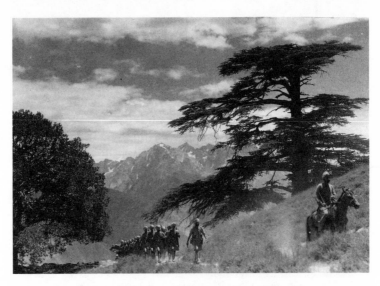

Our military escort on the way to Chitral.

Post. Here, on opening the yakdans, I was relieved to find the film cans still packed in ice, with a good supply remaining for the next day. Indeed, this first day's march set the pattern for those to follow. Although never very long, our daily treks nonetheless proved strenuous: by the time we pitched camp, collected ice or snow, braved a quick splash in the ice-cold stream, and finished our meal, we were ready to turn in early under the watchful eye of pickets from the post.

After an early start next day, our second march took us from the heat of the foothills up to the ice-covered Lowari Pass. Over 10,000 feet high and cold as a studio-official's heart, the pass marked the border between Dir and Chitral states. From there on I knew we would face no shortage of ice and snow for the stock though we ourselves, dressed for the heat of India, were ill-prepared for the sudden change in temperature. But the ride from Dir to Chitral was spectacular. From this lofty position we could see peak after peak stretching off into the haze. Thrilled at the prospect of photographing such exciting country, I hurriedly devoured my evening meal on reaching Ashret Post and climbed the mountain about 3,000 feet above the camp to get a better view of the land ahead. For anyone with a spirit of adventure, what an allurement! The gateway to Chitral with its endless prospect of towering peaks, lonely valleys, and rushing waters seemed to beckon me on and on, while fresh bear tracks lent a cautious exhilaration to the hike.

The trail to Kirkhani Post followed the rushing stream we had first picked up after crossing the ice field just below the Lowari Pass. Now it

The long, rocky, winding trail to Chitral.

grew rapidly into a mighty torrent, with every canyon we passed empty-ing its own melting snow field into it. As we climbed the narrow trail cut into the rock face, we became uncomfortably aware of the sheer drop of hundreds of feet to the boiling water below. On more than one occasion we congratulated ourselves for having trusted our camera and lens-case to bearers rather than the temperamental mules who invariably picked their way along the very edge of the precipice with gravity-defying obstinacy.

After stopping at the Kirkhani Post we passed through rugged country where small valleys opened up from the river course. In this land lived the Red Kafirs, a people claiming direct descent from the army of Alexan-der the Great which had passed this way in 327 BC. Because of their extreme isolation, they remained a unique people whose appearance, speech, and customs bore no resemblance to their immediate neighbours. Unfortunately, the Kafirs we saw were all on the other side of the rushing river, so we had no contact with them. But I could see that the women wore their traditional costume, the material of which looked much like the dark blue denim so prevalent in our own society today. How ironic if this people, forgotten over the centuries, had been the original designers of the industrialized world's most durable fashion fad.

At Mirkhani Post, our last overnight stop before reaching our destina-tion, our wild mountain torrent joined the swiftly running Kabul River. Here, as on each of our previous stops, we repacked the yakdans with snow and ice before turning in early. The difficult terrain and hardy tem-peratures seemed to have sapped all our energy. Next morning, we fol-

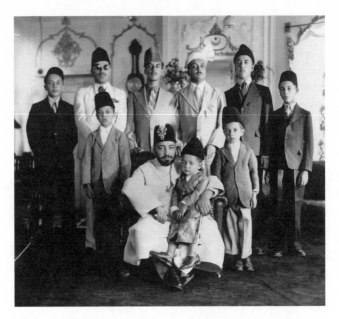

The Mehtar of Chitral with members of his family.
We saw no women at all in the palace.

lowed the Kabul River into Drosh and received a warm welcome from the small British garrison stationed there. The commander, Colonel Jackie Smyth, vc, brought special greetings to me from the Mehtar, or ruler, of Chitral. He recalled how, during an uprising in 1895, General Harry Ben Borradaile of the Indian Army had played a major role in securing the throne for the Mehtar. In return for my distant cousin's part in this affair, our crew was promised every assistance we required. Throughout our stay in Chitral we received full cooperation for everything we wished to stage, from war scenes to polo matches. Indeed, we soon discovered that the two activities were virtually indistinguishable!

We made Drosh our base for the next month because of the availability of the troops stationed there. During that time we shot army forays and battle scenes against glorious mountain backgrounds. The officers and men entered wholeheartedly into the spirit, giving us every assistance. When we finally headed on to Chitral, twenty-five miles further up the valley, we left our pack train at Drosh to await our return. Once again we travelled by army trucks – the same ones we had had to abandon at Dir. The soldiers had taken them apart and transported them in pieces over the same trail which we ourselves had travelled. Now re-assembled, the trucks bore us towards the capital at breakneck speed over the bumps and potholes of the only road in the State of Chitral. Later, in the palace which

had once been a fort, the Mehtar recalled the association of my family name with that distant, rugged land. More importantly, he offered us the use of his army for our battle scenes.

With its wild, rugged scenery, Chitral proved to be the perfect location for our scenes. At the head of our beautiful valley with its fourteen encircling mountain peaks, majestic Tirich Mir rose 25,000 feet above sea level. Only a few thousand feet lower than Mount Everest, its peak sometimes disappeared beneath a silver plume, the ethereal creation of strong winds blowing snow and ice particles from the summit. Yet though surrounded by a snow-covered chain of mountains, we still laboured each day in temperatures above one hundred degrees Fahrenheit. Only the cheerful assistance we received in attending to the film before, during, and even after exposure helped us overcome the exhaustion of filming long hours under a boiling sun.

Although the Mehtar frequently invited us to the palace, we never got to know the people of Chitral. My overriding impression was of a male-dominated society in which women were kept hidden away. Even at the palace, we caught not so much as a glimpse of any female occupants. The place appeared to be staffed and inhabited entirely by men.

The only other residence to which we were invited was the Officers' Mess at the garrison where half a dozen British officers extended traditional hospitality to visitors passing through. Resplendent in dress uniform, they welcomed us to formal dining evocative of gentler surroundings, their toast to the Queen as honorary commander eliciting from all a solemn "God bless her." In such an unlikely setting, we must have looked like bit players toasting the twilight years of Empire. At that time, the troops stationed in Chitral comprised a Sikh company and the Chitralian Scouts, a guerilla unit that had regularly driven back raiding forces from Afgahnistan. From their officers we learned some of the customs of this isolated and little-known land.

Like most mountain dwellers, the people of Chitral were hardy and little affected by the outside world. Where their sparse and rocky land permitted, they grew crops and raised herds of sheep and goats. At the palace I observed a peculiar feature of their social organization – the rather unusual relationship that existed between the heir to the throne and his slave. At the prince's birth, a baby boy of about the same age had been given to him as his slave and childhood companion. The two had played together as boys and grown to manhood as companions. Yet in public, they acted as master and slave, the prince leading the way while the slave followed two or three steps behind, carrying whatever his master might need in the course of his public engagement.

We witnessed this unusual relationship in a much more egalitarian light when photographing a polo game. On that occasion, the prince captained one side and the slave the other. Everything seemed to be on an equal footing. The flip of a coin identified which captain would make major decisions regarding the game. Thus fate, rather than privilege, determined who would begin the selection of teammates, who would choose the end of the field on which to play, and who would have the ball to launch the game. Unfortunately I did not stay in Chitral long enough to know whether all master-slave relationships were as relaxed as that one appeared to be.

Chitralian polo bore little resemblance to the sport as I knew it. First, the terrain was as rough as any battlefield. In that mountainous country, where rocks were continually being cast off from the surrounding slopes, it was impossible to locate a flat piece of land large enough for a polo field, so an area had been selected where the slope from the north was approximately equal to the slope from the south. Where the two slopes met marked the centre of the field and the goals were measured off in both directions. All rocks had been removed from the surface of the field and carried to the sidelines where they formed a solid wall of stone serving as bleachers. Whenever the heckling of boisterous spectators became too much, a player would gallop down the edge of the field, swinging his mallet at the taunting fans. As he thundered towards them, they would propel themselves backward in a sort of last-minute somersault, landing topsy-turvy behind the safety of the stone walls. This dangerous sideline attraction seemed an integral part of the sport.

The game itself was equally hazardous and free of regulations. With no referee to slow down the freewheeling action, ponies charged in all directions, mallets swung, players were dumped from their steeds, and nobody seemed safe from blows, punches, or the hurtling heads of broken mallets. It was a tough sport for a tough people, and I was satisfied to record it on film from the relative safety of the sidelines.

As I couldn't view my processed film, I experienced on-going anxiety as to the quality of my rushes. Particularly troubling were Technicolor's instructions that I avoid two colours at all cost: pure white and purple. Any white material was to be tinted either light blue or – by dipping in tea – light yellow. As for purple, the message was even more categorical: "Don't shoot it!" Purple, it seemed, inevitably came out on the screen either as a strange shade of blue or as an even less attractive hue of reddish mauve. These warnings had seemed eminently sensible in the controlled world of Technicolor's laboratory, but now they returned to haunt me. Everywhere I turned in Chitral the two forbidden colours dominated the scene. Costumes in the bazaar, snow and ice on the Himalayan peaks – all were dazzling in

their whiteness, while below the snow line canyons melted into a haze of deepest purple. What to do? Obviously, the tinting job was out of the question. Should I pack up and go home? Somehow I convinced myself that Technicolor would be able to make adjustments for the natural colours of the region. Despite my own misgivings and Henry Imus's frequent admonitions, I decided to carry on. But with our filming in Chitral drawing to a close, I did so knowing that my anxiety was fully justified.

The return trip to Peshawar was uneventful with the exception of one heart-stopping moment when it seemed we would lose all the exposed negative shot in Chitral. The pack mule just in front of me stumbled on a narrow ledge. As it struggled to regain its footing, its yakdan bumped into the sheer rock wall beside it, propelling the unfortunate creature over the edge. As if in slow motion, I saw the mule hurtle downwards head-over-heels, its two yakdans still firmly attached to its sides. After what seemed an eternity, the luckless beast landed upside-down amid a sickening cacophony of splintering wood, clanging metal, and terrified braying. Yet a miracle had happened – instead of crashing full force onto the rocks below, the mule had fallen between two large boulders that caught and cushioned its yakdans, one on either side. Thus the poor animal hung suspended about six feet above ground level, tightly wedged between the rocks, its hooves frantically kicking the air.

Almost as miraculous as the broken fall was the rescue operation. While our crew watched from above, members of the pack train made their way slowly down to where the mule had landed. Tying the animal's feet together, they put ropes through the saddle harness then passed them up to the men on the rocks above. While those above heaved on the ropes, the men below pushed against the mule's back from beneath. As the yakdans cleared the rocks, they were unhooked from the harness, and passed down to ground level. Finally, the men lowered the poor beast and untied its legs. Incredibly, it clambered to its feet, shook itself and, despite however many cracked ribs it must have had, walked away from its ordeal.

Closer inspection revealed the total extent of the damage: a few cuts and bruises for the mule, two smashed yakdans – but not so much as a dent on the film tins. These we repacked in other yakdans, surrounding them once again with ice. Following our misadventure, I decided to continue our crossing of the mountain trails on foot. In a gesture of generous self-interest, I offered my mount as a replacement for the injured victim of the fall. Not surprisingly, nobody took up my offer. Indeed, like me, other members of the film crew developed a sudden preference for hiking.

In spite of all the difficulties, and the fact that I lost twenty-six pounds on that job, I have wonderful memories of Chitral and of that whole

expedition. Besides the unforgettable scenery and the challenges it presented, we had been blessed with a happy crew. Boothby, Imus, Challis, and I had worked well together, doing our best in often difficult situations. I'd never had a better crew. Only the nagging concern about the results of the colour processing continued to mar what should have been a grand adventure.

Upon our return we found the heat of Peshawar more trying than ever. But we also rediscovered the small comforts one so easily takes for granted: a cool drink, comfortable bed, regular mail service. The latter, containing a back-dated pile of "latest" versions of the script, I regarded as something of a mixed blessing. At that stage, what was filmed was filmed and I felt little inclination to try to accommodate many changes. Nonetheless we took our remaining unexposed negative to Landi Kotal in the historical Khyber Pass where the support and cooperation extended to us made it possible to film some exceedingly fine scenes. Our negative all exposed, it only remained for us to pack, say farewell to our friends, and get our film back to England as soon as possible. To better protect the film from heat, we decided to make the return trip via train to Bombay and thence by boat where refrigeration would be available to us.

On arriving in London, I was dismayed to learn that the English Technicolor laboratory had been closed down for expansion and that our negative would have to be sent to Hollywood for processing. I explained to both Alex and Technicolor the circumstances that had led me to disobey instructions. Nobody seemed particularly pleased with my confession. Anxiously awaiting what must surely be bad news from California, I went home. My lonely vigil was broken a few days later when I received a call from Alex's office. A cable had arrived from Hollywood congratulating him on the beautiful location material received by the lab. Miraculously, all the footage was declared "excellent" – purple and white were not even mentioned. Heaving a huge sigh of relief, I promised myself never to forget that sometimes, just sometimes, it pays to break the rules.

The Drum brought widespread acclaim to London Films. The film was completed at Denham Studios and in Northern Wales with Zoltan Korda directing and Georges Périnal in charge of photography. Confirming Sabu as an established actor, it also whetted the public appetite for exotic, swashbuckling tales of adventure. According to the *Hollywood Reporter* of 5 May 1938:

> This film will be the answer to many an exhibitor's prayer. It skillfully blends the formula of a fast-action Western against the romantic background of British India. Filmed entirely in Technicolor, and liberally spotted with authentic,

spectacular photographic shots of Peshawar and the lands beyond the Khyber Pass, the picture has inestimable box office appeal ... The film is notable for several things, especially the beautiful color shots of India, the suspense built up by the impending revolt, the magnificent photography of the battle between the tribesmen and the Highlanders, the skirling of the bagpipes and the acting of Roger Livesey who, as resident commander, turns in a beautiful and dignified performance of the stubborn Empire builder who walks head first into danger simply because it is his duty.[2]

Back in England *The Times* of 5 April had been equally enthusiastic:

there is scarcely a single scene which is not wildly picturesque. The mountain landscapes are magnificent, the architecture [of Vincent Korda's sets] is fabulous, the Oriental characters are uniformly superhuman [led by Sabu and Raymond Massey], and even the English, in spite of the necessary comic relief that they must occasionally provide, can be relied upon to play up to the setting and to parade or fight with entirely appropriate gestures. The effect depends, of course, almost entirely on the photography, and on the direction of Mr. Zoltan Korda.[3]

With so much acclaim on both sides of the Atlantic, *The Drum* echoed the success of the earlier "Empire" film *Sanders of the River*. But to this genre had now been added glorious Technicolor; valour and skulduggery would never be quite the same again.

Around this time production was slowing down at the studios and a new member of our family was expected shortly. I therefore booked us passage on a 10,000 ton freighter bound from Le Havre for San Pedro, California. With only six other passengers aboard we left Europe looking for sunshine. We found it in abundance as we sailed the Sargasso and Caribbean Seas, then crossed through the Panama Canal and up the West Coast to San Pedro. Here old friends who had driven many miles to meet us welcomed us back to California. Two weeks later our first child, Anita, was born. Her arrival brought joy to yet another uncertain period of waiting for work between films. In retrospect, I saw that my work on *The Drum* had been encompassed by two momentous events: the grievous loss of my mother to a stroke in the last days of filming *Elephant Boy* and the present gift of a child. Death, birth – the life cycle was reaffirmed.

2 "'Drums' Spectacular Film: Fuses Action, Drama, Color," *Hollywood Reporter* (New York), 5 May 1938.
3 "The Drum," *The Times*, 5 April 1938.

Four Feathers ... and a Thief

My career in the motion-picture industry alternated between periods of intense productivity, often in remote locations, and between-film interludes which gave me the chance to unpack my bags and catch my breath. I generally welcomed these periods of respite that allowed me to renew body and soul and immerse myself in the simple joys of home life. But they never lasted long, for in those days London Films was in full production.

The interlude from late 1934 to early 1935 – between *Sanders of the River* and *Elephant Boy* – was a case in point. At that time Alex Korda was preparing *Lawrence of Arabia*, which he wanted me to photograph. One day he called me to his office to introduce me to a certain Mr Shaw. This was not, as I expected, George Bernard Shaw, whom I had previously met in Elstree, but rather Aircraftman Shaw, better known as Lawrence of Arabia. Shaw had legally changed his name from Lawrence in 1927. Alex asked me to help Shaw develop camera angles for an autobiographical script he was writing at the time. About once a week he would ride his motorbike up to Denham from his base in Bovingdon, Dorset, for a conference with Alex. He and I would then sit down to discuss possible scenes. Shaw was so quiet and reserved that, despite the time we spent together, I never felt I really got to know him. I recall him as an intensely private and unhappy man. Tragically, he was killed on his motorcycle shortly thereafter.

Yet a film about this unlikely, enigmatic figure who had played a singular role in the history of the Middle East was perhaps overdue. Lawrence's book, *The Seven Pillars of Wisdom*, had appeared privately in 1926. Now published for general circulation, it quickly captured the nation's pride and imagination. But if public interest was ripe for a film about Lawrence, political tension dictated otherwise and the film was cancelled. With Hitler rattling his chains in Europe, Britain was anxious to

avoid alienating the Turks, whom they saw as potential allies in a future conflict. Not until David Lean's award-winning production of 1962 would Lawrence's legend appear on the screen.

With *Lawrence of Arabia* too politically sensitive, the troubled mood of the late 1930s nonetheless craved inspirational stories of national valour. Following the success of their previous Empire films, and sensitive to the national need, the Kordas quickly obliged. Christiane and I had scarcely been in Hollywood for two months when I received a cable from Alex Korda asking me to go to the Sudan to film *The Four Feathers* in colour. Jumping at the chance, we returned to England in time for me to join Zoltan Korda's advance party, which was to sail for Port Said on 29 September 1938 aboard the *Narkunda*. As it turned out, the date was inopportune. With Hitler threatening immediate invasion of Czechoslovakia and Neville Chamberlain's shuttle diplomacy in ruins, Britain tottered on the brink of war. In view of the crisis, and because the troops which would have taken part in the Sudan sequences of the film would not now be available, London Films postponed our departure until the political time bomb seemed sufficiently defused.

Like *The Drum*, *The Four Feathers* was based on one of A.E.W. Mason's novels of British heroism. The time was 1898, the setting the battle of Omdurman where General Kitchener and his Egyptian allies recaptured the Sudan, thereby avenging at last the defeat and death of General Gordon at the hands of the Mahdi uprising of 1885. Against this backdrop a young British officer undertakes a personal mission of derring-do and bravery to overcome his reputation as a coward and win back the love of the woman who scorns him. In choosing this story the Kordas once again responded to the mood and tastes of the times. When the film was released in the Spring of 1939, the critic C.A. Lejeune noted, "it comes at a time when these bold, patriotic, simple-hearted heroics just touch off the public mood."[1] Richard Haestier concurred in the London *Star*: "Not only is it a grand spectacle, but Alexander Korda, who produced it, and his brother Zoltan, who directed it at Denham, for London Films, have succeeded in striking the right national note of the moment."[2] With war clouds gathering on the horizon, *The Four Feathers* rallied public confidence in the power of individual courage to overthrow overwhelming forces of evil. That the story unfolded against a backdrop of historical grandeur added a dimension of patriotic fervour to the film's appeal in troubled times.

1 C.A. Lejeune, "The Four Feathers," *Observer*, April 1939.
2 Richard Haestier, "Fourth Four Feathers Is the Best of All," *Star*, 21 April 1939.

Once again, location informed everything we undertook. From the bald stretches of desert outside Khartoum – where no roads broke the endless expanse of sand and dust – to the green and wonderfully fertile banks of the Nile at Sabolouka Gorge, we faced obstacles unimagined in a studio set. And yet the production of *The Four Feathers* introduced major improvements that greatly facilitated my work as senior cameraman. For this location we had brought along two Technicolor three-strip cameras and two full crews to operate them, with Jack Cardiff heading up the second crew. Although high temperatures once again threatened film stock and equipment, ice delivered each day by truck from Khartoum provided a relatively simple solution to a problem that had dogged me throughout the filming of *The Drum*. Nor did we have to wait for months before knowing the results of our shooting. With the rushes flown back to London at the end of each day, we now enjoyed prompt and regular feed-back from the labs. In short, dependable transportation, top-notch equipment, and plenty of support personnel ensured that our work was carried out as smoothly as possible.

Almost as significantly, and for the first time in my experience, principal actors came along with us on this location. Ralph Richardson and John Clements – both knighted later in their careers – starred in the scenes shot in the Sudan. The presence of famous actors, unaccustomed to the vagaries of shooting on location, virtually guaranteed there would be no real roughing it on this job. Despite glaring light, sweltering heat, and the ever-present dust, our off-production lives followed a comfortable pattern. After the completion of each day's shooting, we rode back over dusty roads to our hotel in Khartoum and the comfort of a shower, change of clothes, and a drink or two before a good evening meal. From so civilized a perspective, the discomfort and disruptions of each day almost paled into insignificance. Nonetheless we confronted the prevalent heat, mirages, and dust on a daily basis. Indeed, just reaching our desert location could be an adventure, as Ralph Richardson discovered the first time he set out for "Four Feathers Camp":

[From] Khartoum I set out [by taxi] on the 50-miles journey across the desert to the camp. We travelled a long way with nothing but a faint wheel mark in the sand to guide us … We ran through mud villages, [stopping] once or twice to ask the way, but although the driver assured me … that all was well, I saw that, whereas we had been travelling east, we were now heading north-west. The sun was plunging to the horizon … and I didn't relish meeting many watercourses. These … were dry, but going down 10 feet to a sandy river bed and up the other almost perpendicular side requires all the light you can get. When

complete darkness fell, [our] headlights were useful, but even so we missed one or two rocks only by inches – and there was one we didn't miss at all.

Suddenly I saw a rise in front of us. We slowed to take it gently, and down went the rear wheels in the sand. There we were, stuck miles from anywhere, and those two boys ... dived down and swept the sand from under the wheels, but ... after their efforts the back axle was resting on the sand with the wheels in the air.

I tried to fill in the holes again, and, choked with dust, was swearing to myself, when a solitary native boy came out of the darkness. I shouted 'donkey,' and he grinned. I flung my leg over an imaginary animal and clicked my tongue, but the grin merely became an ear-linker. Then he said something to my driver, who turned solemnly to me and said, "No donkey." I managed to send the boy off ... He returned with the population of his village – about twenty. All but four squatted ... to see what happened, while the others began a long argument ... As a last resort I tried ... shouting and a demonstration of lifting the car and putting something beneath the wheels. One of them ran off into the darkness and returned with two rusty pieces of corrugated iron. In fifteen minutes we had the iron under the car. In another ten we had scraped enough sand from under the back axle, and in five more, with the whole village pushing and laughing and the engine racing, we moved out of the hole. About eight o'clock I saw the lights of the camp. Instinct made me tell the driver to stop outside the sergeants' mess, and there I had the largest whisky I have ever drunk.[3]

The Four Feathers called for shooting epic scenes with literally casts of thousands. Using a combination of British troops and about 4,000 native people, we staged some spectacular sequences, such as the historic battle of Omdurman, the attack on the British Square, and the hauling of gunboats through the rapids in the Sabolouka Gorge. Equally dramatic was the episode in which Richardson was struck down by sunstroke under a burning desert sky. Years later I learned to my annoyance that some of the battle scenes had been used in other films, no doubt to cut production costs.[4] Perhaps I should graciously accept the "borrowing" as a compliment, and remain grateful that our own production was supported by generous funding.

At times we had to shoot scenes calling for thousands of men, camels, and horses to be stretched out for miles across the desert. It took much

3 Quoted by Zoltan Korda, "1000 Men Hauled the Gunboats Up the Cataracts," *Sunday Dispatch*, 25 December 1938.
4 Karol Kulik, *Alexander Korda: The Man Who Could Work Miracles* (London: W.H. Allen, 1975, 214) lists *Zarak* (1956), *Master of the World* (1961) *East of Eden* (1964), and Zoltan Korda's remake of *Storm over the Nile* (1955).

Local warriors (known then as 'Fuzzie-Wuzzies') arrive
for the battle sequence.

planning to get them all into position for the camera. We were grateful for
the services of semaphore signalmen of the British Army, who at that time
still depended on flags rather than wireless to transmit messages. Cer-
tainly radio would have been a great asset to us in arranging formations
and giving orders.

I recall one occasion when we had just completed arranging a massive
scene of the Mahdi forces and were about to signal for them to advance
toward the camera. Suddenly a truck appeared over the horizon, trailing
behind it the usual cloud of dust. It drove right up to the camera position,
leaving in its wake a clear set of tire tracks which would have made the
scene totally improbable. We immediately ordered a flag signal indicating
the Mahdi forces could relax, while parties covered the tell-tale tracks.
One party kicked sand into them while another followed, sweeping the
sand smooth with brooms made of scrub branches. Such recurring delays
were costly and exasperating to the crew; to the troops, they were some-
thing of a joke. Before long the soldiers were calling themselves the
"Brigade of Desert Sweepers."

Mirages too proved costly. Frequently we saw shining streams where
none had previously existed. At one location, as we refought the Battle of
Omdurman, a broad and shining "river" would appear each morning
about a mile away just as the cameras were about to roll. Since the cam-
era could not exclude the shimmering intruder, we had to alter the whole
formation of the scenes to avoid it. On another occasion, while we filmed

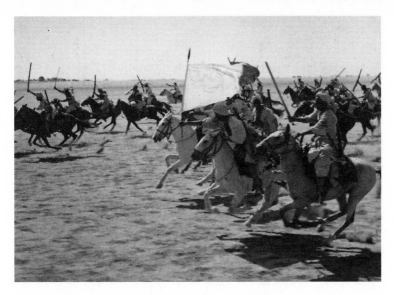
A charge by the Mahdi forces.

Kitchener's actual gunboats *Zafir, Amka,* and *Malik* being hauled up the cataracts, a swarm of locusts descended near the ships, stripping the banks of all greenery in a matter of moments.

One of the many features of the film that critics praised was our consistent attention to detail. One obvious example was the uniforms and rifles of the British Forces of 1898. To ensure authenticity – at least for the troops within close camera range – we brought as many as possible of the original military issues with us from England. Despite their age, those venerable props bore up remarkably well.

Many fine local horsemen and camelmen took part in our location scenes as well as the troops of the British Army and Sudanese Forces. Among them, significantly, were survivors of the actual battle of Omdurman forty years earlier. One proud old soldier with a scarred and toughened face had actually participated in a charge on a British Square. We chose him for a close-up shot showing a fanatic tribesman armed only with spear and sword charging right up to the muzzles of the British guns, where he was cut down. After listening carefully to meticulous directions through an interpreter, the old warrior stormed right up to the guns – but refused to fall down as instructed when the rifles fired. After several unsuccessful retakes, we asked him to explain himself. The old veteran exploded with indignation: in the real battle he had charged right up to the guns *without* perishing, and he was damned if he would let himself be killed in a mock battle now!

Others were less successful in avoiding wounds. During a scene re-enacting the storming of the British Square the over-zealous Sudanese "attackers," wielding their razor-sharp daggers, threw themselves into the range of the British guns. Of course, these were only firing blank cartridges, but even blanks can produce a nasty sting, and some local "attackers" were scorched in the fray. Determined to avoid any further injuries, Zoltan Korda called off the attack. Offering himself as a target, he walked nearer and nearer to the British guns until he too was hit. He then ordered that the attacking forces should stop just before that point. But he himself bore a nasty welt on his side where a wad had hit him hard.

Even with the millions of dollars that present-day producers seem willing to spend on production, I do not believe it would be possible to duplicate the authenticity of this location today. In this regard, the production was considered ahead of its time. C.A. Lejeune wrote in the *Observer* in 1939:

> The Four Feathers lives because it gives you the feel of a cracked, parched, blistering-hot Sudan in wartime. The water-holes are dry. The air swims at midday. Vultures wheel over the battlefields, tear at the carcasses of men and horses as coolly as though nobody in the audience were watching them. Little birds, in tremulous flocks, stream up from the bushes by the river. A blind man stumbles over corpses, shouts aloud in panic, and only the vultures answer him.[5]

Of course, we had filmed the vultures later. Once we had shot all the big scenes, everyone departed for home except for two camera assistants and myself. We remained behind for an extra week or so to pick up some animal scenes, particularly of vultures and crocodiles. I enjoyed these few days without a large crew. Our forays up the Blue Nile opened a new world of discovery and reminded me how much I enjoyed working in relative solitude to capture the savage beauty of the animal kingdom.

My pleasure at remaining behind was somewhat marred when I discovered that heavy holiday bookings prevented my flying home in time for Christmas. The best we could do was to take the train from Khartoum to Port Sudan. There we boarded a p&o liner on which we spent Christmas Day afloat in the Red Sea. Then, leaving my two assistants aboard with the equipment bound for England, I slipped ashore at Marseilles to enjoy a holiday on the Riviera with my wife and daughter. While I was relaxing, Georges Périnal completed the interior shots at Denham Studios.

Sometime around the outbreak of World War II, I was gratified to

5 Lejeune, "The Four Feathers."

receive from the Academy of Motion Pictures, Arts, and Sciences in Hollywood a certificate of Nomination for Award for outstanding colour cinematography for the film *The Four Feathers*.

My next assignment was a curious one. I had barely become reacquainted with my young daughter and was reviving on the Riviera from the rigors of the Sudan when I received a message from Alex asking me to interrupt my holiday and go to Italy. An English chocolate company had commissioned a film and wanted to show where the almonds that went into their product were grown. My task was to go to Sicily in early February to photograph the almond trees in bloom on the rugged slopes of Mount Etna.

I was met in Genoa by a certain Dr Bosio. He handed me a script that had been approved by the Italian government and introduced me to an assistant from Technicolor who brought me a three-strip camera. A member of the Fascist Party, Dr Bosio acted as our guide and advisor. Certainly, he facilitated our work. On numerous occasions he smoothed the way for us with local officials bent on checking and rechecking our papers and work permits. But he also kept a close eye on our comings and goings.

We had almost completed our shooting when the tolling of bells throughout the countryside announced the death of Pope Pius XI. At once I saw the unique opportunity to photograph the ceremonies surrounding the burial of a pope and the coronation of his successor. With a Technicolor camera already in my care and a work permit from the government, all I needed to make this historical record possible was the approval of the Vatican. Or so I believed. I persuaded Dr Bosio to precede me to Rome to pave the way for my proposal.

When at last we met with the authorities at the Vatican, they seemed eager to collaborate and allowed me to view the places where the different functions would take place. I soon found myself in a little chapel opening onto the main body of St Peter's. My Vatican guide and I stood not more than four feet from the body of the late pope. Dressed in his robes, he lay on an inclined bier so that the multitude of mourners could see his face as they slowly passed by the chapel. I was deeply moved by the quiet, dignified outpouring of respect with which the people bade farewell to the late pontiff. They had come from all levels of society and had lined up for hours for this privilege. Finding myself in their line of vision, I felt very uncomfortable. Yet so intense was their grief that few, if any, were aware of my presence. Had I had a camera with me, I could have obtained valuable and dramatic footage.

I was next shown where the coronation of the new pope would take place – a huge area in St Peter's whose dimensions reminded me of the

Hall of Mirrors at Versailles. After the ceremony, the new pope would go to a balcony overlooking St Peter's Square where he would bless the multitudes for the first time as pope.

When I reported to the Vatican officials on the feasibility of filming the forthcoming service, I cautioned them on the necessity of installing additional lighting equipment in both the chapel and the main body of St Peter's. As for the moment of crowning, I feared that the vast, dimly lit enclosure would prevent my doing justice to this deeply symbolic ritual. On the other hand, if it were to take place on the balcony – in full daylight and before the vast sea of upturned faces – the photographic problems would be minimized and the dramatic value of the scene greatly enhanced.

I was told that my request for additional lighting could easily be met. However, my suggestion that the coronation take place on the balcony occasioned a flurried exchange between the government and Vatican officials present. They promised me an answer from Dr Bosio later at my hotel room.

In fact, this meeting never took place and I never saw Dr Bosio again. Instead, two Fascist officials informed me that my assistant and I would be leaving Italy in the morning. Since they had already advised London and the Vatican of our departure, we were not to contact anyone. They were as good as their word. Picking us up early at our hotel, they took us to our train and saw us out of the country.

This premature end to my proposal was proof to me of the tension between the Fascist government and the Vatican. The government, I suspect, feared the Church's popularity and wanted to control the staging of ceremonies of such obvious international interest. Whatever the politics involved, a grand opportunity was lost to record some rich, historical pageantry in colour. Later, I felt somewhat vindicated when I learned that Pope Pius XII was crowned on the balcony of St Peter's – the first pontiff to receive the triple crown there since Pius IX in 1846, over ninety-three years earlier.

My swift despatch from Italy served as a sharp reminder of the clouds gathering over Europe. As though anticipating public reluctance to acknowledge the growing threat of war, Alexander Korda turned for his next production to a tale of pure fantasy. Capturing the magical atmosphere of the Arabian Nights, *The Thief of Baghdad* offered its audiences a brief escape into the world of the imagination. The story of Abu the thief – delightfully played by Sabu – who overcame a wicked usurper and won the hand of a beautiful princess, was pure escape; a charming, lighthearted reflection of the yearnings of the time.

The Thief marked a complete change of style for me and introduced challenges on which I thrived. A fairy tale, it called for technical innovation to conjure up the world of the *Arabian Nights*. Teaming up again with Georges Périnal, we had to photograph convincing scenes of a flying horse, a magic carpet, a huge genie bursting out of a lamp, and a monstrous spider threatening to trap Sabu in its enormous web. These sequences required innovative special effects. For example, relying on mechanical devices to give the illusion of flight, we had to light the scenes so as to obscure the many wires which made the horse and carpet fly. Long before today's computer technology, we created magical sequences that remain effective to this day.

Indeed, only the outbreak of war marred the fun of working on this production. In order to speed up the work, Alex created three units. I was in charge of photography for the Michael Powell Unit which shot the exterior scenes, mostly in Cornwall. Back at Denham, Vincent Korda provided us with very beautiful sets: the Pink and the Blue towns and the pirate ship, all of which captured the imagination, adding to the pleasure of the production. We also shot some of the interior sequences of Sabu escaping from his enemies on the flying horse and the magic carpet.

For all of us, the special challenges of this assignment made for a thoroughly enjoyable experience. To our deep regret, however, we were not able to finish the job. As war broke out, and with only the spider sequence remaining to be shot, the studios stopped production and sent Sabu over to Hollywood. There the film was completed, free from the immediate threat of bombs.

The Thief of Baghdad won Oscars from the Academy of Motion Pictures, Arts, and Sciences for coloured photography, coloured art direction, and special effects for the year 1940. I was somewhere on war duty when Georges Périnal received the presentation for photography and did not hear of it until several years later when I called on Georges at his home near Edgeware. Noticing an Oscar sitting on his mantel, I asked him: "Where did you steal that from?" He said, "Well, how is yours?" When I told him I didn't get one, he replied: "You should have, you shot one-third of the picture." When Peri died, the Oscar came to me, a treasured souvenir of our many collaborations. One of the great cinematographers of all times, Peri left a legacy that attests to a degree of artistry in our profession that has never been surpassed.

Just before the outbreak of war, the Yuvaraja of Mysore re-entered our lives. A frequent visitor to London, he would often call us, a gesture we always appreciated. Occasionally he sent his Daimler around to take Christiane, baby Anita, and myself from our little home near Chalfont-St-Peter

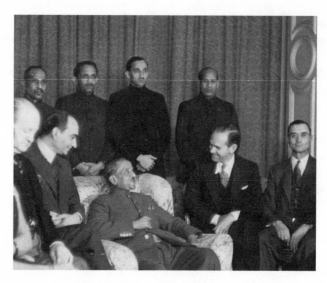

Chatting with the Yuvarajah of Mysore at his London
suite, 1939. I'm seated second from right.

to his suites in the old Kensington Palace Mansions. There Christiane and
I were free to enjoy the festivities while an Indian nanny, or ayah, took
charge of Anita. Sometimes we were the only guests. After a sumptuous
meal we would retire to the reception room to see a film. On these occa-
sions the appreciative audience consisted of His Highness' retinue: coun-
sellors, secretaries, cooks, the butler, musicians, dancers, and others
whom I no longer recall. The Yuvaraja enjoyed good films and valued
them as a medium both for education and entertainment.

On one occasion, he visited our home. We had just moved into our sim-
ple country bungalow, "The Den" – well named for its coziness and small
size – and had not yet unpacked when we received a telephone call from
His Highness asking if he could drop by to pay his respects. We were not
to fuss with refreshments, he added, as the visit would be brief. Scarcely
had an hour passed when his gleaming Daimler slowly wended its way
down our narrow country lane, followed, to our consternation, by a huge
bus. Out of the car stepped the Yuvaraja and his secretaries. From the bus
poured the rest of his retinue, some carrying brass pots, pans, and pitch-
ers, others musical instruments. They swarmed into our little kitchen and
dining room like a flight of locusts. With so many people in a desperate
hurry to accomplish some vital chore, our small home quickly took on the
appearance of a colourful oriental market.

In the midst of all this activity, His Highness remained perfectly serene. Ever observant, he was astonished to discover that we were doing our own decorating. We must have been the first do-it-yourselfers he had ever met! He also expressed an interest in the asbestos panelling on some of the walls and wondered whether it might be useful in India for protection against cold, heat, and fire. Nobody knew at that time of the health hazards of asbestos. In retrospect, it was perhaps as well that the war prevented our living in that home for too long.

Our temporary shortage of furniture in no way interfered with the delightful, spontaneous "snack" that soon appeared from our kitchen. Casually remarking that a lack of chairs was never a problem in his country, His Highness squatted merrily on the carpet as spicy dishes miraculously appeared before us. But almost before it had begun, our joyful feast came to an end. Checking his watch, the Yuvaraja announced it was time to move along; the whole purpose of his visit had been to invite us to a film in London the following evening. His hurricane-like visit dissolved as quickly as it had materialized. In rapid succession the chattering swarm reversed its steps from the kitchen door to the bus. Pots, pans, instruments, and retinue all disappeared as quickly as they had come and once again our quiet little country lane fell silent.

I had the opportunity of hosting the Yuvaraja in a less impromptu manner when I persuaded Alex Korda to invite him to visit Denham Studios. Acting as guide, I escorted His Highness to the many different departments, introducing to him all department heads and as many others as possible. On leaving, the Yuvaraja expressed his delight with the visit to Alex. A few evenings later he again sent the Daimler around to pick up the three of us. This time there was no party, just refreshments and a relaxed Yuvaraja eager to question me about his visit to the studios. I was impressed by his remembering the names of all the people he had met and his desire to know more about their work. His recall of names, rooted no doubt in his upbringing, confirmed their importance in establishing meaningful contact with people.

The Yuvaraja had come to London hoping to form a small production unit to make films in Mysore. When government officials advised him that the threat of war made such a project impossible at that time, he asked me to return to India with him. I had to explain that I was not free to leave on such short notice but would be willing to go as soon as circumstances permitted. Before leaving for India His Highness left a considerable sum of money with the Thomas Cook Company on which I could draw for the purchase of equipment and travelling expenses. Unfortunately, international events changed those plans.

On the eve of his departure, the Yuvaraja hosted a luncheon party in a beautiful home near Maidenhead. Not even the declaration of war seemed to dampen anyone's spirits. Champagne flowed freely, people danced the "boomps-a-daisy" and sang "Roll out the Barrel" and "We'll hang our washing on the Siegfried Line." It was as though nobody had a care in the world. So much jollity in the face of impending disaster made me feel uncomfortable – but perhaps the guests were right to be merry while there was still time.

On the morning His Highness sailed for India, I went to London to wish him a safe journey. Wearing the uniform of the commanding officer of a Mysore Regiment, he looked crisply impressive. As we bade farewell, I again promised to follow him to Mysore as soon as events permitted. Within days, impatient to launch his project, the Yuvaraja sent me a cable from Italy urging me once again to speed up my departure. That was to be our last communication. A week or so later I learned that the Yuvaraja had died shortly after reaching home. I never learned the cause of his death, but I did know that with his passing I had lost a true friend. Whether I could ever have helped him realize his dream still leaves me wondering. With the war now fully upon us, my own career soon followed a very different path. To my profound regret, I would never return to India.

Photographer in Uniform

My first wartime assignment was a documentary drama intended to whip up public zeal in the early stages of the war. Although this was a period of limited military action – the so-called "phony war" – it was clear that much worse was to come. Throughout 1939–40 Britain feverishly speeded up her military production in anticipation of the inevitable onslaught. Predictably, the motion-picture industry had its part to play. By mobilizing public support, boosting morale, and disseminating vital information it quickly proved itself a powerful instrument of national policy. To ensure that film production carried the "right" message and respected wartime budgets, it was placed for the duration under the control of the Ministry of Information.

But Alexander Korda did not wait for official prompting to launch his own call to patriotism. His first propaganda film, *The Lion Has Wings* (1939), traced events leading up to the outbreak of war and featured an RAF ready to take on and defeat the "wily" Luftwaffe. With Great Britain desperately struggling to match German airplane production, such optimism seemed premature. A curious mix of documentary footage, fictional sequences, special effects, and mock battle scenes, *The Lion Has Wings* lacked credibility and only partially served its propaganda purpose. Today, it seems sadly dated. Yet London Films spared no effort to ensure its success. Based on a script by Ian Dalrymple and directed by Michael Powell, Brian Desmond Hurst, and Adrian Brunel, *The Lion Has Wings* featured a stellar cast led by Merle Oberon and Ralph Richardson. Harry Stradling, Bernard Browne, and I were each responsible for a film unit. I shot in some of the secret control rooms and airdromes but was disappointed not to shoot any footage in the air.

My next assignment in March 1940 was for the American producer Walter Wanger. I was to go to Holland to shoot some background scenes

for Alfred Hitchcock's film *Foreign Correspondent*. It was the story of an American journalist assigned to Europe in 1938 who fell among spies. My sequences included high-speed car chases along the canals against a backdrop of supposedly threatening windmills. As it happened, my brief and rather too-exciting involvement in the production bore an uneasy resemblance to the movie's theme.

My difficulties began early. While I managed to arrange air transportation to Amsterdam for myself and my assistant, Jack Welsh, at the last minute the airline refused to carry our rented camera and we had to ship it by sea on the Dutch freighter *Rijnstroom*. When the camera failed to arrive at my hotel the following morning as arranged, I began to make enquiries. Despite an initial wall of silence, my worst fears were at last confirmed: enemy aircraft had sunk the *Rijnstroom* in the English Channel. I now had to scramble to rent another camera, buy negative, arrange to have it processed and censored at The Hague, and procure permits to work and photograph. Because of the tensions caused by the threat of imminent invasion, all this advance work took an inordinate amount of time.

Equally frustrating were the curves thrown my way by the exceptionally cold weather of that Spring. Canals froze over, barges caught in the ice, windmills ground to a standstill. The moody sequences I had planned to give the film its real-life edge seemed hung in suspended animation. Even the weather seemed on Hitler's side.

More threatening, however, was the interference run by the German Fifth Column which infested Holland. Although I had already received permission from local authorities, problems arose whenever we tried to film sequences of car chases roaring through villages and along the banks of canals. Inevitably other cars would appear, cut in, slow down, and spoil the shot. Our complaints to the police did nothing to improve the situation. Only when our hotel manager, a Mr Rosen, heard of our frustration did the cause of it become clear. He warned us that the waiter who served us in the bar was an informer who reported our movements to four men sitting at the next table. To foil further interference in our work, Jack Welsh and I asked the waiter for directions to a village where we said we intended to shoot the next day. We then watched as he casually transmitted the information to the next table. Early the next morning we headed for a village in the opposite direction where we had already made the necessary arrangements for the day's shoot. Remarkably, we were able to complete the footage as planned before a car drove up with four furious men inside, our bar neighbours of the night before. I could not resist giving them a smug smile as we packed up our gear.

Other annoyances followed. During processing, some of our footage

was spoilt in the laboratory and I was secretly informed that the break-down had not been accidental. I therefore decided to try to smuggle back to England whatever footage I could to avoid processing and censorship in Amsterdam, and perhaps even sabotage.

Interference escalated rapidly. One Saturday morning we planned to photograph from the top floor of an old warehouse on the bank of a canal in Amsterdam. The watchman who had let us in was to stay with us during the shooting. Just as we were setting up the camera, four men suddenly appeared, two of them in police uniform. Disregarding our work permit, they informed us in broken English that we were under arrest. When one of them grabbed the camera, Jack pushed him away and packed it into its case. From this point on the scene took on burlesque overtones. To our driver's consternation, the two policemen insisted on riding in our car with us to the police station. On the sly I told the driver to take the camera to the hotel and inform Rosen, the manager, of what had happened. Meanwhile Jack and I were led to a cell and locked up without so much as an interview. Indignant at our treatment, we began yelling at the top of our voices. When a jailer eventually appeared, I let him know that we wanted to speak to the British and American authorities. He agreed to call them. An hour later nothing had happened, so Jack and I started yelling again. This brought our jailer back in a hurry. He shouted to us to "shut up," adding that foreign legations were closed for the weekend and nothing could be done before Monday. As he left, we again began to yell, and this time voices joined in from the neighbouring cells. Within minutes our guard returned. Smiling profusely, he informed us that we could now go to our hotel room, where we should remain until an enquiry was held.

Rosen welcomed us back to the hotel with good food, good drink, and good advice. He pressed upon us the foolishness of carrying on with our project, which had obviously become dangerous. He promised to help us leave Holland if we so wished; it was an offer we could scarcely refuse. At dawn the next morning we left the hotel by the freight elevator and were whisked off by taxi to the airport where we boarded a Danish plane with blacked-out windows. On landing in England we watched the film clear customs, then thankfully headed for home and a debriefing by British Intelligence. Within days, Germany invaded Holland and bombed Rotterdam. I have often wondered if Rosen's political sympathies caused him hardship in the terrible times that followed.

My last involvement with *Foreign Correspondent* was almost as unpleasant as some of the earlier ones. The camera's owner sued me for its loss in the *Rijnstroom* sinking, despite the fact that I had advised him to insure

the equipment against all possible risks. Because it had been shipped by boat rather than by plane as planned, the judge ruled against me, thereby considerably lowering my opinion of British justice. But all was redeemed when Walter Wanger in Hollywood heard of my loss. Very decently, he covered the amount levied against me for the missing equipment.

To my amusement, the story of the sinking of the *Rijnstroom* gained a new twist when it broke in the British press. According to most reports I, too, had boarded the unfortunate vessel along with my camera and only escaped a watery grave when a British destroyer rescued me from a lifeboat and brought me back to England. That at least was how the *Manchester Evening News* saw it. Some accounts had the mishap occur on the way *to* Holland; others, on the way *back*. Thus where one reported all the exposed negative lost and myself returning to Holland for retakes, another had me smuggling all the exposed footage to Portugal for safe shipping *to* Hollywood. No doubt propaganda was at work in all the disinformation. Of the clippings in my album, only the *Yorkshire Post* of 9 March 1940 and the *Cork Examiner* of 12 March got the story right.

In all, I feel I contributed little to the success of *Foreign Correspondent*. Indeed, I never saw the film. Yet I understand its brilliant suspense sequences and ringing final speech exhorting America to "Keep those lights burning there … they're the only lights left in the world!"[1] were effective propaganda and may ultimately have helped to sway American public opinion toward playing a more active role in the war. Perhaps its most telling recognition came from Joseph Goebbels, Hitler's minister of propaganda and national enlightenment, who grudgingly described the film as "a masterpiece of propaganda, a first class production which no doubt will make a certain impression upon the broad masses of the people in enemy countries."[2] Film critic Basil Wright dubbed it "the most excitingly shot and edited picture of the year."[3]

Back in England I discovered that my rifle, ammunition, and hunting experience qualified me for membership in the Home Guard. Our small group was a motley bunch of retirees: a couple of Boer War veterans, a butcher, a gardener, assorted businessmen, and me. Meeting at the club house of the local golf course, we took our obligations seriously. Night after night during air-raid warnings we patrolled the local lanes looking – almost hopefully – for Nazi parachutists. Our expectations were

1 Cited in John Walker, ed., *Halliwell's Film Guide*, Tenth Edition (New York: Harper Perennial, 1995), 391.
2 Cited ibid.
3 Cited ibid.

doomed to disappointment. No parachutists obliged us by landing at our feet and we never fired a shot. Nonetheless, believing an invasion inevitable, each member of our unit resolved to fight to the best of his ability. The bristling determination of those worthy would-be warriors leaves me no doubt they would have put up fierce resistance had the enemy given them the chance.

For my part, I was anxious to make a professional contribution to the war effort. Prior to September 1939 I had placed an order for a 35-millimeter Newman Sinclair camera so that I could work independently. The big advantage of the Newman Sinclair was a spring-driven movement which passed the film through the camera at a constant selected set speed for a full 200 feet. This movement thus freed the cameraman from relying on electricity and the concomitant heavy batteries and generators that so encumbered him on expeditionary locations. I hoped this camera would allow me sufficient freedom of movement to operate as a one-man unit. Ultimately, it exceeded my all expectations. My Newman Sinclair became a faithful companion in the course of a variety of campaigns and eventually saved my life during the siege of Tobruk. Before I was able to follow and photograph troops in action, however, I was assigned to yet another feature film.

In the Spring of 1940 the Ministry of Information approved Michael Powell's idea of shooting a propaganda film in Canada. *49th Parallel* –released in the United States as *The Invaders* – told the story of survivors of a German u-boat who tried to escape across Canada after RCAF bombers had sunk their submarine near Churchill, Manitoba, on Hudson Bay. Their trek took them to many parts of the country and brought them into contact with a variety of set-piece Canadians. Although both plot and casting were highly implausible – even the great gifts of Laurence Olivier could not make him into a convincing "pure-laine" Québécois – the film enjoyed considerable success in appealing to then-current tastes for rousing war propaganda.

When Michael Powell asked me to be exterior cameraman, he made it clear it was a war-effort job with everyone donating their talents for the cause. This I agreed to, but with my own proviso: that Christiane and Anita sail over on the same ship as I. Even during the phony war, I wanted my family on the other side of the Atlantic for the duration of hostilities. Along with hundreds of "war guests" we sailed for Canada 29 June 1940 aboard the *Duchess of Richmond*. It would be five years before my wife and daughter returned home to England.

In Canada, Freddie Young was in charge of photography for the main unit, while I had the aerial shots and the "western unit." In fact, this

Shooting in Banff, Alberta, for *49th Parallel*.

proved something of a misnomer since, in addition to the spectacular Rocky Mountains, our crew filmed in Halifax and other eastern centers as well. Everywhere we went fair skies turned dark upon our arrival and foul weather dogged us. Constant retakes fuelled our frustration during what seemed an inauspicious return to the land of my youth. But for all that I rejoiced in the splendour of Canadian landscapes. I think I knew then that some day I would return to stay.

Though pleased to be back in my native land, I did not care for the film, despite its excellent cast. It included not only Laurence Olivier but also Raymond Massey and Leslie Howard, all of whom I admired. As contrived as it now seems, I still wonder at *49th Parallel*'s immediate success: an academy award for the best original story of 1941 and nominations for best picture and best script. More gratifying to me in the long run was Tony Rayns' 1979 review in *Time Out*: "Some of the plotting and characterization look rather rusty at this remove, but the sense of landscape and figures passing through it remains authoritatively dynamic."4 Yet what ultimately mattered most to me was that *49th Parallel* enabled me to bring my wife and child to Canada. Knowing them safe, I was anxious to become more directly involved in the war effort.

4 Cited in Walker, ed., *Halliwell's Film Guide*, 394.

As our work in Canada drew to a close, I received secret information that the first four of fifty US destroyers that had been exchanged with Britain for the use of bases – the famous destroyers-for-bases deal – were about to sail for the United Kingdom. Anxious to get back to the scene of action, I managed to gain passage on one of them, HMS *Broadway*. These old four-stackers were miserable for the crew. Narrow and shallow, they corkscrewed their way through choppy seas and were tossed like matchsticks by even moderate storms. By all standards these ancient American destroyers were too old and obsolete for modern warfare. Yet Britain desperately needed supplies. With modification, these old tubs served with distinction in the vital role of convoy escort. In May 1941 HMS *Broadway* was involved in the capture of U-110 with its cypher machine and material. This was an event of critical importance to the success of the Allied Special Intelligence cryptanalysis warfare. On 12 May 1943 the destroyer Broadway joined forces with the frigate HMS *Lagan* to sink U-89.

My own voyage in HMS *Broadway* was a wracking experience. When it was possible to hold formation, we crossed the Atlantic in line-abreast. For several days the seas ran so high we saw only one of the other three ships at a time as each rose precariously to the crest of a surging wave. Sliding down into the trough, we saw nothing but an angry wall of water fore and aft. The four battered and leaky ships docked in Belfast about ten days after leaving Halifax.

Back in London, I promoted an idea I had long nurtured. Ever since Mussolini's forces had overrun Ethiopia in 1936, Emperor Haile Selassie of Ethiopia had been living in exile in Bath, England. Now, with British help and the secret mobilization of the famous Ethiopian Patriot Army, the emperor was on the verge of reclaiming his land. This was the story I wanted the Ministry of Information to exploit. Although interested, the ministry had other preoccupations at the time. But the Army was a different matter. Recognizing an opportunity for much-needed propaganda to bolster its image, it agreed to assist in the project, providing all persons involved were army personnel. Within days I was commissioned into the British Army in the rank of captain and issued a crisp new uniform with three pips on the shoulder. Thus attired, and with my newly acquired spring-operated camera, I sailed for the Middle East Command Headquarters at Cairo.

My travel arrangements left much to be desired. Rather than heading straight for Cairo, my ship took the long route down the west coast of Africa. This was disastrous for me, for we soon heard by radio that the emperor and his forces had left Khartoum and were marching towards Ethiopia. I was already too late to get a complete record of his campaign

"Arbenya,"
the Ethiopian
guerilla fighters
under
Ras Ababa
Aragai.

on film. At the first opportunity I collected my camera equipment and jumped ship at Lagos, Nigeria. There, with the help of the governor and many signals to Whitehall, I received permission for air passage to Cairo.

Even the flight was distressingly slow, with overnight stops in Kano, Nigeria, and El Fasher and Khartoum in the Sudan. To my chagrin on reaching Cairo, no one knew anything about me or my assignment. Happily, I was rescued from this obscurity by Geoffrey Boothby, now a major, with whom I had filmed *The Drum*. Geoff and I were to work together as a special unit which could swiftly be assigned to specific jobs. Within a week we were flying south to Nairobi, Kenya, where the South African Air Force agreed to transport us to Ethiopia in one of their old German Junkers. En route we flew over the peak of Mount Kenya, close to the equator and over 17,000 feet in elevation. As we did so, the pilot suggested I get a shot of the mountain's spectacular glacier. This was easier said than done, for I found it no simple task to work at that height without oxygen. The rest of the flight was very rough. Flying through an electrical storm, we streamed flames like blue ribbons from the trailing edges of the corrugated wings. Landing safely at Dire Dawa at last, we continued our journey less spectacularly by truck towards Addis Ababa, which had just fallen to General Alan Cunningham's forces.

Within a day or so I was on the move again. This time I found myself bouncing along a dirt road in a truck loaded with rifles and ammunition destined for the followers of one of the emperor's chief lieutenants. Ras Ababa Aragai had been police chief of Addis Ababa at the time of the Italian conquest. Quiet, astute, and devoted to the emperor, he had spent the years of Italian domination in hiding, with a price on his head. But he had not been idle. Within a hundred-mile radius of Addis Ababa – virtually

under the eye of the occupying Italian army – he had clandestinely and methodically trained volunteers in guerilla warfare. Now their moment had come. An aircraft flying over the Ethiopian plateau dropped sheaves of yellow paper stamped with the seal of the Lion of Judah: "My beloved people – I rejoice to announce to you that I am once again amongst you. I have come with the invincible might of Britain. This verse from the Psalm of David is the watchword of our revolt: 'Ethiopia raises her hands towards God.'"5 As the watchword drummed from tableland to tableland Ras Ababa Aragai's barefoot patriot army rallied to the call. Fully armed by the British, these veterans of night-time fighting and mountain ambush poured from their villages to join their emperor in his sweep towards the capital.

The Ras invited me to stay as his guest so that I could film the activities of his resistance fighters. He gave me two bodyguards who remained close to me night and day for the week-long duration of my stay. They proudly wore assorted bits of uniform, captured – like their weapons – from the Italians. I also acquired an interpreter, a friend of the Ras who had learned English in Khartoum. These three – whose long hair constituted their badge as "Arbenya," or Ethiopian guerilla fighters – became my constant companions. Besides the sense of security their presence afforded, I also appreciated their offer of help in carrying my camera equipment.

In the course of my short visit, the Ras and I became good friends. He insisted that I attend all the meetings that took place when the Balabats, or head men from across the country, reported to him for instructions. These meetings were followed by a big meal at which I would be seated at the Ras' left hand. We sat on cushions before small individual wicker tables. Each table was covered with a mat on which two or three knives of different sizes were placed, as well as a plate and several small bowls containing various sauces. Once everyone was seated a red curtain at the far end of the room was flung back to reveal a man covered from head to toe in a flamboyant red cloak. This he threw back as he approached the Ras, revealing a full side of raw beef hanging from one shoulder. But for the meat, he was almost naked. Once the Ras had inspected and approved of the beef, it was borne from guest to guest. Each would use his assortment of razor-sharp knives to slice off strips of raw meat and dip them into the sauces. It was delicious. Equally enjoyable was the refreshing drink called "tej" which was kept cool in a clay crock hanging in the shade. With its flavour of honey and herbs, tej reminded me of mead. After my second glass, I felt ready to take on Mussolini and his boys single-handed.

5 Script extract, private collection, Osmond Borradaile.

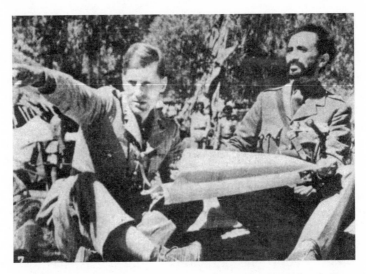
Emperor Haile Selassie confers with Colonel (later General)
Orde Wingate, leader of the guerilla campaign.

Once I almost went too far in discovering local customs. During a con-
versation with the Ras, I learned of the Ethiopian tradition of hanging an
enemy's testicles over one's doorway as a victory trophy. Thoughtlessly, I
jocularly remarked that such a souvenir over the entrance of my home in
England would be an unusual reminder of my soldiering experience in
Ethiopia. To my dismay the Ras took me seriously and offered to make the
necessary arrangements. With difficulty I managed to convince him that I
had only been joking and that I would be horrified if some poor Italian
were mutilated on my behalf.

My stay with the Ras and his men came to an end when Geoffrey
Boothby arrived from Addis Ababa with the news that the Emperor's
forces were about to attack Debre Mark'os. We scrambled to leave, but by
the time we finally joined up with Haile Selassie's troops, the town had
already been taken. By now it was obvious that I had failed to record the
most important military events of the emperor's march back to his home-
land. Bitterly disappointed, I resolved to make the best I could of what
remained of the campaign.

On joining the emperor's march to Addis Ababa I became part of the
East African campaign, whose principal objective was to ensure the secu-
rity of the Red Sea and the Gulf of Aden. Both waterways formed vital
links in the lifeline from Britain to the Far East. As the small British Forces
advanced in Ethiopia, I got to know some of their colourful leaders.

Among them was Brigadier Daniel Sandford, commander of the unit. An acquaintance of the emperor from pre-war days, his intimate knowledge of the country and the people was invaluable in the present campaign. The leader of the guerilla campaign was Colonel (later major-general) Orde Wingate, a first-class soldier who brilliantly coordinated the efforts of the Sudanese and Abyssinian irregulars. When I remarked on his striking resemblance to Lawrence of Arabia, he replied rather obliquely that they were, in fact, "brothers under the skin." Later I learned they were distant cousins. With his appreciation of Ethiopian history and politics, Wingate helped us write the script for our little film *The Lion of Judah*. After the Ethiopian campaign, his considerable talents would affect the course of another theater of war: accompanying Churchill to Quebec for the meeting with Roosevelt, he had the opportunity to promote his idea of guerilla warfare. Although Wingate himself was killed in an airplane crash in April 1944, his corps of British, Gurkha, and West African commandoes, known as "Wingate's Raiders" or the "Chindits," played a key role in the recovery of Burma and helped prevent a Japanese invasion of India.

In the course of the long march to Addis Ababa, I often reflected on the contrast between the present British Ethiopian campaign and the last one. The latter had taken place in 1868 with General Robert Napier leading his forces against the self-appointed Emperor Theodore II. At that time Ethiopia was being torn apart by warring chieftains. Through his ambition and ruthlessness, Theodore managed to control a large section of the mountainous country. Like despots everywhere, he ruled by fear, imprisoning, torturing, and often executing his political opponents. Among his victims were several British subjects, including the British consul. When negotiations for their release failed, Britain sent an expeditionary force to Ethiopia to free all the political prisoners. The successful campaign contained elements that harkened back to Roman times. The British included elephants from India in their march across the country and Theodore chose to take his own life rather than suffer the humiliation of defeat. Ironically, he shot himself with a pistol Queen Victoria had sent him as a gift in happier times.

Now, in 1941, the British Expedition was marching to reinstate the emperor of Ethiopia upon his throne by defeating a common enemy. The Ethiopian Patriot Army had rallied to Wingate's lodgement in the mountains and now joined the British for the descent upon the capital. Along the way Wingate's guerilla tactics confounded the enemy, causing them to abandon their key outposts one by one. On 5 May 1941, one month after the fall of Debre Mark'os, Emperor Haile Selassie entered his capital of Addis Ababa to a tumultuous welcome. The emperor rode in an open car

with Sandford, while Wingate – perhaps emulating Lawrence of Arabia's triumphal entry into Damascus on a white charger in 1918 – followed on a white mule. The date was significant: five years to the day since Italy's Marshal Pietro Badoglio had invaded the capital as conqueror.

In honour of the occasion Wingate wrote a short talk which the emperor agreed to deliver before my camera wearing a borrowed British uniform. The script, comparing the emperor to the biblical David and the Italians to Goliath, was appropriate. Once enthroned, Haile Selassie became head of the Ethiopian Coptic Church, described by former Emperor Menelik as an "island of Christianity in a sea of paganism for 1500 years."[6] Unfortunately Boothby and I had to overcome a major technical difficulty – I had only a silent camera with me and no sound-recording equipment. To my relief the South African Army came to my help with an old disk-recording outfit. Setting the camera speed at twenty-four frames per second, and smothering it with a couple of sleeping bags, I photographed the emperor's speech with trepidation. Later in Cairo Boothby had the formidable task of transferring this sound from disk to film, then synchronizing it with the visual footage. He succeeded admirably.

Despite our many disappointments, *The Lion of Judah* did capture a turning point in the war. As the first production of the Army Film Unit of the Middle East Command it enjoyed wide distribution and served as a valuable propaganda film. With its concluding sequence of Haile Selasse's return to Addis Ababa, it provided me with a rare occasion to film war footage that was actually cheerful. On a much larger scale, it helped boost the morale of a British public hungry for news of military success.

Before leaving Ethiopia I enjoyed some contact with emperor Haile Selassie. On three or four occasions he summoned me to his Gibbi, or palace. On one of these visits he ordered a bottle of champagne uncorked. When I expressed astonishment at being served champagne in Ethiopia, the emperor replied: "Graziani – that man you soldiers call a 'son of a beech' – had plenty of good champagne. French champagne – not the bad Italian stuff!" We toasted each other with the best, thanks to Graziani's good taste in wine.

The emperor had an inquiring mind and questioned me particularly about my own country. He showed great interest when I told him of the huge land concessions that had been granted to the Hudson's Bay Company and the Canadian Pacific Railway to open up the country. I recall how amused he was when I drew on a piece of paper the old flag of the CPR, which showed six squares, three above a horizontal line and three

6 Script extract, private collection, Osmond Borradaile.

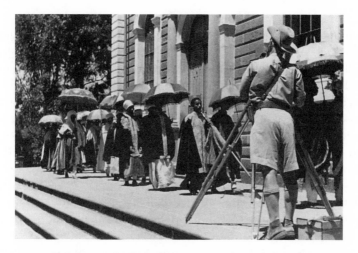

I photograph the Emperor's return to his church
in Addis Ababa.

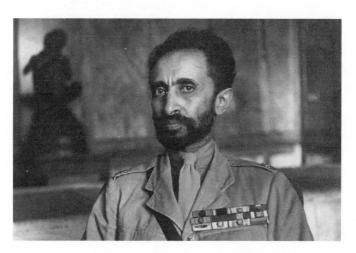

"The Lion of Judah." I photographed Haile Selassie on the
day he returned to his capital. He is wearing a borrowed
British uniform for the occasion.

below. The squares were of two colours – red and white – and they alternated, one colour for the country and the other for the CPR. The horizontal line represented the railroad. Perhaps the concept appealed to an emperor whose dreams for his country would be severely curtailed by limited resources.

Once restored to his throne, Haile Selassie still faced enormous difficulties. The British government had already made it clear he could expect little financial help from his allies, whose every penny was directed towards the war effort. Yet, following his own war of liberation, he had an impoverished country to build up and improvements introduced by the Italians that had to be maintained: good roads, agricultural developments, commerce, a radio station, and hotel. His only alternative was through taxation, a highly unpopular measure that even the Italians had been unsuccessful in implementing.

I believe that Haile Selassie was sincere in wishing to do the best possible for his people. Certainly he effected many improvements during his reign. In 1963 he also proved instrumental in establishing the Organization of African Unity. Yet his international prestige could not save him at home. When famine ravaged Ethiopia in 1973, economic chaos spurred the army to revolt. Within a year Haile Selassie found himself ignominiously deposed. Yet recalling his vision and courage in the face of an implacable foe, I regretted his passing. I will always remember the day he stood at the head of his troops looking down on Addis Ababa after five dark years of exile. Though small in stature, the indomitable "Lion of Judah" had inspired a war-weary world.

North African Campaigns

The Ethiopian campaign was drawing to a successful conclusion when we heard of the siege of Tobruk. A vital link in the Axis supply line, this superb North African port had been captured by the Australians in January 1941. Now it was again besieged and bombed – this time by the Germans under General Erwin Rommel. Unable to get an air flight to Cairo, Geoffrey Boothby and I drove our little truck to Asmara, via Dessie and Amba Alagie. The road swarmed with surrendered Italians also making their way to Asmara. On arrival we were surprised to discover how much the town had obviously prospered under Italian rule. Its numerous sidewalk cafés thrived on crowds of Italian soldiers – freshly returned from defeat at the hands of the British troops. We were almost embarrassed to be warmly greeted by these recent enemies who now offered us coffee or wine. We could scarcely believe these same people had been so hostile towards us only a short time before. Perhaps the propaganda had made them seem so. There is nothing like war for skewing our perception of other peoples.

From Asmara we drove to Keren, where we marvelled at the audacity of the troops that had stormed the Italian position on the crest of the mountain overlooking the town. The stench from the shallow graves was nauseating. I felt particular sympathy for those who had fought there, for a cousin of mine had participated in that attack.

After a couple of days of hot, dusty driving, we arrived in Khartoum, where we managed to wangle two air tickets to Cairo. There army headquarters procured cutting-room space in the local studios so that Boothby could complete *The Lion of Judah*. Meanwhile I asked to be put into Tobruk. Rather expecting to be air-dropped into the besieged garrison, I held myself in readiness to move on short notice. After a day or two of anxious waiting, I was ordered by train to Alexandria and there hustled

aboard an Australian destroyer, loaded both inside and out with food, medical supplies, and ammunition. Just before midnight, with the crew ordered to stand by their posts, I hunkered down on deck with my camera equipment. Only a few stars pierced the darkness as we put on speed and zig-zagged through the quiet waters to avoid enemy patrol craft guarding the sea approaches to Tobruk.

Miraculously, we made it. The crew brought the ship into harbour and unloaded the cargo with incredible speed. Before they could complete the job, however, bombs came streaking out of the sky and landed all around us. I managed to get all my gear ashore and made a separate pile of it on the far side of the dock. As soon as she had completed unloading, the ship slipped her lines, backed away from the dock, revved up her engines, and made a dash for the open sea. Bombs continued to fall, but none hit the dock.

With the ship gone, I was now on my own. Not knowing where to go in the dark and encumbered by my equipment, I decided to stay where I was. Curling up with my camera, I questioned my sanity for being there at all. Once the bombing had ceased, I fell into an uneasy sleep, thanking my guardian angel that my dock had been spared. On awakening cold and stiff in the early morning light, I got my first view of Tobruk and the imposing white buildings the Italians had built for their naval installations.

Tobruk under siege was an exciting place. The spirit of the troops – whether Australian, Polish, or British – was magnificent. They remained cheerful and determined despite major hardships. Food rations were in short supply, the drinking water foul, and the daily bombings merciless. Ironically, daily broadcasts from Germany by the traitor William Joyce, or "Lord Haw Haw" as the Allies called him, provided comic relief. Every available radio was tuned to him for the day's entertainment. Guffaws and catcalls met his pronouncements that Germany was all-powerful and just, and that it was madness to resist the Führer's will. Cheers and raucous obscenities broke out when he cautioned that all the rats bottled up in Tobruk should "save their dirty hides" by surrendering. Good old Haw Haw! Contrary to his intentions, he did much to boost morale in those stressful days of the siege.

Another source of merriment in the midst of so much devastation was the antics of the Australian Bush Battery. This happy group consisted of the non-combatant members of the Australian troops: cooks, machinists, signalers, and the like. Anxious to do their bit in stopping the enemy, they had collected Italian guns and ammunition abandoned when Tobruk fell to General Archibald Percival Wavell's troops. But, unfortunately for the

Bush Battery, the fleeing Italians had taken the precaution of removing the sights from the guns, thereby rendering them almost useless. *Almost*, but not completely. Showing spirited reserves of cunning and ingenuity, the Aussies resorted to the old technique of laying and training their guns by observing the fall of shot. If it landed short of target, elevate the barrel. Shoot too far, depress it. Nelson's and Wellington's gunners had used the technique; so too had gunners in World War I and World War II even with good range-finders and sights. The Aussies may not have known this lore, but they soon figured out their own way by regular practice.

To determine the direction of fire, they would withdraw the block from the breech, look through the barrel, and shift the gun until the target was visible in the center of the barrel. Determining the angle of elevation was more complicated. By trial and error they had determined marks painted on a long pole placed at a given distance from the muzzle of the gun. The gun barrel was then elevated to the height of the appropriate mark, the block replaced in the breech, and the gun loaded. Orders were shouted, the crew hopped through their paces as though staging a tattoo at Aldershot, the command "Fire!" rang out, followed by an ear-piercing explosion. Suspense reigned while the smoke cleared. If – as was usually the case – the target was still standing, the bystanders lost no time in proffering advice: "A hundred yards short," "Six inches higher," and so on. The gun-layer then rushed to make the necessary adjustment, and the whole procedure repeated itself. Whenever the Stukas returned for their daily spate of dive-bombing, the order "Cease fire and disperse!" brought the exercise to a sudden close. Throwing a camouflage net over the gun, everyone beat a hasty retreat before the arrival of enemy shells. These often seemed more erratic than those of the Bush Battery.

Ultimately, the Aussies' gunnery exercises paid off: one night the battery scored direct hits on enemy trucks moving along a supply road. Although the drill sessions continued to amuse, the results now commanded a measure of respect.

During my time in Tobruk I shot footage of a number of events that seemed newsworthy: the Stuka dive-bombing, the Bush Battery, a sortie with the tanks, and the old monitor under attack. My goal, however, had been to photograph the lifting of the siege by Allied troops, and after a couple of weeks I saw no sign that this was imminent. The scene of action was shifting instead to the emerging Syrian campaign. Anxious to be in on that show, I sent a signal to headquarters seeking permission to return to Cairo. I then waited for the dark nights of the new moon and a signal to let me know that a ship was heading our way. We departed Tobruk amid the usual rush to get the ship clear of the harbour. Although I felt

enormous relief on clearing the enemy patrol boats, I remained fearful for the brave troops we had left behind.

When I arrived back in Cairo, Boothby had completed *The Lion of Judah* and shown it to General Wavell and "the Auk," General Claude Auchinleck. Both praised the little film liberally, especially General Wavell. Whether their approbation made any difference to the support we received was not clear, but certainly headquarters was generous to us for our trip to Syria. Not only had they provided an almost-new small truck at our disposal but a driver to go with it.

After a couple of days in Jerusalem, we headed for Syria via Haifa on the coast road. Checking in at the border, we passed through the ancient Phoenician cities of Tyre and Sidon. With all enemy troops inland towards the north, ours became among the first Allied vehicles to enter Beirut. To my disappointment, however, the Syrian campaign proved generally uneventful from the perspective of British cinematography. For the most part the fighting in Syria at that time pitted General de Gaulle's Free French against Pétain's Vichy troops. Judging by our scarce opportunities to film Allied action, we tended to regard British General Henry "Jumbo" Wilson's forces rather as referees between the warring factions.

Several times, I acted as conducting officer for civilian war correspondents. This was a job I did not enjoy. I had not enlisted to assist well-paid civilians to get their stories and pictures. Yet the assignment did introduce me to some of the well-known war correspondents, among them Matthew Halton, Chester Wilmot, Alan Moorehead, and James Aldridge. Matt Halton and his family eventually became close friends of my family. He gained a reputation during the war for his honest, unsensational reporting of actions as he witnessed them. Even today, rebroadcasts of Canadian troops in action during the Second World War usually carry a commentary by Matt.

Because there was little to observe on the war front, I made a point of visiting numerous historical monuments within the borders of Syria and what is now Lebanon. I saw the ancient fortress of the Crusaders, the famous Krak des Chevaliers; Dog River, where all invading armies passed on their way to the Holy Land, leaving a marker to commemorate the occasion; Damascus with its bazaars and Straight Street, said to be the oldest street in the world; the beautiful ruins of Baalbek; the Holy Valley of the Maronite Christians; the old ports of the Phoenicians; the Jebel Druzes; the Cedars of Lebanon. The more I saw, the more I was convinced that we could give the story of the present battles added depth if we set them in context against these ancient backdrops. I shot several background sequences for a proposed propaganda film, but never succeeded

in selling the idea, although Randolph Churchill, then responsible for public relations in the Middle East, seemed interested.

Still in search of action, I returned to Cairo to have the truck checked over and better adapted to carry film and camera equipment. My driver and I then set off into the desert in hopes of capturing action. When a cinematographer is permanently attached to an army unit, his scope for action sequences may be limited, depending on the arena in which he finds himself. But he does have the advantage of secure rations, transportation, and the support of his commanding officer. Such was not my case. As a roving cinematographer with the British Army film unit of the Middle East Command, I generally followed tips as to where action might break out next. On arriving at a unit I first had to prove my identity and then convince the commanding officer of the value of propaganda and a historical record. One successful line of persuasion ran that the "folks back home" would have a chance to see the unit in action on their local screen. Another line argued that I understood military behaviour and would not unnecessarily jeopardise the lives of the men. Once accepted, it was up to us to be self sufficient in rations and transportation. My driver and I never left Cairo without drawing thirty gallons of petrol, a week's rations, and twenty gallons of water. This, together with bedding and equipment, we packed into our light truck, securing tarpaulins over the lot in a vain attempt to keep out the pervasive desert dust.

Once, when the enemy had broken through the wire with 200 tanks and 300 supporting vehicles, we drove to the 7th Armoured Division, hoping to accompany their tanks into battle. To my disappointment they retired, hoping to coax the enemy into a more suitable position before giving him battle. But by dawn it became clear that "Jerry" had no interest in falling into our trap. If I wanted to film action, I would clearly have to move on. With warnings and the latest information as to the enemy's position, we set out on a compass course into the desert.

The day was hot, with poor visibility due to the dust. Soft sand and the wind on our tail soon caused our truck to over-heat and boil. At first I was generous with our precious water supply for I was impatient to catch sight of the enemy. But, unable to sate the radiator, I soon devised a more sparing strategy. When it began to boil we would swing the truck around to cool off in the wind, then run her for a mile or so before repeating the procedure. It made for slow progress. We reached the escarpment that was our destination at sunset, then followed British tracks into a wadi where, acquitting ourselves in the usual interrogations with sentry, intelligence officer, and finally commanding officer, we bedded down for the night.

The next day proved more successful. Starting off at dawn, we soon

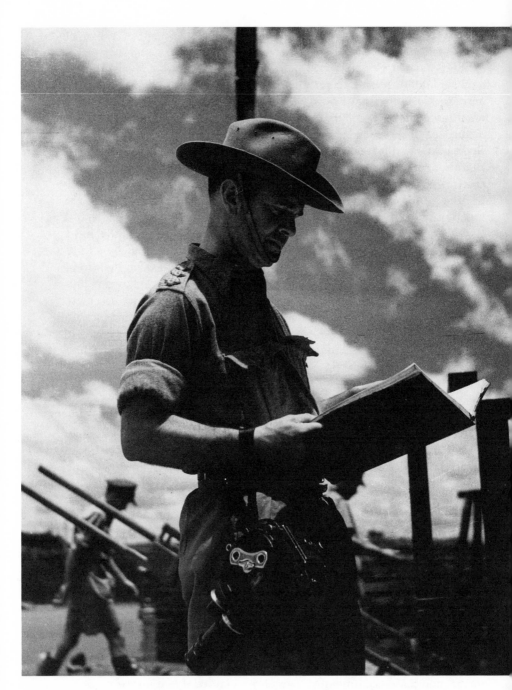

Myself as captain, British Army Film Unit, Middle East command.

picked up German tank tracks. Following them up and out of a depression, we suddenly encountered two armoured cars cresting a rise and bearing down upon us. We stopped, grabbed our rifles, and watched as they separated to take up positions of advantage. Each side scrutinised the other through field glasses. Friend or foe? Only when satisfied that we were indeed friendly did the armoured cars close in on us. I grabbed some pictures as they came alongside for they had on board a couple of Italian airmen they had just taken prisoner.

From the crews I learned that our bombers had caught a concentration of enemy tanks refuelling ten miles to the south. When we came upon the site one of the latest German tanks lay in ruins, its mutilated crew still smoldering and giving off that nauseating smell so distinctive of burning human flesh. Beside the tank lay the scattered ruins of two burnt-out petrol lorries, two ammo-carriers, and a staff car. Once again I had arrived too late. But twice we had to "lie doggo" as enemy planes came over that scene of desolation, though I could never resist a shot at them with my rifle. As we tried to scrape together the remains of a German and give him decent burial, another armoured car drove up and told us the enemy had retired behind their own wire. Disappointed at not having been in the thick of action, we set compass course for our wadi, where the commanding officer welcomed us back with a drink and what seemed a damn fine meal.

My frustration at missing enemy action reminded me that desert warfare is typically a war of dispersal and that the "camouflage boys" were too good at their jobs. The enemy proved far too elusive for my taste. Of course, had I caught up with the Germans I would have had other problems to solve. My first challenge would have been finding a position from which to photograph the enemy without being spotted and knocked out – not easy in flat terrain bereft of any vegetation. A second consideration would be the shimmering heat waves that so often prevailed, making the use of long focal-length lenses impractical. Unless I could get close, images could be rippled and broken up as though seen through a mirage, and action sequences remain fuzzy and unclear.

Following a number of similar desert sorties, I learned of our forthcoming November offensive. Believing the best shots would be secured from low-flying bombers strafing Rommel's tanks, I moved on to the Twelfth Squadron of the South African Air Force. An easy-going group, their friendship and confidence afforded me the best chance of getting some spectacular air battle scenes. They were flying Martin Maryland bombers with a crew of four: the pilot, a bombardier-navigator, a radio operator, and a rear gunner. Anticipating the chance to attack Rommel's tanks, they punctuated their regular reconnaissance and high-level

bombing sorties by training missions in low-level bombing. The aircrew quickly agreed to take me along on these practice flights, regretting having to leave me behind on actual battle missions – they couldn't afford to have a passenger replace a vital combatant member of the crew.

Grasping an opportunity, I joined a short tail-gunnery course composed of only six students. We spent one day becoming familiar with a Browning machine gun and swinging it around on a scarf ring mount – (Marylands had two Brownings mounted side by side on a ring with the sights between the guns). Then followed two or three days driving around in the back of a truck fitted with a gun on a swivel ring. Our truck bumped along at about forty miles an hour behind another vehicle which released small helium-filled balloons into the air as our targets. By the time we reached them, the balloons had lofted about a hundred feet high. After years of pointing cameras, it came naturally to me to shoot down rapidly vanishing balloons. In any event, I scored the highest number of hits. With my new reputation as a sharpshooter, I joined a crew as rear-gunner – No.4 – on condition that guns take priority over cameras if ever we were attacked. This stipulation I planned to overcome by camera mounts and remote controls so that guns and cameras could be worked in tandem. The squadron artificer agreed to build a camera mount between the two guns on the Marylands, thus enabling me both to film and fire bullets at the enemy simultaneously.

My first raids were more routine than spectacular – though always interesting. Each day began with hot breakfast before dawn, followed by a briefing on the weather, the latest Intelligence reports, and the day's orders. We then piled into trucks and drove to our planes which, already revved up and taxied to the take-off point, awaited us. Pulling on our heavy kit at the last minute, we climbed in, I with my cameras. To protect them from the dust I carefully wrapped them in silk salvaged from an Italian parachute that had not done its wearer much good. Then we tested our oxygen supply and our intercom system. The latter furnished the only means of contact between the foreward members, No.1 (the pilot) and No.2 (the navigator bomb-aimer), and the rear members, No.3 (the radio-operator) and No.4 (the gunner). Between the forward and aft stations lay the bomb-bay with its unfriendly load.

Our take-offs were always dramatic. As No.1 opened the throttle and we slowly began to move, the ground crew gave us a cheery thumbs-up and wave. But as soon as we began to gather speed, a huge plume of cream-coloured dust blotted everything from view. A brief glimpse of our tents sliding by a few hundred yards beyond the starboard wing disappeared into the ever-growing cloud that pursued us. Once airborn, our

bomber lumbered under the weight of the eight 250-pound bombs. I felt reassured on feeling her lift herself clear and seeing the dust serpent die in its tracks below.

We generally circled the field a couple of times to reach altitude and gain formation. Then, running out to sea or into the desert, we would turn at last and cross into enemy territory. As we climbed my position became acutely uncomfortable. With the rear half of my turret open and an icy oxygen tube clamped between my teeth, I kept my eyes peeled for enemy fighters approaching from behind or above. The lack of any heating at all caused me to worry that the cameras might freeze up. But they never did.

Our missions followed a pattern. It always thrilled me to hear No.2's quiet voice announcing that he had spotted the target and directing us into position. I would then start operating my camera, shooting the opening of the bomb doors and the bombs tumbling out. With my camera mount not complete, I would lean out over the side to try to follow the bombs down. I always felt deep anxiety watching those deadly missiles sail down on their mission of destruction; then deep satisfaction if they landed on target. Either way, flak generally followed, the black puffs appearing in the sky beyond our tail affording me a good closing camera shot.

Our mission accomplished, we would turn and streak for the wire. Sometimes we would see the dust plumes of enemy fighters taking off from their fields. We didn't worry. With speed and altitude in our favour, we were more concerned about the fighters already in the air. As we crossed the wire No.3 notified our base that we had bombed the target and all planes were returning. Then No.1 would ask for music and we would fly home to melodious strains, usually coming in clearly from Radio Rome. We used to joke that if "Musso" equipped his army with violins instead of guns, we would surely lose the war.

Of course, not all flights were this uneventful. One of my last missions was a bombing raid on an enemy ammunition dump near Tobruk. Scarcely had we made our run, dropped our bombs, and turned east for home than a flight of fighters appeared about a thousand feet above us. I reported them to the skipper over the intercom. "They must be our Tomahawks come to escort us home," he replied. But just as the leading plane pulled its nose up and flared out, the sun hit the underside of the wings and – to my horror – I glimpsed the iron crosses. It was a flight of German Messerschmidts. Quickly putting aside the still camera I had used to film our bombs bursting on target, I yelled into the intercom that we were being attacked, grabbed the guns, and fired a burst at the enemy leader. His bullets just missed us as he dove below us and away. We were ready for the second plane as it too dove down, its bullets screaming all around us. As

we opened up, we could see our tracers smacking into it. As it hurtled down below us, I clearly saw the pilot clawing at the cowling before he fell off into a spin. Watching from the belly of the Maryland, our radio operator saw the Messerschmidt hit the desert in a cloud of dust.

We tucked into close wing-tip formation to present the enemy with a smaller target and more concentrated firepower. Surprisingly, they did not return to harass us. We were greatly relieved. Their attack had nevertheless taken its toll. Unable to hold formation, our No.3 plane dropped away and landed at an emergency field badly shot up. The rear gunner, hit by an explosive bullet, died on the way to the dressing station. I knew him. He was a young South African Jew named Solomon who had been on our gunnery course. That had been his first combat flight. Later the army reported finding one German Me-109F just on our side of the wire. This was gratifying. But my camera mount not being ready, I had missed a marvellous chance for sensational footage.

On landing, I received a signal from Cairo calling me back to Headquarters. The timing was bad – the artificer had at last completed the camera gun mount and wanted me to test it. Built to my specifications, it carried my camera between the guns, giving a fine angle showing the gun muzzles and the course of tracer bullets. To enable me to handle guns and camera at the same time, he had fastened the remote-control operating the camera onto the gun handle near the trigger. Although this arrangement made it difficult to avoid vibration when the guns opened up, I was satisfied it would allow me some very worthwhile footage from the air. At last I felt well prepared to do the job I had come for. Yet despite my arguments and a special request from the squadron, headquarters remained adamant. For now I was to return to Tobruk to photograph the lifting of the eight-month siege. I could return to low-flying strafing shots with the Twelfth Squadron afterwards.

Once again I found myself in Alexandria, where I waited two days before boarding HMS *Latona* for a pre-dawn departure. At 2,650 tons she was a large, fast minelayer designed to run into enemy waters at high speed, sow her mines, and make a quick getaway. Depending for her protection on speed, manoeuvrability, and anti-aircraft fire, she bristled with ack-ack guns, two turrets of high-angle four-inch guns fore and aft, several batteries of multiple pom-poms, and many Oerlikons. Conveyor belts between decks carried mines to fusing and depth-setting personnel prior to launch. The ship was packed with supplies on this occasion, both inside and on deck. They consisted mainly of 250 tons of land mines and ammunition. The crew was high-spirited despite the danger, but I dreaded the prospect of unloading this formidable cargo. Even the presence of our

escorting destroyers, HMS *Encounter* and HMS *Waterhen*, only partially reassured me, for I knew our ship was a floating ammunition dump.

Around three o'clock on 25 October 1941, I was sunbathing on the deck when the alarm signaled the approach of a high-flying Italian plane. Hoping to film our guns in action, I grabbed my camera. Almost at once our three ships increased speed and started to zig-zag. Although our guns were manned, for some reason they did not receive the order to fire. An officer on the bridge tracking the plane through his binoculars shouted: "Bombs coming down!" The violent movement of the ship altering course made it very difficult to handle the camera. I gave up waiting for our guns to open fire and swung the camera around to get a few moments of one of the destroyer's spectacular manoeuvers. Startled, I saw through my view finder three huge columns of water momentarily obscuring the destroyer as three bombs fell between us. At last, I was getting the sort of action footage I had so long sought. Again I heard, "Bombs coming down!" Following the officers' binoculars, which were directed portside, I swung my lens and captured the twisting destroyer and three more bombs hitting the water with the force of huge erupting geysers. After dropping its six bombs, the plane flew off to the west. We knew we had not seen the last of the enemy.

That evening I was enjoying a drink in the wardroom with some of the officers when action stations sounded. Grabbing my camera, I rushed onto the deck. A glaring sun hovered just above the horizon, and we were heading right into it. Planes suddenly appeared overhead out of the dazzling brightness. Once again we took evasive action. A low-flying plane, only fifty feet or so above the water, shot out of the sun and headed straight for us. The *Latona* swerved sharply as the aircraft dropped a torpedo and veered away. Just as I caught the plane in my camera finder, our pom-poms opened up right on target. A flash and cloud of smoke followed the steady thump of shells and the water below sprang to life as the disintegrating plane hit the surface.

The enemy attack slowed down sporadically, only to pick up again with added fury as reinforcements closed in. It was getting quite dark when a concentrated attack opened up on us. In the course of the ensuing action I think the Axis threw everything they possessed at us: torpedoes, bombs from both high-level and dive-bombing planes, flare after flare. All this together with our own guns made a spectacular display and provided me with enough light to get something really worthwhile. I had scarcely exposed three rolls when a heavy bomb landed by our four-inch gun turret. Knocked unconscious by the explosion, I saw no more of HMS *Latona*'s desperate fight for survival.

Eye-witness accounts allowed me to piece the story together. The bomb that had knocked me out had crippled the ship's steering gear. Ablaze, she had become a sitting target. As the crew assembled on deck to abandon ship, two officers ordered batches of men to jump onto the deck of HMS *Encounter* as she passed close by. By the time the last group of men had jumped to safety, the section of the ship where they had been standing had become a mass of flames and the two officers were too late to make the jump themselves. They made their way to the stern to signal one of the destroyers to come back for them. A pile of land mines caught fire as they waited. The intense heat forced the decision to jump into the water and swim to the destroyer, when a body fell onto them from atop another stack of mines. Although badly burned, it seemed to move, and those two valiant officers decided not to desert it. Instead of leaping into the sea, they waited for HMS *Encounter* to make one final pass across the stern. Grabbing the unconscious bulk by the ankles and wrists, they tossed it to the passing deck before jumping to safety. I owe my life to those two brave men, for I was the dead weight they saved. Minutes later, the *Latona* blew up in a huge ball of flames and sank almost immediately, taking thirty-eight of our men with her.

I regained consciousness around midnight in the wardroom of HMS *Encounter* where the doctor was attending the wounded. I had second-degree burns from my neck up: my lips, ears, and scalp were crisp. These the doctor plastered with tannic acid jelly. But what grieved me more than my wounds was to learn that my cameras and negatives had gone down with the ship. Indeed, my precious Newman Sinclair camera must have acted as a shield, for it saved my face from severe lacerations. It possibly even saved my life. I had a broken jaw, loose and cracked teeth, perforated eardrums, a smashed right wrist, four knuckles blown out of the fingers of my right hand, and several other minor wounds. Enough to make me uncomfortable for quite some time.

On docking in Alexandria, I was taken to 26th Hospital where I remained for two or three weeks. In my hospital ward lay three other burn patients. They were RAF pilots being treated in saline baths – a new treatment for burns. I, on the other hand, received the old tannic acid treatment which had recently been condemned because of the large number of infections that occurred beneath the scabs that formed. Several doctors particularly interested in burn procedures examined me daily. They all agreed that my recovery was remarkable. Ultimately, few scars remained of my ordeal.

Anticipating large numbers of casualties in the major offensive against Tobruk, the authorities were anxious to free up as many hospital beds as

possible by November 1941. By then, I was ready for convalescent care. Bidding a quick farewell to my pals at headquarters, I boarded ship once again. The contrast between my last two sailings could not have been greater. This time I was aboard the liner *Franconia*, still fitted out as one of the Cunard Line's luxury cruise ships. The passengers were either war casualties or doctors and nurses who had been in the Middle East since before the outbreak of hostilities. Realizing that the war was going to last for some time, Cunard decided to unload some of their luxury provisions on us. They treated us to caviar and other gourmet delights and we paid only sixpence for drinks at the bar. As we steamed down the peaceful waters of the Red Sea, we realized this was one convalescence we would never forget.

Durban and Capetown welcomed us like heroes. Indeed, as casualities from the invasion of Tobruk, we enjoyed a certain derring-do reputation. My old home-town newspaper, *The Victoria Daily Times*, later ascribed to me the singular honour of "being wounded while helping to hurl the enemy back during the siege of Tobruk."[1] Our hosts apparently harboured similar notions. They showered us with kindness, proudly touring us around their sun-drenched towns and beaches and generously inviting us into their homes. After the turmoil of war, it was almost a shock to realize that life could still go on normally. But things changed as we approached Freetown, Sierra Leone, where u-boats had just torpedoed a nearby ship. On receiving the signal, *Franconia* hastily weighed anchor and headed south again at full speed. Later, we shaped course westward.

Despite the luxurious nature of our journey, we and the crew knew that enemy action was an ever-present threat. Lifeboat drill took place every day after medical rounds. Although taken seriously, it was also a source of fun. I was put in charge of a lifeboat whose crew included a chief petty officer, four nursing sisters, a couple of RAF pilots, and sundry members of the ship's crew. The commanding officer of the troops, a grand old colonel of the First World War, together with the ship's captain were the inspecting officers. Anyone caught late for drill had to account for his tardiness. Generally, the culprits' excuses took the form of witty monologues which did little to lighten their sentence: usually, a round of drinks at the bar.

About a week after our hurried departure from Freetown, we dropped anchor at Port-of-Spain, Trinidad. We all went ashore to enjoy the town with its beaches, parks, and well-known Pitch Lake. No less pleasurable was our introduction to the famous Planters' Punch which we sampled at the Café de Paris in the company of a rowdy group of Venezuelan revolutionaries.

1 *The Victoria Daily Times*, 6 October 1942.

Returning to the ship, we learned that U-boats had shelled the big oil tanks on the Dutch island of Curaçao. Abruptly, we ceased loading our cargo, weighed anchor, and departed stealthily. Later I learned that the ship which had anchored just beyond us had been torpedoed.

While I was strolling the deck just before nightfall of the same day, a huge flash lit up the horizon. Bells clanged, we made a sharp turn to the south and increased speed. I never did find out what caused that particular explosion. By next morning we were again heading north. Gradually the days got colder until we found ourselves cruising along a fog bank rising from the ice beneath it. This struck a sharp contrast to the warmth we had known, and we were all glad when we turned south again and entered at last the port of Greenock, Scotland. Our luxurious month-long convalescence had come to an end. It was time to return to the harsh realities of a world at war.

In the course of our cruise I had time to reflect on what I had accomplished and where I had failed. I was frustrated at how often my efforts had been foiled by factors beyond my control: equipment unsuitable for the job, poor advance information, poor timing. Yet although I did not achieve the amount of footage I had hoped, I had experienced action in the three branches of the service, all of which offered different problems for the cinematographer. These I noted in an article that appeared in *The Cine-Technician* of July-August 1943:

> War photography is largely a matter of luck; but it also calls for the right equipment for the job, advance information, and the full co-operation of the senior officers. The photographer with the Army should be as mobile as possible; his camera must be light – if possible 16mm. With the Air Force he needs various camera-mounts to fit different airplanes and, again, small, preferably 16mm equipment. He should also be a fully trained air-gunner. The Navy cameraman is lucky – he can accommodate 35mm equipment, and when he gets action, it is generally spectacular.
>
> In whichever branch he serves, the war cinematographer must be keen on his job, have an appreciation of danger, a cool head and a practical understanding of maps and compasses. Wherever he finds himself, he should always remember that good deportment has never been a hindrance.[2]

Nor, perhaps, was a sense of bravado. Among the troops it was often said: "The brave ones shoot the enemy; the crazy ones the film."

2 Osmond Borradaile, "Shooting Action Movies in the African Desert," *The Cine-Technician*, July-August 1943, reprinted by courtesy of *The American Cinematographer*. Osmond Borradaile private collection.

The Tide Turns

The Britain I came back to at the end of 1941 had become a fortress. Approaches to towns and cities bristled with anti-aircraft guns and concrete pillboxes, while every street bore further signs of preparedness: first aid centres, air raid shelters, air raid wardens' posts, auxiliary stations. In school grounds and sports fields members of the Home Guard drilled with rifles and machine-guns alongside civilians undergoing physical training with the Fitness for Service scheme. On main roads, camouflaged military vehicles – armoured cars, tanks, transport wagons, and guns new from the factory – streamed towards the coast to take their place in the defence network. High above, float-barrage balloons stretched as far as the eye could see. Even the peaceful English countryside took up the cudgels. Fields heavily planted to augment food production lay broken up with old cars, wagons, tree trunks, trenches, heavy cables – all obstacles to entrap enemy planes attempting to land. Camouflaged gun emplacements occupied wooded copses and empty cottages while lines of war machines concealed among overhanging trees lay ready to swing into battle at a moment's notice. Planes roared into action from hidden airfields across the land, spiralling into formation, then streaking towards the sea and distant enemy targets. And all along the coast barbed wire, tank traps, pillboxes, and gun emplacements turned former holiday resorts into the first line of defence against an invading foe. Seaside towns swarmed with soldiers, sailors, and airmen. Coastal Patrol planes soared overhead on their twenty-four-a-day duty. Occasional plumes of smoke on the horizon attested to the Navy's constant off-shore vigil. With Britain's defences greatly improved, the Luftwaffe's nightly assaults on major cities gradually subsided at last.

Still on convalescence leave, I returned to a bomb-battered but defiant London from my luxury cruise aboard the *Franconia*. Though required to

report twice a week to hospital for further burn treatment, I was clearly on the mend and anxious to rejoin the war effort. So far I had served in both a civilian and military capacity in Europe, North America, and North Africa. Before hostilities ceased I would film again in Canada and Britain. Finally, as the threat of global conflict escalated in the Pacific, I would join a production unit in Australia, filming on one more continent before war's end.

I returned briefly to Denham Studios to keep in touch with production there. On one occasion I visited the set where Noël Coward was directing his widely acclaimed *In Which We Serve*, an emotional patriotic film charged with propaganda potential. Its plot climaxed in the sinking of the fictional destroyer HMS *Torrin* and the valour of its surviving crew. I met Coward between scenes. He was charming, witty, and well-informed on his subject. To authenticate his own rendering of the torpedoing of the *Torrin*, he questioned me closely about the sinking of the *Latona* – how the attack began, how it sounded, looked, and felt. Later he casually presented me to two other visitors to the set: their Royal Highnesses, Princess Elizabeth and Princess Margaret. Like so many visitors to the studios, they seemed delighted by the behind-the-scenes bustle that went into film production. Practised in the art of easy conversation, they plied me with questions concerning film-making in distant locations and the war in Africa. Meeting within the sheltered cocoon of a studio set, we could have been talking about life on another planet.

Yet in recounting something of those earlier experiences, I was reminded that the war was ever-present and bad news a daily companion. Even as I prepared to pick up my camera again I learned that three of my former assistants under the Korda banner had died in enemy action. Henty Creer was lost commanding a two-man submarine during an attack on the battleship *Tirpitz* in a Norwegian fjord; Hatchard was killed serving with the RAF in North Africa; Bernard Browne went down aboard a destroyer. The waste of those young lives sickened me and I grieved the loss of men with whom I had shared much. It seemed as though a mad dictator had locked the whole world up in an insane asylum and thrown away the key.

Early in 1942 the London representative of the National Film Board of Canada invited me to join its wartime production. Elated at the thought of establishing a home in Canada with my wife and daughter, I accepted eagerly. Within a week the Film Board arranged my release through Whitehall. Yet neither then nor later did I receive a discharge from the British Army, much less the "gongs" that go with it. I still wonder whether they owe me back pay or regard me as a deserter.

With my travel papers in order, I crossed the Atlantic comfortably and uneventfully aboard a refrigerator ship built to carry meat from Argentina and Uruguay to Britain. From New York I wasted no time in catching a train for Ottawa. Here Christiane and Anita joined me from Hollywood where they had lived as war guests with generous friends, Joan and Zoltan Korda. After the vicissitudes of wartime separation, we rejoiced at the prospect of normal family life – even if short-lived. To be near the Film Board in Ottawa, we rented a small cottage high on a hill across the Ottawa River near Hull, Quebec. Here we settled down to enjoy our first Eastern Canadian winter together, complete with skis, toboggan, and a Newfoundland pup too friendly with every passing stranger to ever be of any use as a watchdog.

My engagement with the National Film Board proved disappointingly unproductive. The major problem was my total lack of rapport with the commissioner, John Grierson. I had known of his documentary films in England and looked forward to collaborating with him in Canada, where he had almost single-handedly created the Film Board. But though his drive and vision inspired a generation of filmmakers, his relationship with me was less than cordial. Whether due to extraordinary pressures inherent in his office or to simple personality clash, we could not agree on anything. I first met Grierson about one week after my arrival in Ottawa. My impression was of a busy man eager to assume complete control of all propaganda and information for Canada. As I was ushered into his office, the phone rang and he waved for me to sit down. After a lengthy conversation, he hung up and we shook hands. Symptomatically, the telephone interrupted our handshake. This became the pattern of all our ensuing conversations. In the course of the next few days, amid repeated intrusion, Grierson and I attempted to have an exchange of ideas. I found the experience profoundly unsatisfying. Perhaps Grierson set the unsympathetic tone by asking what I had been doing lately and turning his mind at the same time to other things. When I told him, for example, about my work in Africa for the British Ministry of Information, he cast aspersions on it. Between interruptions and mounting exasperation, Grierson made it clear that he regarded the Ministry as a miserable, useless organization. I disagreed and said I hoped that I could participate in as good a job under the NFB banner. On that discordant note, we concluded our first meeting.

A few days later we again met and Grierson asked if I had any ideas for films. I had three. One was to produce a documentary on the building of the Alaska Highway, a Canada-U.S.A. venture punched through mountainous terrain from Dawson Creek to Fairbanks in response to the threat of Japanese invasion. Grierson's reply was quick and short: "Forget it!

That's an American show!" Before I could express my feelings, the telephone rang. As Grierson hung up, I told him that if he would throw the phones out of the window, I would describe two more subjects which interested me. But before I could do so, he dashed off to another meeting. Only later, with the phones still noisily in evidence and Grierson in an agitated state of mind, was I able to present my ideas. These I fired off as precisely and quickly as possible.

Prior to leaving London, I explained, I had learned from a well-informed friend about a deadly new fighter-plane. A high speed, high or low-altitude bomber or photographic reconnaissance plane, it was to be built in Canada using Canadian material. Grierson tried to interrupt. I asked him to allow me to finish. I told him I hoped to photograph the building and testing of the plane in Canada, fly to Britain with it, and, if possible, go into action with it to record its contribution to the allied cause. Grierson burst out laughing, saying that the idea was good but impossible. No such plane was being planned; even if it were, it would certainly not be built in Canada. The only aircraft construction going on was the production of the obsolete Anson. Who had informed me otherwise? I retorted that he should enquire into the matter – a cheeky reply that reflected my annoyance at his obstructionism. I later took satisfaction in the fact that events proved him stubbornly wrong.

My other idea had arisen from a lunchtime conversation with my brother and a friend of his who was a public relations officer for the Eldorado Mines. From him I learned that the company's Port Radium mine at Great Bear Lake was again in full production after closing down at the outbreak of the war. Although he could give no details, he insisted that the war had created a great demand for their product. With the mine now in full swing, three shifts worked steadily around the clock. I told Grierson that the mine and the wartime use of its ore constituted another dimension of the Canadian war effort. Grierson countered that the NFB had already photographed the mine operations. Moreover, he believed the use of radium was limited to illuminating the faces of alarm clocks and instrument dials in the dark – a minor contribution to the war effort. So ended my few, frustrating encounters with John Grierson.

Not surprisingly, I did not find my NFB assignments satisfying. There were, however, a few exceptions. Notable among these was photographing the story of Norwegian volunteers training in Canada as commandos in preparation for slipping into Norway on covert operations. But my favourite assignment involved trips on a Canadian corvette escorting convoys on the "triangle run" between Boston, Halifax, St John's, Newfoundland, and sometimes beyond. With noted Dutch filmmaker Joris

Ivens in charge of production and Canadian novelist Morley Callaghan as script writer, the film documented Canada's vital role in defending Britain's North Atlantic lifeline against the onslaught of German submarines. This was the famous Battle of the Atlantic in which Canada's navy was coming of age. Curiously, the *Montreal Daily Star* for 2 August 1942 picked up news of my new assignment and noted with journalistic flourish that "sea warfare is nothing new in the book of this compactly-built Westerner who has squinted through camera finders in Hollywood, India, England, Syria, Abyssinia, Holland, at Tobruk, on the Mediterranean and on the Atlantic." After recounting some of my adventures, it ended by citing my ultimate concern: "I only hope this time I don't lose my cameras; they're getting awfully hard to get." Disappointingly, though my cameras remained intact, I never realized my hope of filming allied anti-submarine action, even though Canadian coastal waters, including the inland reaches of the great St Lawrence River, were touted in the press as being "alive with Nazi U-boats." As we now know, they actually were – in August and September of that year, five U-boats penetrated the river to within 170 miles of Quebec City, attacked five convoys, sank seventeen merchantmen, a loaded troop ship, and two Canadian warships. They finally outraged the population by sinking the Sydney-Port aux Basques ferry ss *Caribou*.[1] To think I missed all that!

In October 1942, two years after filming sequences there for *49th Parallel*, I returned to British Columbia to direct production of *Men Without Wings*. This short documentary focused on the often-forgotten ground crews whose technical skills kept the pilots flying: "grease-monkeys," fabric workers, intelligence officers, office staffs, and those manning the "met" (meteorological) stations. Indeed, in their capacity as my assistants, Pilot Officer M.W. McLellan and Leading Aircraftman C.D.M. Bidmead also advanced the cause of the Royal Canadian Air Force by recording its war effort for national distribution. We shot at "Pat Bay," the RCAF station at Patricia Bay just north of Victoria, where once again the scenic beauty and mild climate of Vancouver Island provided ideal conditions for filming. The congenial surroundings, augmented by the unduly flattering optimism of the local press – "much of the history of this war will be depicted in pictures taken by Capt. Borradaile working in the role of soldier-cameraman" – made for a satisfying homecoming to a town of happy childhood memory.[2]

1 See Michael L. Hadley, *U-Boats against Canada: German Submarines in Canadian Waters* (Montreal and Kingston: McGill-Queen's University Press, 1985).
2 *The Victoria Daily Times*, 6 October 1942.

Some months after my last meeting with Grierson when he had off-handedly rejected my proposal for filming production and trials of a top-secret aircraft, I discovered he had been less than forthright with me. Don Mulholland, acting commissioner during Grierson's absence, now asked me to go to the airport to select camera positions for filming a new plane due to be tested the following day. The pilot was the son of the designer and builder of the famous English de Havilland aircraft. On pressing Don about this mysterious test aircraft, I discovered it was the first Canadian-built Mosquito. Remembering my fruitless discussion with Grierson, and angry at his apparent duplicity, I exploded. I asked Don to inform Grierson that I refused to accept the assignment at that late date. Naively, I hoped my refusal to cooperate would trigger an internal investigation into why the NFB had delayed so long in tracking this magnificent aircraft. Of course, no such enquiry ever took place.

To this day I regret that Grierson and I were unable to communicate productively. Had he been more open to suggestion, the NFB archives would have three more films of major historic importance to its credit: the Canadian contribution to the building of the Alaska Highway, the production of the Mosquito (a state-of-the-art aircraft in its day), and the Canadian participation in the development and testing of the atomic bomb. These were major contributions to the allied war effort and should have been recorded by the National Film Board as an important page in Canada's coming-of-age.

Given my deep frustration with the NFB, it was as well that my own page in its service was about to turn. An unexpected cable from the J. Arthur Rank Organization invited me to return to the United Kingdom to photograph a feature film on the RAF: *Signed with Their Honour*. Compared to the feeble effort in which I was then engaged, I considered the assignment of real national importance. Although it meant breaking up our family once again, I knew I must go. My decision was later confirmed when Christiane wrote to me in England that we were expecting a second child. Given the vicissitudes of raising a family in wartime conditions, I needed to work full-time, even if far from home.

Signed with Their Honour was based on the best-selling novel by James Aldridge, a young Australian war correspondent whom I had met in the Middle East. It captured one of the RAF's most heroic epics: how a handful of outdated Glocester Gladiators fought a six-week delaying action against the Luftwaffe through Greece and Crete until the single British squadron was wiped out. An ambitious project, the film ultimately fell victim to the limited resources of the day and was never completed. Yet on my return from Canada to Denham Studios, we already had the green

light to begin shooting the air sequences: the Air Ministry had extended all necessary facilities for the use of aging double-winged and strutted Gloster Gladiators. Meanwhile director Vernon Sewell and his assistant, Philip Thornton, had selected locations around Shrewsbury, while back at Denham all the studio models were built. Most importantly, RAF pilots enjoying a "rest period" after two or three years of continuous flying comprised the cast. Among them were two winners of the Distinguished Flying Cross: Squadron-Leader Richard Acworth, who had earned recognition in the original battle over Greece, and Flying-Officer Tommy Tinsey, home with fifty-two pieces of shrapnel in his legs after flying Spitfires in the North-African campaign. Two New Zealanders, an Australian, and a Canadian were also among them. A closely knit group, the pilots became known as "Soskin's Squadron" after the producer, Paul Soskin. Those men were all top-notch pilots whose exuberant bravado was tempered by the skill born of experience. Entering into the spirit of the production, they crash-dived again and again with startling realism while simulated smoke poured from their plummeting planes. For Squadron Leader Ackworth, looping and rolling above England must have been particularly poignant as he reenacted how 80 Squadron dwindled and died as it fought fiercely over Greece and then Crete. Local townspeople must have wondered about so many crash dives that left no trace of wreckage. As the London *Daily Express* recorded on 14 February 1944:

In a market town in the wilds of north-west England, where the sirens have never been heard, the country folk run from their cottages day after day to gaze up at the strangest series of aerial dogfights ever seen over Britain. The first happened on a market day, when the shepherds were trudging from the hills with their flocks and the farmers were driving their cattle through the streets. Out of the sky fell a queer-looking plane, spinning down, smoke pouring from the fueslage. Following it down were a pack of ancient biplanes – Gloster Gladiators, the RAF's front-line fighters before the Spitfire was born. And one very old Wellington Bomber.[3]

In fact, one attempted simulation did turn rather real when a Gladiator was lost during a forced landing in a hospital yard. The pilot escaped unscathed.

Photographing *Signed with Their Honour* caused me new headaches. Paul Soskin's determination that the film not be "just another picture about the RAF" meant that the air sequences had to be fresh and spectacular. Yet

3 *Daily Express*, London, 14 February 1944.

shooting in the air was never easy. We used three types of aircraft for the cameras: a two-seater Tiger Moth, a 1936 Gladiator, and an early-model Wellington bomber. Like the others, the Tiger Moth in which we mounted a camera was an icon in its way: a double-winged, open-cockpit fabric-covered aircraft driven by a single 175hp engine – less power than a modern car. The camera in the Tiger Moth was swivelled by hand and operated from the open cockpit – no mean task on a frosty morning. On the Gladiator, we clamped the automatic camera onto the lower wing, surrounding it with sacking, silk, and hot-water bottles to ensure against freezing up. Focused at infinity, it aimed through the gun sights. The Wellington – piloted by Canadian Flying-Officer George Bain, the well-known journalist – carried three cameras: nose, tail, and midships. Together they covered each shot from three different angles, showing the action from different vantage points. The manoeuverability of the camera planes, together with their wide rang of speed – from 90 to 250 miles per hour – diversified visual perspectives even more.

I had anticipated that keeping the cameras revved up at 18,000 feet would present a challenge. What I had not foreseen was my own discomfort when shooting down through clouds in an open cockpit. To counteract the sensitivity of my recently healed burns to such low temperatures I contrived a mean-looking leather facemask that no doubt gave me a sinister appearance.

Wartime restrictions added to our difficulties. Prior to each day's filming we gathered around the old iron stove in the dispersal hut to receive our directions. We might be warned, for example, of barrage balloons to the east and told that ack-ack guns would open up on us if we approached the land from the sea. But always playing safe proved next to impossible. By the time we broke through the clouds and formed up to get a shot, we often found ourselves over restricted areas. Then, for a few tense moments, we incongruously became the targets of our own guns.

The risks, the challenges, the camaraderie as pilots and film crew ended the day with a glass of grog at the local pub, all added up to a most enjoyable production period. Yet despite our excellent footage, production of *Signed with Their Honour* was cancelled indefinitely soon after shooting the air sequences. To my deep disappointment the film was never completed and I do not know what happened to our negatives.

Back in London, ideas for short films that I had submitted to the Ministry of Information attracted keen interest but never got off the ground. I was therefore very pleased when Michael Balcon of Ealing Studios – "Mickey," as he was known to his friends and employees – asked me to go to Australia for a film he hoped to produce there. On accepting the

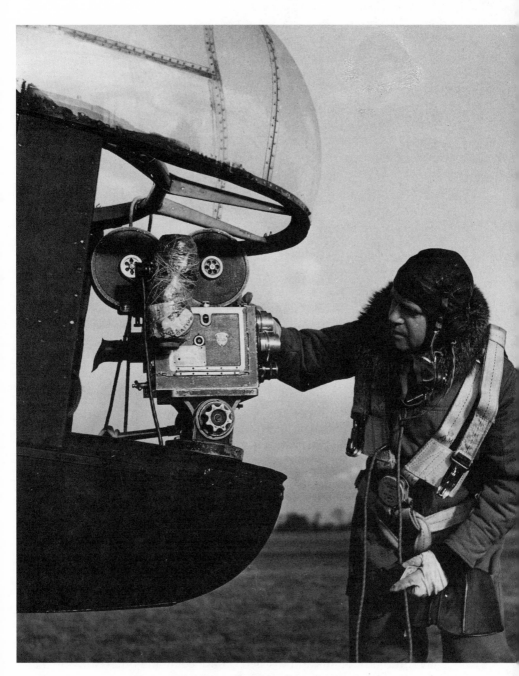

Checking my camera in the tail of the "Wimpy" for air sequences
in *Signed with Their Honour*.

Enjoying a "mug up" with producer Paul Soskin (overcoat), pilots, and crew near Shrewsbury for *Signed with Their Honour.*

assignment I asked to travel via the longer western route: across the Atlantic, North America, and the Pacific. In return, I agreed to deliver to Los Angeles a Mitchell camera that had fallen off a cliff during production in Cornwall and needed to be completely rebuilt. Our arrangement was beneficial to both Mickey and me. I would stop to see my family in Canada, and he would regain a camera at a time when film equipment was in short supply.

After a particularly long delay, arrangements for my passage to Australia were completed. Thus began my seventh wartime Atlantic crossing, this time aboard the *Ferncourt*, a Norwegian vessel, reputedly the largest tanker afloat. A prized U-boat target, she was steamed in the middle of the convoy, with less volatile craft on either side and corvettes darting around the periphery. Despite a couple of stand-to warnings, we enjoyed a quiet crossing to New York. There Bob Flaherty met me, quickly assuming the role of a generous and ebullient host. He took me on a round of his favourite restaurants and insisted on my being interviewed, wined, and dined at the prestigious Savage Club. Between gastronomic adventures he showed me the three- or four-page outline for *Louisiana Story*, the semi-

documentary he had contracted with backing from Standard Oil. I felt that he had a wonderful story: a successful oil strike in the bayous seen through the eyes of a young native boy whose world would be forever changed by the discovery. Bob wanted me to photograph it for him but I was already committed to Mickey Balcon. Yet remembering our close collaboration on *Elephant Boy*, I turned down Bob's offer with regret. Wishing each other well in our respective endeavours, we parted ruefully with a toast or two. After the austere diet of wartime Britain, I doubt I could have survived much more than two days of Bob's hospitality.

From New York I followed a circuitous route to Australia. First to Hollywood – always a homecoming – where I dropped off the smashed camera with the Mitchell company, met old friends, did the round of the studios. Then, at last, to Canada to join my family and meet for the first time our second daughter, Lilla. Blue-eyed, dark-haired, almost a year old and toddling, she was a promise of joy in a war-torn world.

Our reunion took place in Chilliwack, at the heart of British Columbia's beautiful Fraser Valley. Not wishing to remain alone in Eastern Canada, Christiane had moved west after my return to England for *Signed with Their Honour*. She stayed first with elderly relatives of mine in Vancouver, but it soon became clear that the needs of a growing family would be too much of a strain for them. Then Ruth Goodall, Chilliwack's librarian and a friend of mutual friends, opened her home to my wife and daughter for the duration of the war. In this welcoming haven our daughter Lilla had been born in April 1944. I will always be indebted to the dear friends in the States and in Canada – Joan and Zoli and Ruth – who harboured my family during my lengthy wartime absences.

During my short, happy interlude in Chilliwack, I was captivated by the beauty of the surrounding mountains and lush farmlands. In this fertile valley I discovered an abiding peace that would lure me back to settle when I was ready to put my globe-trotting days behind me. But I did not know this at the time. For a few days with my wife and daughters I rediscovered briefly the small joys of family life, that first precious sacrifice on the altar of war. I also learned the ways of steelhead fishing, a sport that would become an abiding passion in later years.

My return to San Francisco for the flight to Australia interrupted this happy interlude. By good fortune I was booked on the same plane as Joris Ivens, the Dutch film-maker with whom I had worked briefly at the National Film Board in 1942. Like myself, Joris had been deeply frustrated by his experience at the NFB and the lack of scope it offered. Now our paths crossed again briefly as we boarded a Consolidated flying boat bound for Australia. As the only passengers we found ourselves hemmed

in on all sides by cargo consisting mostly of medical supplies. With scarcely enough room to squeeze into our seats, we island-hopped across the Pacific – from Honolulu to Johnston Island, Christmas Island, Canton Island, New Caledonia, and eventually Brisbane, Australia. Our brief touchdowns allowed us to stretch cramped limbs and fill our lungs with the warm, fragrant air of the fabulous South Sea islands where for years I had longed to live. Only the brevity of our stops disappointed me.

From Brisbane, I flew to Sydney where I met Harry Watt, the successful Scottish director who had already spent some time in Australia looking for a story. Eventually he had chosen an historic episode: the great desert drive of 1942 when drovers herded one million cattle from the Northern Territories into Queensland to prevent their falling into the hands of the Japanese. The enormity of the challenge captured the imagination. It was the distance from London to Moscow, explained Harry Watt for the British public in *Picture Post*;[4] and from Paris to Moscow touted the *Libération*,[5] doubtless thinking of Napoleon's grand – and failed – campaign. Although the narrative was based on fact, the characters were fictional. The film's Dan McAlpine – played by veteran actor Chips Rafferty – represented the first of many cattlemen who chose to save their herds in defiance of government orders to destroy them. In the course of the 2,000 mile trek to safety, McAlpine and his small band of inexperienced volunteers drove the cattle across the drought-dry desert, the crocodile-infested Roper River, the narrow, precipitous mountain passes. When their own mounts died from eating poison weeds, the drovers caught and broke in wild bush horses. When their thirst-crazed herd rampaged at the smell of water, the same unlikely heroes miraculously held up the stampede, thereby saving the cattle from the sucking mud of a deadly swamp. All of these events, which made for such exciting footage, had been part of the 1942 experience.

In choosing an outdoor story, Watt wanted to show the limitless horizons and sun-drenched beauty of Australia. It was a happy decision. The spectacular scenery provided a dramatic backdrop to the tenacity of the human players caught up in international geopolitics.

The production of *The Overlanders* challenged us all. We shot in the Northern Territory with its limitless spaces broken only by sudden craggy mountains. As the first film crew in this isolated area, we faced considerable organizational difficulties. With no facilities nearby we built our own roads, stockades, and film sets. We worked six days a week, eleven

4 Harry Watt, *Picture Post*, London, 18 May 1946, 12.
5 *Libération*, Paris, 24 October 1947.

hours a day. For four-and-a-half months we lived in army tents and ate army rations. We bounced to and from location in military trucks over roads that were little more than cattle tracks. Although we had a complete production unit, including a portable projector to see our rushes, we often had to endure long delays in receiving reports from the laboratory – a frustration familiar to me from earlier locations.

One particular challenge was the filming of the stampede. The suspenseful highlight of the film, it had been part of the original drive. To emphasize the courage and tenacity of the drovers who had to stop their demented herd from reaching the swamp, I decided to make the scene as visually dramatic as possible. We dug a pit about four feet deep into which I knelt behind my tripod. The crew then covered the opening with railway ties, leaving just enough space between them for me to aim the camera. As the thundering hooves roared over my head, I was too preoccupied to worry unduly about the safety of my temporary shelter. In fact, only one steer stumbled and caught its leg between two railway ties. Luckily for both of us, its predicament was short-lived. The momentum of the rest of the herd swept the poor beast along, leaving me to complete the stampede sequence from my unique vantage point.

From my perspective, the greatest obstacle in filming *The Overlanders* was the dust. As the herds moved across the great expanse of Central Australia they kicked up a thick fog of fine, choking inland dust. It found its way into everything, specially threatening the gears of the cameras. In fact operator Karl Kayser and I got to a stage where we alternated cameras after almost every take – one for shooting, one for cleaning, then switch. Only when the wind blew did the dust subside, allowing us to take close-ups of the cattle. Otherwise we did without – no wind, no close-ups. With its dust and flies Central Australia reminded me of North Africa and Ethiopia respectively. But the weather proved ideal: no humidity or excesses of heat or cold to threaten the film stock. I only regretted that wartime constraints and restricted availability of equipment and processing made it impractical to shoot in colour. Only then could I really have done justice to the magnificent outback of the Australian bush.

Its own peculiar challenges notwithstanding, *The Overlanders* remains one of my favourite films because of its authenticity. Unlike *49th Parallel* where British actors unconvincingly portrayed Canadians, or *Elephant Boy* where plummy-mouthed expatriates assumed the parts of the Maharaja's mahouts, *The Overlanders* was played by local people. While some had no previous acting experience, all had an affinity with the characters they portrayed. Dialogue was direct, accents genuine, costumes simple, make-up minimal. The actors took part in all their scenes without recourse to

With hat and reflector for the crossing of the Roper River in *The Overlanders*.

doubles or back projection. Nor was there any coddling of personalities. Like the rest of us, the performers looked after their own tents, laundry, and wardrobes. Whenever an extra hand was needed, everyone pitched in to help. The shooting of the cattle stampede and river crossing were cases in point. Although my background in filming *North of 36* in Texas in 1924 proved useful in planning these difficult sequences, without the droving experience of the actors, those scenes could not have been successfully carried off.

I enjoyed working with the all-Australian cast. Six-foot-six Chips Rafferty was a man of many parts, well-suited to the role of the boss drover. Of his forty-two previous jobs, thirty-six had been in ranching. Now a seasoned actor, he had already appeared in a number of Australian productions. Lanky, drawling, tall in the saddle, he won acclaim as "the Australian Gary Cooper" for his portrayal of the hard-bitten Dan McAlpine.

Other players were similarly well cast. Twenty-year-old Daphne Campbell, an army nurse with no previous acting experience, looked magnificent on horseback and epitomised the freshness of young Australian womanhood. Her opposite number, real-life soldier Peter Pagan, competently portrayed an ex-merchant marine sailor. He and Daphne provided the love element generally considered essential to a production's success. Imposed on the story with an eye to the distributors, the love sequence

struck me as needlessly disruptive. More satisfying for me were the roles played by twelve-year-old Helen Grieve as a daughter of the outback, or John Fernside as an irrepressible, imbibing cowpoke, and aboriginal Clive Combo as a top-notch drover. Clive's presence as drover and actor added a particular element of authenticity to the film – of the herds we used, many had been entirely mustered and driven by aboriginals.

In many ways the cattle were the real stars of the show. Month after month they plodded on a few miles each day, clambering up mountains, crashing headlong over precipices, straining across the pitiless desert in search of brakish water-holes. Accustomed only to drover and horse, they initially became nervous during production and stampeded whenever we set up the cameras near them. Yet even in the midst of charging cattle I knew if I stayed still they would always swerve to keep clear of me. Only were I to panic and run would they have had difficulty avoiding me.

On one of my rare days off, I persuaded a young aboriginal lad to take me on a "Walkabout." We caught, cooked, and ate witchity grubs – a kind of maggot that lives on the roots of certain shrubs – and an iguana. Delicious! I had taken along a water bottle and was glad of it because of the heat. Yet I had a hard time persuading my shy companion to drink his share. That one memorable day gave me some insight into the traditional life of the aboriginal people and their innovative husbanding of the resources of the so-called "Dry Heart" of the continent. I felt sure that one day, given the soil and climate, irrigation would transform the region around Alice Springs into the Southern California of Australia.

The Overlanders proved timely in that it appealed to public demand for realistic films. Coming out of the war years, people grew impatient with artificial values and situations. They wanted to learn about the lives of ordinary men and women in realistic settings. Richard Trevor, writing from London for Perth's *West Australian* in October 1944 saw it this way:

> In their present mood there is no doubt that British screen audiences prefer realism and stories based on the drama of the lives of real people rather than the usual type of studio escapism – and they are not averse from seeing new backgrounds and open-air settings ... British filmgoers ... would like to know a great deal more of how the average Australian lives and the difficulties he is up against![6]

In its authenticity *The Overlanders* flagged new directions for filmmakers to follow.

6 Richard Trevor, *West Australian*, 12 October 1946.

It also became the first of many good films made in Australia with British cooperation. At the time, Harry Watt envisioned future exchanges between Britain and the Dominions. As he wrote:

> By creating a solid foundation for a film industry in a young country like Australia we can establish the cultural roots that transform a country into a nation. By exchanging ideas we can smooth out differences. And finally and practically, we can reinvest the monies earned by British films, thus creating employment and national income, instead of transferring it back to London, as American money goes back to Hollywood.[7]

When the film was released the *Sketch* of London echoed Harry's vision:

> At last the movie moguls of Metroland are beginning to appreciate that Britain has an Empire, that the Empire has stories, and that these stories will delight many nostalgic travellers, and need not be without interest even to the homebound clerk who has never journeyed further afield than far-flung Margate. It has occurred to several of our producers lately to send units abroad to make films in our Dominions and Colonies, and I understand that the practice is likely to increase and become something of a policy. If all these new Empire films are as refreshing as *The Overlanders*, nobody should complain.[8]

Of course, as the world map shifted to accommodate changing political realities, new "Empire films" bore little resemblance to Alexander Korda's successful pre-war productions. New times and sensitivities called for new approaches: documentary-type narratives about current life met the new criteria.

I have always believed that we in Canada would do well to follow the *Overlanders* formula – realistic material, natural characters, authentic setting, and local talent – in establishing an independent film industry in this country. The Canadian potential for stories and talent seemed at the time unlimited. It still does. And international acclaim for *The Overlanders* attested to the public's appreciation of an authentic rendering of the human struggle in all its manifestations. Yet although I would eventually offer my services to the building of an independent Canadian film industry, my efforts in this direction were ultimately frustrated. Reluctantly, I had to recognize that I lacked the promotional skills of an Alexander Korda to bring the project to life.

7 Harry Watt, *Picture Post*, London, 18 May 1946, 12.
8 *Sketch*, London, 6 October 1946.

As work on *The Overlanders* drew to a close in the late summer of 1945, we heard that atomic bombs had been dropped on Hiroshima and Nagasaki and that Japan had agreed to the terms of surrender. The war was over. Within days of completing our production I flew back across the Pacific, stopping over in New Zealand, Fiji, Hawaii, and briefly, San Diego. With Christiane and the children already home in England I was impatient to join them. The dark clouds of war had lifted and new horizons beckoned.

Safari Scenes
and Scottish Mists

The spell of home life I had longed for after the war soon drew to an end. Scarcely had I rejoined Christiane and the children at "The Den," when I received a call from Zoltan Korda in Hollywood asking me to go to Africa for *The Macomber Affair*, a United Artists production. I was to contact his brother Alex concerning film crew and travel arrangements. Although Zoli had as yet no script, he would base his next film on Ernest Hemingway's short story "The Short, Happy Life of Francis Macomber."

This savage story of contempt, cowardice, and bitter marital strife unfolds within the tensions of an ill-fated African safari. When the lacklustre Francis Macomber turns and runs during a lion hunt, his wife scorns him by initiating an affair with her husband's hired guide. Unbearable pressure born of disdain, cruelty, and humiliation plays itself out within the brutal context of a big-game hunt. Just as Macomber redeems himself in an act of courage, a shot rings out and he falls. Did his wife shoot to kill a charging buffalo? Or did she murder the husband she could no longer dominate? His death remains as ambiguous as her intention.

While the wild sweep of the landscape and the ruthlessness of the hunt mirrored the escalating passions of the film, the actors themselves never set foot in Africa. I was therefore responsible for all the African footage, including roaming herds of wild animals, rampaging buffalos, a charging lion, thrilling hunt scenes, and – in Hemingway's words – the safari camp "pitched under some wide-topped acacia trees with a boulder-strewn cliff behind them, and a stretch of grass that ran to the bank of a boulder-filled stream in front with forest beyond it." Against such authentic background material Gregory Peck, Robert Preston, and Joan Bennett would enact the tortured relationships of Hemingway's unhappy triangle without actually experiencing a safari. That left me scouring the African countryside for doubles for the safari scenes, procuring costumes for them, and sending

duplicate outfits back to Hollywood for the stars.

From the producer's point of view, the assignment no doubt looked like just another holiday for me: a quick dash to Africa to capture on film its boundless landscape and abundant wildlife on film, and home again almost before I had time to unpack my bags. Yet to me the difficulties were all too evident. Once again I was to work in a distant location with none of the technical backup that studios and laboratories provide. Even transportation could become problematic. Knowing all this, I hoped to take a fair-sized crew along with me, including the doubles. Postwar restrictions soon dashed these expectations. The Ministry of Transport granted us only three passages to Central Africa, while Treasury regulations limited the amount Alex could invest in the project to the sum of 10,000 pounds. Faced with such constraints, I almost turned the assignment down. On reflection, however, I recognized yet another challenge I wanted to beat. Settling for the three air tickets and the ten grand, I boarded a plane for Uganda. My assistants John Wilcox and Freddie Francis followed a week later with cameras and film.

At Entebbe airport an old friend from the *Sanders of the River* days met me. "Squash" Lemon had again agreed to put his knowledge of the country and people at my disposal. But our very first effort almost ended in disaster during a drive to the country to show me a large herd of buffalo. Easily located grazing beside the road, the beasts suddenly broke into a gallop alongside us on our approach. This impromptu race thrilled me, for it perfectly simulated the buffalo stampede required for the film. But my elation was cut short when one of the beasts lunged abruptly across our path and collided with the front of the car. Crumpling the vehicle on impact like an accordion, it sent us careening to a thundering stop. Beneath the wreck sprawled the buffalo, horns protruding from one side, hind quarters from the other. As "Squash" and I shakily reached for the doors the beast thrashed about beneath us, bouncing us about in the car like beads in a rattle. Amid a cloud of dust the buffalo extricated himself and galloped off to join the rest of the herd, apparently none the worse for its adventure. My encounters with the four-legged stars of *The Macomber Affair* had begun.

Despite Squash's assistance, I soon realized that Uganda simply could not offer me the facilities I needed to organize a safari, hire doubles, and procure costumes. Once John and Freddie had arrived with the cameras and film, I moved us on to Nairobi, Kenya, where support was more readily available. Here another member joined our crew. A New Zealander named "Babe" – her full name eludes me – served as secretary, continuity girl, and indispensable assistant to us all. Without her skills, resourceful-

ness, and quick assimilation of Swahili, our job would have been done only half as well.

Official help ultimately made it all possible: permits from the game department, a small generator from the military, hired help from manpower offices. We faced greater difficulty locating the doubles, for few employees in those early postwar days could leave their occupations to play at being movie stars. Nor did we readily find men measuring up to the sex appeal of Peck's and Preston's six-foot-two frames. Fate ultimately smiled at our endeavours, for I chanced upon a likely planter who thought a bit of acting might be fun. He convinced an equally engaging friend to join him. By this time Babe had discovered an adventursome female for the third stand-in part. We costumed them and air-mailed a duplicate set of the clothing to Hollywood. All three doubles proved excellent.

We engaged a safari outfit to furnish the equipment and personnel needed to ensure a comfortable camp: cooks, drivers, tents, cars, trucks, bathtubs, refrigerator. Once all was assembled, we moved off to a location in the Masai game reserve where we hoped to find all the animals required for the film. Haste was essential, for we knew as we left Nairobi that the rainy season would break within three weeks, turning the whole region into an impassable swamp.

We set up camp in the game reserve surrounded by beautiful grazing land. Here flat-topped acacias grew alongside candelabrum trees rising like giant cacti to a height of thirty to forty feet. Across this rich landscape roamed a variety of fauna: lions, zebras, giraffes, wildebeests, wild dogs, wart-hogs, and others. Fortunate in locating the animals we had come so far to find, we filmed scenes with lions, buffalos, impalas, and mixed herds. Our atmosphere footage captured the vast sweep of grasslands those magnificent beasts roamed.

Once again I found myself working without a script. I didn't require one covering all the camera angles and lengths of shots, for my preference has always been to build as I go along. I did, however, need an outline to establish the number of shots and to give continuity. With only a copy of Hemingway's short story in my pocket, I felt free to carry the right tempo through a number of sequences. I watched for animal shots that could be worked into the Hollywood shooting. By intuiting how a zebra hunts or a lion stalks I could position the camera to best get the action, for the action was the story. By laying out a rough outline of sequences for the doubles, I then shot "off the cuff" in complete sequences.

For much of my filming I used my own Arriflex camera. A friend had found it on a battlefield in North Africa and had been happy to sell it to me when he needed some cash. I already knew of it by reputation. As the

first practical electric camera, the Arriflex had been the envy of Allied cameramen throughout the war. Built for the Luftwaffe, it was specially designed for filming in cold temperatures. Light weight (twelve pounds), with a continuous through-the-lens viewing system and simple film movement, it could be changed quickly in the heat of action. In Nairobi I had a shoulder mount made for it to hold it steady. Comfortable to use and relatively quiet, the Arriflex allowed me to film herds of wild animals without disturbing them.

During our time in camp we saw no one except the occasional solitary Ndorobo hunters. Any we encountered seemed to be on a routine walk to trace the movements of animals and locate bees storing their honey. They gave the impression of a shy, tough, but friendly and happy people. They carried spears, bows, and an assortment of arrows, most of them treated with a deadly poison.

Just before breaking camp to return to Nairobi, I visited the nearest Masai "manyatta," or village. It was typical of transient Masai settlements, which must frequently shift their cattle to fresh pastures to avoid over-grazing. The village consisted of simple dwellings and a compound for the cattle. All around the outside a high fence of cut thorn branches protected both man and beast from the nightly hunt of marauding lions.

I set off for the village with my truck-driver, an interpreter, a Ndorobo guide, and a few pounds of tea as a gift. As we approached the settlement, we met four stalwart young Masai men walking in single file toward open pasture where cattle were grazing. Stopping to greet them, we admired their beautifully made spears. The men's bodies gleamed from the mixture of red dye and grease which completely covered them. Their smiles revealed startling white teeth and their hair, encrusted in red clay, hung in two shoulder-length braids. Lightly clothed, they wore a length of reddish-brown cloth loosely draped over their torsos, the ends tied in a knot over one shoulder. Our encounter was necessarily brief for, as they shyly but proudly informed us, they had cattle to tend.

Though allowed to enter the precinct of the thorn fence surrounding the village, we were forbidden access to the houses. We nevertheless witnessed the bleeding of a bullock, a daily ritual essential to the diet of the Masai. Tying a thong around the animal's neck and pulling its head to one side, a herdsman then shot a small arrow into the jugular vein. As the blood gushed out, a woman collected it into a gourd. When she had collected enough of the precious fluid, she pressed the wound closed, sealing it with a handful of mud or manure. Combined with milk, the blood constituted the Masai's basic food. The fine physiques of this proud Nilotic people attested to the sufficiency of their simple diet.

Pressed by the rapidly encroaching rainy season, I could not tarry to witness the herd of cattle being driven into the enclosure for the night. Clouds were already gathering as we packed up camp next morning. Scarcely had we stopped for lunch at the roadside when the first heavy drops began falling and the deluge burst. Our successful safari had drawn to a sudden close. From start to finish my assignment had lasted only one short month – a record for me. Karl Struss finished filming *The Macomber Affair* in Hollywood and Mexico.

On leaving Africa I already knew where my next assignment would take me. While on safari I had received a telegram from Alexander Korda asking me to photograph *Bonnie Prince Charlie* in the Highlands of Scotland. From the heat of the equator, the cool of the Highlands had seemed particularly inviting. But when I reported in London, Alex told me that the starting date for *Bonnie Prince Charlie* had been delayed. Instead of leaving for the Highlands of Scotland, I was to set off for Hollywood to learn about a new Technicolor process called Monopack, not then available in England. It essentially consisted of a low contrast Kodakchrome-type film whose separation negatives could readily be intercut with original three-strip negatives. Because it did not require a cumbersome three-strip camera, Monopack afforded the ease of movement essential to location filming. As might be expected, photographing a range of splendid tartans posed a special challenge. Thus, to ensure consistent results, I took with me samples of the different plaids we intended to use. These swatches facilitated photographic testing of the new process with Technicolor technicians.

Zoltan Korda was still working on the interiors of *The Macomber Affair* when I visited him in Hollywood. Everyone seemed pleased with the production and congratulated me on the footage shot in Africa. Hemingway, who knew Africa well, delighted me by calling it first class. My brief visit to the studios was my last involvement with *The Macomber Affair*.

London Film's first feature production after the war, *Bonnie Prince Charlie* aroused considerable interest. Recalling the wide appeal of Alexander Korda's earlier historical films, the press eagerly reported on the extensive preparations preceding production. These were considerable. If, as his critics claimed, Alexander Korda allowed himself to "hot up" history, he was nonetheless a stickler for authentic detail. As with *Four Feathers*, so with *Bonnie Prince Charlie*: he went to considerable trouble to get the props right. He consulted widely with experts to ensure that the costumes and arms of the period replicated historical specifications.

Drawing on war surplus items, artisans made clan and personal pipe banners from dyed parachute silk. The Stuart standard presented a par-

ticular challenge. The original, made by Jacobite supporters in France, had been burned after Prince Charles Edward's defeat at Culloden. With no description remaining, the props department produced a twenty-four-foot replica based on details supplied by the Scottish King of Arms. However authentic, it billowed proudly over the assembling "clansmen" when we filmed the raising of the Jacobite standard at Loch Shiel.

Other props specially produced for the film included hundreds of targes (or shields), broadswords, dirks, muskets, and fifty-four sets of bagpipes – all true to period detail. The company of Kinloch Anderson wove special tartans of the '45 period while the curator of the Scottish National Portrait Gallery prepared authentic sketches of chieftains and clansmen.

With so much attention to detail, the production should have been a success. But props alone can never ensure a good film and our venture seemed ill-fated from the start. David Niven, contracted to play the lead role, was tied up with other commitments until the New Year, but many others were waiting to begin. One thousand soldiers on loan from the army were encamped near Fort William. Fitted for costumes and with their hair grown long they were ready to play the part of the clansmen of '45 rallying to their Prince's call. Similarly, highland ponies and cattle had been assembled to give authentic atmosphere to the location sequences. With so many resources on standby, Alex decided that we could no longer wait. In the first week of August 1946, the largest crew with which I ever worked left London for Scotland.

The contrast between the location filming of *The Macomber Affair* and *Bonnie Prince Charlie* could not have been greater. In Africa, with scenes that were much more difficult to shoot, I had a crew of only three experienced technicians. In Scotland, by contrast, dozens of crew members stood by to do a much simpler job. In addition we had two location directors, Herbert Mason and Geoffrey Boothby, my old friend from *The Drum* and the Ethiopian campaign.

Many encumbrances annoyed me. Whether because of union requirements or the producer's desire to train new technicians for future productions, we found ourselves burdened with an overstaffed unit that impeded efficient filming. One seemingly trivial incident intruded on my professional freedom. According to union rules, only electricians were entitled to handle the switch on an electrical apparatus. This new regulation meant I could no longer switch my own camera on and off. Unused to being dictated to on how to operate my equipment, I called a meeting of the crew and informed them in no uncertain terms that no one but myself would ever start and stop my camera. With their hidebound union attitude, I added, the crew would hinder rather than help the film industry

In Scotland, 1946, for *Bonnie Prince Charlie*. Too many crew members assembled for a relatively easy job. (OHB with hat)

in its efforts to recover prewar levels of production. Such assertions probably did little to enhance good working relationships. Nor, from my perspective, did the increasing number of tea breaks – always called at the most inconvenient times.

Despite the beauty of the landscape, I was glad when we finished our shooting in the Highlands and returned to London, where Robert Krasker completed the studio photography. When released in early 1948, *Bonnie Prince Charlie* was roundly panned by the critics, who found it too long, too dull, and too improbable. As the critic of the *New Yorker* wrote:

> The picture is not lacking in moments of unconscious levity, what with David Niven rallying his hardy Highlanders to his standard in a voice hardly large enough to summon a waiter.[1]

1 Cited in John Walker, ed., *Halliwell's Film Guide*, (New York: HarperPerennial, 1995), 138.

Gerald Garret, looking back in 1975, was much more acerbic:

> Time has made it the film industry's biggest joke. But the joke turns a little sour when one reflects how extravagance, recklessness and sheer bungling administration during the fat and prosperous years left the British film industry so poor and vulnerable when the hard times came along.[2]

Remembering the overstaffing of the location filming, I have to concur. Yet the *West London Observer*, after roundly complaining that the film was "about as compelling, exciting, vigorous and stirring as the dullest of dull history manuals," did acknowledge at least some of its achievements: "The only persons who come creditably out of the piece are Margaret Leighton as Flora MacDonald, and Osmond Borradaile, whose exterior photography is magnificent."[3] But, despite our combined efforts, Prince Charles Edward Stuart's second 'return from exile' was no more successful than his first.

Back in London I reminded Alex of a promise he had made in 1934 on my return from the *Sanders of the River* locations in Africa. At that time I had proposed filming a documentary on the world's longest river, the 4,000 mile Nile. I had conceived the idea in the course of the most comfortable and interesting air passage I had ever experienced: a slow, low-flying journey from Cairo to Juba. I flew part of the way in an Empire flying boat and completed the journey in a Hannibal biplane. Although both aircraft were ungainly, they offered a good view of the magnificent waterway below. As occasion warranted, the pilot would descend even lower than our cruising altitude of only a few hundred feet. We could then clearly see the historic and natural phenomena that made the region unique: the ancient temples of Abu Simbel, huge herds of wild elephants roaming the plains, crocodiles basking in the sun.

This enthralling flight convinced me that a film should be made tracing the journey of the Nile from its three principal sources: at Ginga, Uganda, where the waters of Lake Victoria spill out to form the main flow of the White Nile; at the Mountains of the Moon near the equator, where melted snow and ice tumble down through exotic vegetation to eventually join the White Nile; and at Lake Tsana, high in the mountains of Ethiopia, whose clear waters form the Blue Nile. On reaching Khartoum, the Blue Nile loses its lovely colour as it joins the milky White Nile. Here the convergence of those two streams, along with their many waters, becomes at last the River Nile.

2 Cited in ibid.
3 *West London Observer*, undated, Osmond Borradaile collection.

Sharing rare home time and mementoes with Christiane before leaving for the Antarctic.

The contrasts of this historic waterway and the regions through which it flowed impressed me deeply. As the Blue Nile blended into the White, so did ancient and new civilizations meet and converge. In this land of antique ruins there co-existed both archaic and modern ways of irrigation, of tilling the soil, of harvesting crops. Villages which had remained unchanged since the time of the Pharoahs bore testimony to a timeless past. Yet Cairo had burgeoned into a modern, bustling city almost beneath the gaze of the enigmatic sphinx.

Although Alex had once promised that I would go back to capture all this on film, the day I went to see him he insisted that other jobs must come first. Obviously I had timed my request badly. Our conversation escalated quickly from discussion to discord, to my being fired. Never had I entered and left Alex's office in such short order.

As I headed home jobless to Chalfont-St-Peter, I stopped by Ealing Studios on the chance of finding work. There I saw the head of Ealing productions, Mickey Balcon, for whom I had gone to Australia to photograph *The Overlanders*. As it happened, Mickey was in the planning stages of a

film on Captain Robert Scott's ill-fated dash to the South Pole. He intended to send a crew to the Antarctic to bring back good atmosphere footage as well as staged shots using doubles. If I would like to go, the job was mine. I naturally jumped at the chance of visiting that mysterious, little-known continent. But I did so shaking my head in disbelief. Even for a vagabond like me, changing my sites from the Nile in the morning to Antarctica in the afternoon called for major reorientation. Hurrying home with my news, I could only anticipate Christiane's bewilderment at the day's reversal of fortune.

To the Antarctic ...

In 1946 Antarctica was still a mysterious continent to most of the world, a distant, hostile region known only to a handful of explorers and scientists. Ealing Studio's Sir Michael Balcon was determined to change all that. He wanted to show the story of Captain Robert Scott's doomed 1910 race to the South Pole over the frozen expanses and ominous mountains of that vast, unforgiving terrain. To this end, he sent a crew of three to Antarctica: myself, my assistant, Bob Moss, and our technical advisor, David James.

Once again, I had a small crew for a big job. In over six months we traveled some 30,000 miles to regions where hostile weather conditions seemed bent on frustrating our endeavours. Yet despite endless setbacks we achieved what we set out to do. Unaccompanied by actors, we produced the footage that gave the film its authentic background. Other locations would be in Switzerland and Norway. These distant realistic settings made *Scott of the Antarctic* the most ambitious British film to date.

Shortly after my momentous meeting with Mickey Balcon, he informed me that the Falkland Islands Dependencies Expedition Force had agreed to provide transport, lodging, and assistance for three members of the film crew. The role of the Expedition Force (or FID) was to take supplies and relieving scientists to a number of widely scattered Polar research stations. For this purpose the Colonial Office had chartered the 325-ton *Trepassey*, a vessel of extra-sturdy construction well-suited to making her way through the ice of the southern latitudes. Built in Newfoundland, the *Trepassey* had a Newfoundland crew. Her skipper, Captain Burden, was a former sealer, while the two mates and engineer had just been released from the Royal Canadian Navy.

With *Trepassey* due to sail within days, I hurried to have my cameras checked, tested, winterized, and stowed aboard, together with a replica of Scott's sled and clothing. For this location I decided to take three cameras:

a Mitchell, a Newman-Sinclair, and my own Arriflex. I knew we would have to watch the Mitchell and the Newman-Sinclair carefully during the initial shooting because lubricating oils inclined to freeze quickly at sub-zero temperatures. I felt no such concern for the Arriflex, having already obtained good results with it in the air at minus fourteen degrees.

Assistant cameraman Bob Moss was to accompany the equipment on the long journey to the Falkland Islands. David James and I would fly down to join him there a few weeks later. David's previous experience as a member of a British expedition stationed at Hope Bay – our eventual base of operations – made him an able technical adviser. I was always reluctant to accept a crew with whom I had no experience but, in this instance, we three worked well together to complete a rather formidable assignment. We set off with no script other than Scott's diary, and no doubles but ourselves. Small wonder that our excitement at the prospect of "discovering" a new continent was mingled with a healthy dose of apprehension.

The original plan had been to shoot *Scott of the Antarctic* in black-and-white, which some thought appropriate for large expanses of snow and ice. Convinced that colour would enrich the pictorial value of the film, I strongly disagreed. Paintings by Dr Edward Wilson, the biologist accompagning Scott on both his Antarctic expeditions, fortunately convinced the producers that snow and ice, far from being a uniform white, could come shimmeringly alive with reflected colours of the spectrum. Yet, shooting in colour in Antarctica posed production problems that ultimately doubled the scope of our assignment.

The first difficulty was the physical impossibility of our three-man unit carrying a cumbersome three-strip camera up and down the ice faces of Antarctica. The only other way to get colour would be to shoot with Monopack, which I had already used for *Bonnie Prince Charlie* and which could be exposed in an ordinary camera. But the obstacle here was that not even Technicolor staff had any experience with Monopack in sub-zero conditions and they could not guarantee success. As an alternative, Ealing proposed a technique that had been used in wartime documentaries: filming the Antarctic sequences on 16mm and enlarging them later. Technicolor, however, were no longer using this procedure and felt that the chances for success were still better with their new product. After considering all the technical advice, Mickey Balcon decided to gamble on Monopack. But to ensure that we came back with usable footage, he directed me to shoot back-up scenes in black-and-white as well. As if this were not enough, I was further charged with making a black-and-white documentary on the operations of the Falkland Islands Dependencies Expedition. In effect, I set off for Antarctica to shoot three films in one.

In many ways, my journey was one of uncertainty. Between picking up 10,000 feet of Monopack in Montevideo, Uruguay, and delivering it personally for processing in Hollywood some four months later, I would not know whether the Antarctic footage was worth anything at all. It was a long time to remain so uncertain about the success of our venture. And a long time for Ealing Studios to wonder whether they would ultimately complete *Scott of the Antarctic* in colour or in black-and-white.

The period of suspense that accompanied me throughout this assignment began well before I reached the Antarctic. Monopack being as yet unobtainable in England, I flew to Montevideo to pick up the stock which Technicolor was shipping to me from Hollywood. While awaiting its arrival, David James and I spent three or four delightful days enjoying the bounty of Uruguayan hospitality. After the restrictions of postwar Britain, it seemed almost excessive. My sense of guilt on sitting down to a steak equal in size to a full week's ration at home was almost as keen as my anxiety about the film stock, which had not yet arrived. Yet I need not have worried. With almost precision timing, the shipment reached me just hours before my departure for Port Stanley aboard the Falkland Islands Company vessel ss *Lafonia*.

We reached Port Stanley in late December. There we found *Trepassey* safely docked, with Bob Moss and our equipment all in good shape. We were just in time to accept an invitation to spend Christmas at Government House as the guests of Governor and Mrs Miles Clifford, themselves recently arrived from a posting in West Africa. Their hospitality added much cheer to our introduction to those barren, windblown islands.

Our film unit was to sail south to our base of operations in the ss *Fitzroy*, a small Falkland Islands steamer that had been chartered to help restock the FID bases. Before heading south, however, *Fitzroy* had to make a brief round-trip to Punta Arenas, Chile. I was delighted when her skipper, Captain Freddie White, invited the three of us to go along. The weather was perfect for the two-and-a-half day's voyage. We enjoyed bright sunshine and a flat sea through the Straits of Magellan where school after school of playful black-and-white porpoises frolicked around our hull, eventually guiding our ship to the entrance of Punta Arenas harbour.

The world's most southerly town, Punta Arenas was charming. Well laid-out, it boasted a manicured park, a proud statue of Magellan, and a fine restaurant featuring delicious Chilean wines and centoyas, or big sea spiders. We stayed for two delightful days as the skipper's guests on a large sheep ranch managed by his cousin. The comfortable home and garden nestled in the shelter of a huge slatted structure that towered over the two-storey house to protect it from strong seasonal winds. In the distance

the southern Alps rose beckoning above the western horizon. It would have been tempting to stay, but our schedule brought this enjoyable interlude to a close and we sailed back to Port Stanley where *Trepassey* was loading supplies for the trip south.

Unforeseen setbacks, including a broken generator, delayed *Trepassey*'s departure. But on 2 January 1947 we at last filmed her casting off her lines and setting her course for Antarctica. She carried supplies to keep the bases stocked for a full year: food, fuel, books, instruments, and other essentials. Also on board were the relieving scientists who had volunteered to work in the various Polar research stations, carrying out surveys and meteorological work and collecting specimens of minerals, flora, and fauna. Most of these new arrivals were recent graduates of Oxford and Cambridge. Before their own replacements arrived, they would all have spent two years in a tiny, God-forsaken base.

To my consternation, *Fitzroy* too experienced delays. But at last, on the evening of 12 January, a small crowd gathered on the jetty to wave us off. As we headed southwards, I wondered what sea conditions awaited us on our journey. During our delay we had already seen the fate reserved for earlier navigators. While waiting for *Fitzroy* to depart, some of us had rowed around the harbour of Port Stanley. We beheld a desolate scene: the hulks of old ships that had fallen victim to the fury of wind and waves. Carried by the currents in the direction of the Falkland Islands, the crippled vessels had been towed into port, some to be repaired at their owner's expense, others to serve as depots and eventually rot away if no money for restoration was forthcoming. The sight was not encouraging.

Yet the Antarctic summer being full upon us, we sailed at the most propitious time of the year. Indeed, timing had been a major consideration in our venture. To avoid the winter months of continuous darkness, it was essential that we conclude our shooting before the freeze-up made departure impossible. If all went well, we would return in March. Tiny Port Stanley, I reflected on departure, would look like a metropolis when we called in on our journey home.

It took us nine days to reach our base of operations at Hope Bay on the northern tip of the Antarctic Peninsula. We experienced mixed weather on our voyage southwards and saw new and exciting territory. The first day broke sunny and clear, enabling me to lounge on the upper deck and watch the effortless flight of our escorting albatross. But by midnight the barometer had dropped and we were surrounded by dense fog and a rolling sea. As a southeast gale cleared the fog away next morning, falling temperatures gave rise to occasional snow flurries. For the following two or three days, strong winds tossed *Fitzroy* about uncomfortably.

On our fourth day out we saw brash ice, then an iceberg. Shortly afterwards, I was the first to spot land: the high peaks of Coronation Island in the South Orkneys. The sea flattened, the sun shone, and the small bergs we passed looked peaceful and beautiful. As we approached the distant mountains, we could see the huge glaciers hanging to their sides. By evening we stood off Brown Bay on Laurie Island, which was to be our first port of call. But with clouds hanging low on the icebergs at the entrance, the skipper decided not to proceed, and we anchored where we were for the night.

The next morning we rose early to photograph the spectacular scenery of mountains and icebergs. After dropping anchor in the harbour and sounding our whistle, we boarded our motorboat to approach the FID base of Laurie Island. To our consternation, we detected no sign of life in response to our hailing. Yet as we approached on foot, the door burst open and the men tumbled half-dressed from the hut to greet us. With their radio equipment out of order, they had not known when to expect us. Their exuberance at our arrival attested to their long months of bleak isolation.

At Laurie Island we experienced the unimaginably pure air of Antarctica. With neither topsoil, sand, smoke, nor bacteria to be carried by the wind, the air sparkled crystal clear. Although the far side of the bay lay actually a few miles away, I felt I could almost toss a stone to it. Distant mountains, too, looked much closer than they were.

On an out-cropping of rock above the base hut we came across a small colony of Chin-strap penguins, so called because of their cap of black feathers extending to a band under their chins. Otherwise they were snowy white. The smallest of all penguins, they delighted us with their lively acrobatics. We photographed them, along with seals, terns, the surrounding scenery and the activities of the base. By the time we bade farewell to the relieving crew and reboarded *Fitzroy* at the end of the day, we were well pleased with our endeavours.

From the spectacular scenery of Brown Bay, we passed along the South Coast of Coronation Island to anchor at Borge Bay on Signy Island. The site of a former Norwegian whaling station, it bore testimony to the violence of the elements. The roofs and walls of the buildings had collapsed onto the furnaces, vats, and machinery of what had been a busy plant twenty years before. Now, green and yellow lichens grew thick upon the rocks of a shoreline strewn with the huge bleached bones of whales. Higher up, amid the ruins of the old factory and beyond, boundless herds of sea elephants kept watch. With rheumy eyes, runny snouts, and sparse moulting fur, they were not a pretty sight. Twenty feet in length and weighing 7,000 pounds, the huge bulls wallowed in their own filth and

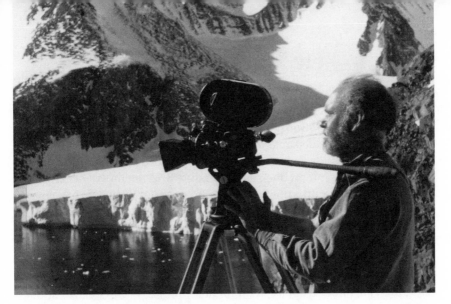

Where the glacier meets the sea. Clear Antarctic air makes distances deceptive.
The glacier face is actually 90 feet high.

stench. I waded in to photograph them, then climbed higher up the slope to where the giant petrels nested. Almost as foul, their nesting grounds proved equally unpleasant to visit.

After a welcome wash and late lunch aboard *Fitzroy*, we sailed for Sandefjord Bay on the southwest tip of Coronation Island. Here we discovered a colony of Ring penguins surrounding an abandoned FID hut. As I prepared to film them, a sudden blizzard hit, foiling my attempts. We had to wait three hours before visibility cleared sufficiently for us to weigh anchor. Having my work sabotaged by inclement weather would become a recurring frustration throughout our Antarctic assignment.

Fog slowed us down the next morning. When visibility cleared, we at last saw our first pack ice. To enable me to photograph it, the skipper took the ship close alongside. Yet our excitement soon turned to anxiety. Although we had been heading southwest for Hope Bay, the build-up of ice soon forced us to retrace our course northwards. The following day found *Fitzroy* pocketed by ice. Passing slowly up the Straits between Elephant and Clarence Islands, we saw a shining iceblink on the horizon, an eerie phenomenon produced by the reflection of light from distant ice masses. A more menacing or inhospitable land I had never seen.

For my cabin companion, Professor Wordie, this was an emotional time. He had been a member of Ernest Shackleton's expedition in 1916 when their ship, the *Endurance*, had been crushed by pack ice in the Ross Sea. Now, once again, he saw the cove where he and his companions had

survived months of hardship while Shackleton and others set off for help in a 22-foot open boat for South Georgia Island, eight hundred miles away across the world's stormiest seas. While for Wordie the cove represented a haven from the ice, for the rest of us it seemed the most desolate and cruel place we had ever imagined.

The morning of 21 January 1947 we approached our destination, the First Mate calling me on deck as we passed Bridgeman Island around 4 am. Here lay a magnificent study in contrasts: a jet-black volcanic cone in a sea of ice. Soon thereafter, we picked up Graham Land and a signal from *Trepassey* that she was on her way out to meet us. Our relief was almost tangible. The pressure of the thickening pack ice threatened to crush *Fitzroy*'s hull which was not built to withstand such extreme conditions. When at last we caught sight of *Trepassey* by late afternoon, we welcomed her with a cheer. As we fell in behind her, I photographed seals and penguins on the floes. I also filmed sturdy *Trepassey* setting our course as she resolutely nudged the ice out of our way. This was not the last time we would count on her for safe passage.

Our arrival in Hope Bay augured well, with a flock of penguins swimming out to escort us to our anchorage. For me, the moment I first set foot upon Antarctica marked the realization of a life-long dream. David, who had already been stationed here, rejoiced in his return. Both of us warmed to the welcome of the eight-man crew of the base together with their team of Huskies. The dogs' friendliness astonished me, for Huskies had the reputation of being fierce and hostile. I could only assume that being well-fed and well-loved had made the difference. But it distressed me to see that the dogs were allowed free run of a huge Adelie penguin rookery that came to within three hundred yards of the base. On the snow surrounding the huts, a sickening mess of flippers and heads bore mute witness to a constant carnage that troubled me deeply.

Otherwise, a quick tour of the base and its surroundings reassured me. Our new home, though rough, afforded ample shelter for ourselves and our equipment. And the surrounding area seemed promising as a location. I returned to *Fitzroy* for the night, well satisfied with the studio's decision to make Hope Bay our main base of operations.

Yet I knew that I would have to venture farther afield to capture the vastness and diversity of Antarctica. After unloading supplies and participating in the high jinks of a farewell party aboard *Fitzroy*, I arranged for our film unit to accompany *Trepassey* on a four-day survey trip. Initially, this journey took us south through heavy pack ice and deteriorating weather. With pack-ice diverting us through Larsen Straits, we tied up to an iceberg near Rosamel Island for the night. The next day we

stopped off at Dundee Island, unvisited since Lincoln Ellsworth began his trans-Antarctica flight there in 1935. Other stops included Paulet Island, where Captain Larsen and the survivors of the *Antarctic* wintered in a crude stone hut after their ship had been crushed by the ice in 1901. Here, as elsewhere, the little that remained of man's passage bore mute testimony to the ravages of this most unforgiving land: crumbling walls, spoilt tins of food, strips of garments, pots and pans. Even the grave of young Wennersgaard, who had died during the horrors of that endless winter, had disappeared.

Encountering continuously deteriorating weather ourselves, we were struck by the inevitability of the *Antarctic*'s doom. The fast-flowing tide and currents carried huge bergs along at two or three knots, crashing their way through the floes. At one point *Trepassey* worked her way behind a big iceberg, allowing it to clear a channel for us. Despite darkening skies, I managed to get some exciting shots of hostile weather building up. Once again, we tied up to the lee side of an iceberg for a night's rest. The old polar explorers were never far from our thoughts.

On our last day out, we found our passage blocked by a huge tabular berg. Retracing our course, we discovered an uncharted channel cutting d'Urville Island in two. It was a thrill to pass through and photograph this unknown waterway, which we entered on the chart as Burden Channel in honour of our skipper. Another shooting highlight was the discovery of a splendid blue tabular iceberg rising sixty or seventy feet above the water. Knowing that I wanted as many angles on it as possible, Captain Burden took the *Trepassey* around it three times, enabling me to photograph it twice in Monopack and once in black and white. The shots were used for the film's Ross Barrier sequence.

After further delays caused by heavy ice and fog, we at last returned to Hope Bay with a wealth of authentic location shots. At least, I felt reasonably sure of success with the black-and-white stock; only time would tell whether we had captured anything worthwhile in colour. We spent the rest of the day settling into our quarters, digging a passageway to the rear door, and clearing the ice from our new camera room. All rather heavy work for studio folk! We finished just in time to wave *Trepassey* off as she weighed anchor for other lonely bases in ice-strewn waters. Following a tight schedule, she was to return for us in six-week's time. As we watched her go, we felt like forsaken mariners marooned in a sea of ice.

The challenge of our assignment quickly dispelled any sense of gloom. That evening the leader of the base, Victor Russell, gathered the members together to partake of my proffered bottle of whiskey and hear what I hoped to accomplish at Hope Bay. We worked out a mutually beneficial

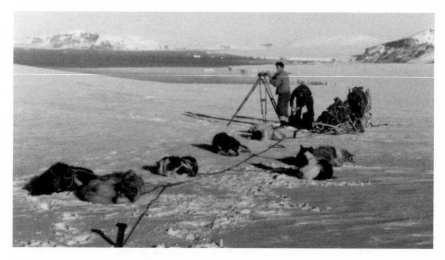

Setting up for a sequence at Hope Bay.

agreement: we of the film unit would assume our share of household and victualling chores, while the FID crew would help us as they could, particularly by filling in as doubles when required.

In the days that followed, howling blizzards and driving snow largely confined us to the base. Bob developed film test-strips and cleaned cameras, while David and I made up a shooting schedule and arranged for a convincingly hungry team of dogs to be tied up for the film. The FID crew unpacked, checked, and stored the new supplies. We all took our turn as bull-cook in the kitchen. I especially appreciated the BBC link with the rest of the world, and radio communication which made it possible to contact my family by cable. The winter of 1946–47 being particularly harsh in England, I worried from Antarctica that my wife and children might be cold in our uninsulated English cottage. Christiane's reassuring telegrams soon dispelled my somewhat ironic anxiety.

We had already decided that we would do much of our shooting on the top of a 600 foot hill rising behind the camp. As soon as the weather cleared, Bob, David, and I, together with Dick Wallen, a Falkland Islander in charge of the dogs, climbed the hill to get shots of the dog teams and sleds. It was not easy, for the wind had polished the ice surface to a glassy sheen and we carried heavy equipment. We took a few shots before sending the dogs back to the base. Looking for other locations, David and I then climbed another 1,400 feet to the shoulder of Mount Flora. Stretching away to the south in shimmering shades of blue and purple lay

Prince Gustav Channel. After days of blizzard, this splendid panorama augured well.

Yet in the course of the next six weeks, bad days outnumbered the good. Each day, burdened with camera equipment, Bob and I climbed the 600 foot hill of solid ice. More often than not, a blizzard would blow up just as we reached the top, effectively ending production for the day. Our worst experience was the 100 mile an hour blizzard that lasted two days and nights, forcing us to crawl about on our hands and knees. Still we persevered. When the weather turned bad we would set up the Mitchell camera in the base tent for blizzard scenes. Or we'd shoot interior scenes for the FID film: activities in the map room, weather room, kitchen, and messing facilities. But throughout all this, our primary goal remained the location scenes.

Poor shooting conditions and lack of manpower made our work in Antarctica a daily struggle. Realizing that filming opportunities could be scarce, I began to plan for less ambitious scenes. As blinding blizzards constantly played havoc with our shooting schedule, I became increasingly worried about our many technical setbacks. The all-pervasive cold affected camera speeds, and even when the weather cleared the dazzling light sometimes changed quickly from very high to very low intensity. Moreover, I found the work difficult with such a small crew, particularly when Bob and David had to stand in for the FID doubles who were otherwise occupied with their own responsibilities.

Typical delays continued to plague us in early February. On Monday the third, David prepared the poignant scene when Scott's party reaches the South Pole – only to discover Amundsen's tent. David pitched the tent in anticipation of our shooting the polar scenes with the doubles the following day. For once we hoped for overcast skies appropriate to the despondent mood of the scene.

Next day's heavy freezing fog more than fulfilled our wishes. Climbing the hill to check our location weather conditions, we found them not only dismal but dangerous. Unable to see more than fifty feet ahead of us, we sat on the ice for an hour hoping for the weather to break. It grew terribly cold. With no improvement in visibility, we returned to the base and cancelled our doubles, promising to call them the next day if conditions improved.

By Wednesday, soft snow and driving wind made filming impossible. Thursday showed no improvement. By afternoon, we climbed the hill in wet, falling snow, hoping for better conditions at the top. We didn't find them. While David skied back to cancel the doubles, Bob and I covered the cameras with tarpaulin and snow, hoping to save time for an early

start if the weather improved by morning. My journal notation for that day ended with the now-familiar refrain: "Becoming very concerned for success of trip."

By noon on Friday, 7 February, the weather looked more promising. Bob and I dug out the cameras and set them ready to go by mid-afternoon. By the time David and the doubles arrived, an oppressive, brooding sky conveyed the desired effect, allowing us to shoot at last the scene of Scott's polar party approaching Amundsen's tent. We returned to base by early evening, cold, tired and hungry. But at least we had something in the bag. It had taken us five days to obtain one short sequence – one that would last only a couple of minutes in the finished film.

And so it went. Whenever the weather cleared we filmed as much as we could: the surrounding panorama, the penguins, the seals, our own reconstruction of Scott's Mount Hooper depot. One day, when temperatures rose to a startling forty-two degrees Fahrenheit, I stripped for a snow bath, adding to my already painful sunburn. When the weather turned uncooperative, Bob would clean the cameras and attend to the film while David and I looked for new locations. Although we wandered some distance from camp, our search for suitable crevasses to represent the Beardmore Glacier proved unsuccessful. We would ultimately film that sequence in Switzerland.

Besides our own activities, we shared the daily round of camp life. As bogey-boys, we cooked, washed up, and hauled what must have amounted to tons of unsoiled snow and ice to melt for drinking and washing. For those so inclined, it even served for shaving. On different occasions we helped haul in crab-eater seals the team had shot. Seal livers, I discovered, were the most delectable part, though I still preferred penguin breasts. Nonetheless, the slaughter of thousands of penguins to feed the dog teams at the different FID bases continued to distress me. I could not help but wonder whether these charming, too-friendly little creatures might not go the way of the bison of the Canadian prairies.

On Sundays I had not the heart to ask the FID crew to play movie heroes. Usually they spent the day writing reports and letters home. There never seemed to be enough hours in the day to accomplish all they planned. With no time for boredom, the men generally found the two long years of their isolated posting passed quickly. Wanting to exploit my own short stay, I profited from a quiet Sunday to prospect for fossils under a rock face. I found a few fossilized ferns which the geologists claimed to be ten million years old, and appeared to confirm the theory of continental drift. I found it a humbling experience to split open the rock to re-expose the fossil to sunlight.

By mid-March we received word from the leader of the FID expedition, Commander Bingham, that *Trepassey* would stop in on her way farther south. Because of the difficulty in getting good shots, and the filth from the penguin slaughter surrounding the base after a thaw, I was more than ready to move on.

... and Back

Poor weather conditions and scarcity of suitable locations had frustrated many of our efforts up to mid-March 1947. Despite some exciting shots, I had been increasingly worried about the success of our trip. So when at last *Trepassey* emerged from a black cloud of flying ice particles and anchored just beyond our ice-shelf, Bob Moss and I were waiting for her. Two hefty Newfoundlanders rowed us out to the ship through heavy freezing seas. With a gale blowing up and heaving the ship around we settled in for a miserable night. Regrettably, limited room aboard prevented David James from joining us in our search for fresh locations.

With pan-ice forming quickly on the surface and heavy snow falling, we left Hope Bay and headed south for Marguerite Bay, where a large American expedition had established itself near the existing FID base. I looked forward to meeting the Americans and seeing how they operated in the frozen south.

We called first at Deception Island in the South Shetlands. Here the sea flowed through an immense crack into a huge volcanic crater, splitting the sheer walls that rose for hundreds of feet on either side of the entrance. A vista of hell-on-earth awaited us inside the harbour: a ring of high vertical cliffs of red and yellow lava overshadowed beaches where jet-black volcanic cinders soiled the snow. Small icebergs floating in the harbour contrasted with the overall griminess of the shore. As at Signy Island, the ruins of an abandoned Norwegian whaling station and cemetery added their own particular scar on an already bleak landscape. In stark counterpoint, the bones of whales scattered along the beach attested to human greed and waste.

Low water exposed jets of steam and hot water bubbling up through the black surface of the shore. We had been told that one could have a bath where the scalding waters flowed into the icy bay, but I opted for safety

rather than cleanliness. As the sky grew darker that night, a gale blew up. With the wind groaning and shrieking through that dismal landscape, all the demons of Hell seemed to have been let loose.

The following morning, Bob and I went ashore to photograph for the FID film. We also helped the ship's crew fill *Trepassey*'s water tanks by connecting hoses to a water main left over from the old whaling plant.

At Deception Island *Fitzroy* joined us, carrying the governor on his visits to the FID bases. When he invited us to join him in his tour we quickly accepted. Closer contact with principals for the FID film and much more comfortable quarters proved irresistible. The added luxury of a hot bath before dinner later confirmed the wisdom of our decision. We were nonetheless reassured to know that *Trepassey* would be accompanying us, for experience had already taught us that we could count on her when thickening ice threatened navigation.

I was glad when we left eerie Deception Island behind. Once again, deteriorating weather dashed our hopes for good footage. With spectacular Neumeyer Channel and Copper Mountain hidden in mists, we pushed on to the two-man base at Port Lockroy, where Commander Bingham barely managed to carry out a quick inspection before storm conditions forced us to move on.

Following *Trepassey* through narrow Peltier Channel with its overhanging glaciers, grounded icebergs, and swift currents, we arrived at the three-man base at Wordie House, named after my distinguished cabin companion. Situated on Argentina Island, the station nestled into a natural basin with walls of solid ice rising perpendicularly for several hundred feet to the east and west of the hut. Slowly moving ice had polished smooth the rock base from which they rose. The three-man crew at Wordie House had had a busy year. They had erected their hut from prefabricated sections, installed their radios and meteorological instruments, sent out two daily weather reports, started a dog farm, and killed, gutted, and put into ice pits one hundred and forty seals to feed the dogs at the two main bases. Forty of these we loaded aboard *Trepassey* for delivery to Marguerite Bay.

In Antarctica, perhaps more than anywhere else, sudden disaster looms continuously. One night just before our arrival, the crew had awakened to a deafening roar as an enormous wave of icy water burst open the door of the hut. Caves in the eastern ice wall had suddenly collapsed into the sea, exposing a huge, raw area of crevasses and broken ice. Well anchored to rock and ice, the hut fortunately suffered little damage.

As we headed south from Argentine Island, the sun shone brightly. Bold landscapes emerged wild and impressive in the clear sharp air. Sur-

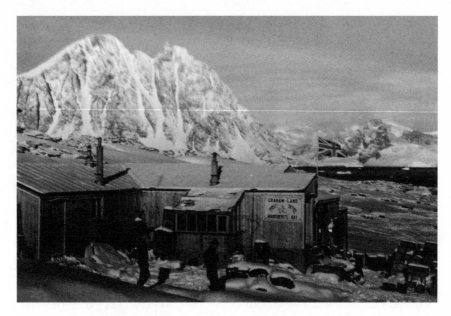

The FID base at Marguerite Bay would have been a far better
location than Hope Bay.

rounded by icebergs, we could see in the distance the razor-sharp peaks
of Graham Land. As we crossed into the Antarctic Ocean, Commander
Bingham offered a round of drinks to celebrate the occasion. Throughout
the night, strong winds and heavy swells from the north drove us along
at an uncomfortable pace. By morning, heavy seas and driving snow cut
visibility to zero. The sea remained rough the next day, although the skies
cleared to reveal unexpected snow-clad mountains to the west. A fix con-
firmed them to be Alexander Island, farther south than we had intended
to go. Two days of miserable weather had pushed us off course, an all-too-
common experience for navigators in those waters.

The panorama at Marguerite Bay proved a shock for me. A quick sur-
vey of the surrounding territory showed this as a far better location for
our work than Hope Bay had ever been. Ranged close to the base lay the
very essence of the Antarctic we wanted to capture: fine ice cliffs which
could have represented the Barrier, striking mountains for the Beardmore,
tremendous jumbles of crevasses, and a perfect plateau for our polar
scenes. Moreover, the base itself was comfortable, clean, well kept, and
manned by a crew who would have loved to have taken part in the film-
ing. The only advantage for us at Hope Bay had been the proximity of the
penguin rookeries. To think that I, an experienced location specialist, had
been caught in such an unfortunate situation made me physically ill. To

make matters worse, I discovered that Commander Bingham himself had originally recommended Marguerite Bay as our base of operations but had been ignored by Ealing Studios. The regrettable decision to use Hope Bay had been made before I even joined the organization.

After surveying the surroundings, I returned to *Fitzroy* feeling depressed and more than ready for a hot bath, supper, and long night's rest. I awoke on 1 April to heavy weather and the unwelcome news that we would sail at 5 am the following morning. Despite threatening skies, I determined to make the most of our brief stopover. We went ashore to shoot whatever we could get in both black-and-white and colour. Although disheartened at exposing film under such poor light conditions, I clearly had no alternative. Even so, I bowed to the inclement weather by mid-afternoon and called it quits. Yet no sooner had we reboarded *Fitzroy* than the skies capriciously cleared and the sun broke through with intense brilliance. Antarctica had played me for her April fool.

My short stay at Marguerite Bay, the southernmost station I would visit, left me with poignant memories. Commander Bingham's miniature greenhouse, tacked against the wall of the base hut, provided vegetation where none would normally grow. With a few panes of glass and soil brought down from Port Stanley, Bingham nurtured such rare treats as watercress, radishes, carrots, and violets. Whenever a celebration seemed in order, morsels of his produce would decorate each man's plate.

I also enjoyed contact with the Americans, whose privately financed Ronne Antarctic Research Expedition was also based at Marguerite Bay. When his Excellency invited Finne Ronne and his crew aboard *Fitzroy* for drinks, I happily found myself pouring for our guests. Notwithstanding the alarming disappearance of our supplies, our merry party drew too quickly to a close as our guests slid down the gangway into their boats. On a return visit to their impressive, well-equipped vessel *Port of Beaumont*, I met Mrs Edith Ronne and a Mrs Darlington, wife of one of the aircraft pilots. They eventually became the first women to winter in Antarctica. Years later, I discovered that a huge mass of territory inland from the Weddell Sea had been named "Edith Ronne Land." Although no doubt honouring a landmark experience, I regretted that relative latecomers received considerable recognition while many who had faced long years of real hardship often went unrecorded.

A near-disaster delayed our departure from Marguerite Bay by three precious days. Awakened at 2 am by shouts for help, we rushed up on deck to see heavy smoke pouring from *Trepassey*. Coming alongside, *Fitzroy* put her pumps and hoses to work but had to withdraw temporarily on scraping bottom with her keel. Creeping in again as close as possi-

ble, her crew had the blaze under control by 5 am. But by then Captain Burden and First Mate Stone, who had done most of the fire-fighting below decks, were suffering from smoke inhalation and exhaustion. Moreover the damage to *Trepassey* reminded us how much we depended on the sturdy Newfoundland vessel to get us out of the southern seas before thick ice set in. Despite fatigue and hands raw from handling icy hoses, we all threw ourselves into the task of making *Trepassey* seaworthy again.

The grim possibility of wintering in Antarctica filled us with renewed energy. I spent the day scrounging for useful material from both the British and American bases: spikes, bolts, timber, plywood, canvas – even liquid spirits to cheer us up. Over the next two days *Trepassey* underwent major operations both above and below deck. Crew members removed some of her heavy eight-by-eight beams to prop up damaged areas where the strain would be greatest. I worked on the decks, patching the holes with plywood and covering them with canvas before planking over the whole repair. Long before completing the work, my hands were raw and swollen.

By late afternoon on Good Friday, 4 April, we prepared to leave Marguerite Bay. But by evening the weather turned angry, the wind rose, and *Fitzroy* began dragging anchor. Twice in the night we had to move off and re-anchor to avoid bumping *Trepassey* and the much larger American vessel *Port of Beaumont*.

By now signals from London and Port Stanley echoed our own anxiety at our late departure. No ship had ever remained in those waters so late in the year without being frozen in for the winter. Warning signs abounded. Heavy icing aboard comfortable *Fitzroy* caused pipes to freeze. *Trepassey*, whose crew had worked through the night, had no heating at all until they got the engines operating again.

By Saturday afternoon, Captain Burden called for a test run. We watched anxiously as *Trepassey* fought her way past us through a Force Ten storm and out into Nany Fjord. Soon we received her signal: she was heading north and we were to follow. With a sense of now-or-never, *Fitzroy* chased after her. As howling winds tore the tops off waves, *Trepassey* rolled and pitched as though trying to free herself from some underwater monster. Icebergs whistled by like huge vessels under sail. I tried for some footage, but the tossing and heaving made work impossible. Besides, flying spray reduced visibility and obscured the surrounding mountains. Although disappointed at not enjoying one last view of those cruel distant shores, I felt relief at heading north again. After dinner I invited Governor Clifford, Commander Bingham, and Doctor Slessor to join me for a shot of 1812 Calvados given to me for good luck by a friend in Paris. It seemed an auspicious way to propose a toast to our safe return.

Easter Sunday dawned crystal clear. Just after breakfast Captain Burden in *Trepassey* signalled his intention to anchor to a large iceberg; we could tie up alongside. Creeping into the leeward side of the berg, *Trepassey* let off one of her mates who cut steps into the ice to reach a good holding ground. Another crew member followed with a light line onto which was fixed a hawser with an ice anchor attached. With *Trepassey* secured to the ice, *Fitzroy* came alongside to nest, and both ships prepared for a day of rest. Having scarcely closed their eyes since the fire, the crew of *Trepassey* hovered on the brink of exhaustion. After downing a big bowl of soup and a shot of rum, they retired to their bunks on Burden's orders. While they slept like dead men for the rest of the day, *Fitzroy*'s crew kept watch. We passengers spent a lazy Easter Day reading, playing cards, or snoozing in our bunks.

Although vital for the crew, the day of rest added to the gnawing realization that time was running out for us. We still had to call in at all the bases we had visited on the outward passage. To avoid delay and speed our return to civilization, we all agreed to pitch in and help whenever possible.

Our brief visits to the different bases marked the last time their crews would see outsiders before their nine-month winter set in. At Wordie House, I went ashore to photograph his excellency inspecting the base. I also photographed the introduction of a husky bitch we had brought from Marguerite Bay to her new home and mate. With obvious enthusiasm on the part of both canine parties, love blossomed at first sight.

While year-end business wrapped up on shore, repairs continued aboard *Trepassey*. Two heavy cables holding down the aft deckhouse and galley after the fire had slackened during the storm, causing the whole structure to shift. Generator failure added to our woes. All available hands turned to, some carrying out vital repairs, others loading ninety seals aboard for Hope Bay. When we could do no more, we went ashore to wish the boys good luck and take their latest mail. They would see no more outsiders until the supply ship returned in the spring.

In gentle swells under a light, overcast sky, we proceeded through spectacular Frenchman's Passage and Peltier Channel. Conditions being excellent, I shot a good deal of footage in both colour and black-and-white. By late afternoon we anchored off Lockroy Base. Assuming that the heavy storms would prevent our returning to them, the base's three-man crew had slaughtered 400 Gentoo penguins to carry them through the winter. By now well used to the unpredictable, they evinced little surprise when Bingham informed them their station would be closed until spring, and they would be accompanying us to Hope Bay. We helped them pack their instruments and belongings and stash the provisions for their return in the Spring.

Making our way back to the ship, we watched aghast as a huge section of the glacier behind *Trepassey* broke away with a thundering crash, throwing water high into the air. The little bay churned wildly, tossing *Fitzroy* and *Trepassey* about as if in a mad celebration to mark the birth of an iceberg. I regretted leaving my camera on board, for I would surely have obtained prize-winning footage of an extraordinary phenomenon.

Heavy clouds obscured the mountain tops as we steamed back through Neumeyer Channel. But I did catch a glimpse of spectacular Copper Mountain, which had been totally hidden on our journey south. I also got shots of several pods of whales. Some of the bulls sporting around our hulls seemed as long as *Trepassey* herself.

Stopping off again at the former whaling station in Deception Harbour, we took on fresh water. In driving snow and howling winds, the place seemed even more desolate than before. I had hoped to photograph the hot springs and steam jets along the cinder-black beach, but high water and foul weather made this impossible. Consoling myself with a hot bath after dinner, I reflected how much worse my lot could be. Aboard *Trepassey* they had no heat at all. Even the bunks were cold.

Conditions improved greatly the following day. With the winds easing off by noon, we up-anchored and steamed through the gap, happy to leave grim, volcanic Deception Harbour behind. All morning we passed pod after pod of very large whales. By noon the sky suddenly cleared and the sun shone brightly on the strange, angular mountains of distant Graham Land. Yet this brief afternoon of spectacular scenery proved to be the lull between two storms. During the night the weather changed again. Next morning, penetrating cold awoke me. Driving snow impaired visibility while ice formed on the sea. Even aboard *Fitzroy*, pipes, washstands, and toilet bowls had frozen solid overnight.

We anchored off Hope Bay later in the morning. With thickening sludge camouflaging the sea, no friendly penguins gathered to welcome us this time. It took time for the crews of both ships to thaw the pipes for the winches and get the motors running in the landing launches. Going ashore with the first load of supplies, I shot footage of the governor with the members of the base. By mid-afternoon the three Lockroy men had moved ashore with their gear, ninety seal carcasses, dogs, and provisions. When David James at last joined us aboard *Fitzroy*, our film unit was once again up to full complement.

With the ice moving in on us rapidly, it was time to leave. Yelling our farewells between gusts of driving snow, we prepared to follow *Trepassey* as she nudged her way through the narrowing lanes of water between floes. As the ice thickened, she would charge up to it with her 350 horse-

power Vivien diesel under full throttle. Rising up onto the ice, she would then crush it under the full weight of her hull.

At one point I transferred to *Trepassey* to get exciting footage of her bow breaking through the ice. To film this grinding, churning spectacle, I adopted the same technique as the great photographer Herbert Ponting, who had shot similar scenes with his hand-cranked camera during Scott's 1911 expedition. Precariously perched on the end of a ladder swung out from the deck, I filmed the ship's bow as it sliced its way through the floes. It was an exhilarating ride, with the ice breaking and swirling around me. In the film this footage represented the *Terra Nova* breaking its way southward through the ice to carry Scott and his men to their final expedition.

Once safely clear of the floes, we actually rejoiced at being tossed around in the open sea. Although rough, our return to Port Stanley via Deception, Signy, and Admiralty Islands was pleasantly uneventful. Taking advantage of the wind, *Trepassey* at times would hoist her two sails – a pretty sight as she dipped and rose in the long swells. Albatross on effortless wings occasionally veered in close to inspect our laborious progress, then flew on after briefly encircling the ship to satisfy their curiosity. As they soared away to distant horizons, they left me wondering what instinct had brought them so far from land and which shores beckoned them onwards.

During the last few days before reaching Port Stanley I had time to reflect on the voyage that was coming to an end. After so many delights and disappointments, I realized that what I would remember most vividly was the land itself. A stark, beautiful, ghostly continent, Antarctica's grandeur lies not in flora or fauna, of which there is little, but rather in the harder elements of rock and ice, and the purity of air and light. I came away with mixed feelings: satisfaction at having accomplished my task despite so many obstacles; exhilaration and privilege at having been the first to stand upon some small, distant crag; humility at my own insignificance as a passing shadow on the timeless landscape. I felt concern too. Recalling the mineral-rich mountains of Graham Land and the slaughter of so many penguins, I wondered whether even Antarctica would one day fall victim to man's insatiable hunger for new resources. Just as I had disturbed the long sleep of a fossilized fern, so too, I feared, would others eventually lay waste the beauty of our planet's most unspoiled continent.

I experienced mixed feelings as we sailed into Port Stanley on the afternoon of 19 April: joy at returning to home and family, sadness at parting with *Trepassey*, *Fitzroy*, and their stalwart crews. A spirit of brotherhood

having grown up among us, we felt like deserters abandoning ship as we off-loaded all our gear.

Despite a warm welcome ashore, I soon found myself beset by a shortage of funds, the studios having failed to send money to cover my unit's expenses. Over the next seventeen days, ineffectual cables flew back and forth across the Atlantic. Treasury Board regulations, it seemed, prohibited transfer of money out of the United Kingdom. Finally forced to borrow money, I boarded *Fitzroy* one last time bound for Montevideo. There I spent five pleasant days before flying on with the film to Los Angeles. David caught a plane for London, while Bob accompanied the equipment home by ship.

Met at Los Angeles airport by my old friend Al Gilks, I accompanied him directly to Technicolor to arrange for the clearance and processing of the film. Two suspenseful days later we were called back to see a print. To my huge relief, the colour footage was good and drew unconditional praise from the Technicolor people. They immediately cabled Mickey Balcon in London, advising him to continue the film in Monopack. The message could not have come soon enough. Mickey had endured almost six months of acute suspense before being sure that *Scott of the Antarctic* would indeed be a colour production.

On my return to London, Mickey invited me to join the composer Ralph Vaughan Williams in viewing the rushes. This charming, engaging man obviously enjoyed the screening, requesting a second running and asking many questions. Encouraged by his enthusiasm, I expressed to him my delight that he would compose the music for the film. On the release of *Scott of the Antarctic*, Vaughan William's score drew wide critical acclaim for its sombre, plaintive evocation of vast Antarctic spaces.

Although I had hoped to enjoy a holiday with Christiane and the children upon returning from the Antarctic, this was not to be. Mickey Balcon informed me that a complete crew was already in Switzerland, getting accustomed to the high altitude and learning to ski in preparation for location scenes. In the time it took to greet my family and repack my suitcase, I found myself on my way to join them.

The steep trip by electric train from Interlaken to Jungfraujoch climbed from verdant valleys with neatly shaped fields and orchards to summer alpine pastures that gradually gave way to the permanent snow line. Glistening against a sky of deepest blue, the snowy crest of the Jungfrau dominated the surrounding alps.

I had no sooner reached my room than director Charles Frend invited me to ski over to proposed locations with him. On the recommendation of glaciologist Gerald Seligman, he had selected the Aletsch Glacier because

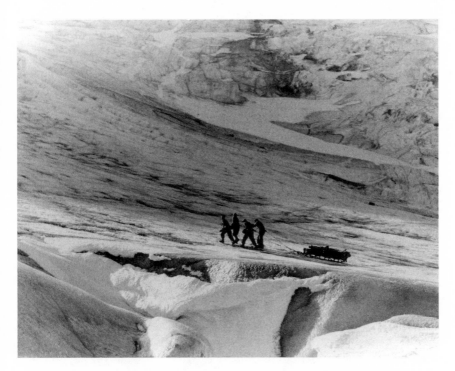

Actors and doubles crossing the Aletsch Glacier in Switzerland for
Scott of the Antarctic. (Photo: Dick Woodward)

it resembled the rough ice formation of Antarctica's Beardmore Glacier.
This magnificent location allowed us to photograph scenes under ice con-
ditions similar to the pressure ridges and crevasses through which Scott
had to pass on his way to the Pole.

Yet, like all distant locations, the Aletsch would present its own diffi-
culties. From the first day of shooting I realized that the sky at this alti-
tude was a much darker blue than the Antarctic skies shot at sea level.
Matching the intensities of different lighting effects would become an
ongoing challenge, not only in Switzerland but also on location in Nor-
way and in the Ealing Studios. Somehow, it all came together. Jungfrau-
joch, at 11,342 feet, was probably the highest elevation at which a film unit
had ever operated. Breathing became difficult until we grew accustomed
to the altitude, particularly for the film crew transporting heavy equip-
ment up the ice face of the glacier. Although we now had more hands to
help in this daily task, we also rented a dog team from the Swiss railway
to haul our unwieldy sledge.

Moreover we relied heavily on our three Swiss guides to lead us safely through the treacherous reaches of the glacier. At one point, for example, they slowly lowered me and my camera to a ledge deep inside a crevasse so that I could get a striking angle for a scene of John Mills crossing a natural ice bridge overhead. On another occasion, I almost came to grief. I had just stepped back from looking through my view-finder when the snow beneath me suddenly gave way. Suspended by my outstretched arms, I could feel the rest of me swinging in an icy void. After our guides had pulled me out, they opened up the crevasse. It seemed bottomless. We all took turns throwing huge snowballs into it, but none of us could hear them land.

In addition to their regular duties, our Swiss guides acted as doubles from time to time. Of the cast, only John Mills as Scott and James Robertson Justice as Evans had travelled to Switzerland. Both actors bore striking resemblance to the characters they portrayed, adding to the authenticity of a production based on intensive research and attention to detail – down to the wrappers round the chocolate bars taken along on the Scott expedition. The stars who portrayed the other members of the polar party – Harold Warrender, Reginald Beckwith, and Derek Bond – would travel to Norway for the remaining location shots. There, too, they would encounter realistic settings and a race against winter. Geoffrey Unsworth photographed the Norwegian sequences while Jack Cardiff handled the Ealing studio scenes. To editor Peter Tanner fell the task of weaving together seamlessly our combined efforts.

I enjoyed working in Switzerland. The crew got along well and John Mills and James Robertson Justice were good company. Everybody became proficient skiers. As my share of the production drew to a close, I felt satisfied that a good piece of work had been done.

Although not my favourite film, *Scott of the Antarctic* received excellent reviews. Critics particularly singled out its authenticity, its beauty, and its haunting musical score. Accolades for the film units, selected randomly from my collection, remind me how new and exciting our location sequences were for the general public of the time. The critic for the *Natal Mercury* wrote on 27 January 1949:

> The colour photography is magnificent. The pastel shades of the ice floes and the Southern Lights, the contrast of sea and cloud and sunset, the wise handling of vast backgrounds, against which the struggling specks that are the cast are shown in lonely proportion, the snowstorm fadeouts ... All form a masterpiece of great craftsmanship.[1]

1 "You Can Feel It Happening," *Natal Mercury*, Durban, S.A., 27 January 1949.

Others echoed similar views: "My outstanding impression of the film is the superb photography of Jack Cardiff, Osmond Borradaile, and Geoffrey Unsworth, whose Technicolor work in this film is very nearly the most poetically exciting ever seen." (London *Daily Mail*)[2]; "Full marks go to all concerned in this epic presentation, particularly to European [sic] photographic artist, Osmond Borradaile and his collaborators, Jack Cardiff and Geoffrey Unsworth." (*Melbourne Sun*)[3]; "*Scott of the Antarctic* has some of the most masterly scenes ever set on celluloid." (*Otago Daily Times*).[4] Noel F. Moran of the *Dublin Sunday Independent* offered a special tribute:

> the real star of this picture is the camera. No earnestness of characterisation could have given it authenticity without those marvellous Technicolored shots of the breathless beauty of the Antarctic – the great frozen plains, the shining glaciers and treacherous, deep ravines, the gloom of the Antarctic night, the savageness and fury of wind and storm, the scintillating, fairy world of the Antarctic sun. When all is said and done, it is Osmond Borradaile and his team of cameramen who have measured the deathless glory of Scott's losing battle with nature. This is the type of film which makes me utter a silent prayer of gratitude to the cinema and bow in admiration before the artistry of its technicians.[5]

As I packed up to return to England, I was struck by my own sense of gratitude to an industry that had given me the world for my workplace.

2 Fred Majdalany, "Scott Film Is Epic," *Daily Mail*, London, 30 November 1948.
3 "Scott Film Superb," *Melbourne Sun*, Australia, 11 March 1949.
4 "Scott Film Will Revive Old Memories," *Otago Daily Times*, New Zealand, 8 August 1949.
5 Noel F. Moran, "Camera Recaptures Thrills Of Antarctic Venture," *Dublin Sunday Independent*, 6 February 1949. See also Maud M. Miller, "Best Royal Command Film," *Manchester Daily Despatch*, 30 November 1948.

Journey Home

I did not know it at the time, but *Scott of the Antarctic* ended my travels to distant lands for feature film footage. Personal and professional reasons urged me to look beyond the film industry for new frontiers on turning fifty. With the birth of our son, George, in August 1948, the time had come to realize my life's dream of returning to Canada. I wanted my son to grow up in the land I had known as a boy. Besides, with the British film industry severely constrained by Treasury Board regulations, I sensed that distant locations would soon be scrapped in favour of less expensive studio productions. Although I continued to shoot other films, the locations were closer to home and, from my point of view, generally less exciting.

One of my fondest dreams had always been to make a film in the islands of the South Pacific. If anything my recent experience of Antarctic ice, rock, and volcanic beaches had firmed my resolve of bringing the white sands and lush fauna of those fabled isles to the screen. Shortly after my return from Switzerland, it seemed that my wish might be realized. I had gone back to work for Sir Alexander Korda, photographing *The Winslow Boy*, directed by Anthony Asquith and starring Robert Donat. Then Otto Preminger hired me to shoot the location sequences for *Lady Windermere's Fan*, a Hollywood production based on Oscar Wilde's play and distributed in the U.S. as *The Fan*. While each assignment had its own interest, only when Alex assigned me to photograph *The Marriage of Loti* did I feel a new surge of adrenalin. Yet the story was sentimental – a sort of Tahitian "Madame Butterfly" in which a French naval officer falls in love with a young girl of the islands.

On acquiring the film rights to Pierre Loti's semi-autobiographical romance of life in Tahiti, Alex had engaged Julien Duvivier to direct the production. This augured well, for the renowned French director recognized the need to infuse the story with the languorous beauty of its set-

ting. To my delight Duvivier agreed to my proposal of including under-water footage. I wanted to show the clear waters and abundance of beau-tiful sea-life that surrounded those distant shores. With Alex's blessing, I arranged to take a course in scuba diving – still very new at that time, Cousteau's aqualung having been invented in 1943 – and acquire the nec-essary equipment for underwater photography.

I had first filmed underwater in the 1920s when working on Para-mount's *The Sea God*. We had used US Navy diving equipment at that time: hard helmet, waterproof canvas suit, lead-soled boots, and weighted belt. The surface crew pumped air to us manually through a hose, while we communicated with them by means of a microphone attached inside our diving helmet. We used a standard motorized Bell and Howell camera mounted in a waterproof copper case with a glass window to shoot through. The heavy tripod consisted of three pieces of angle iron on which a crude type of freehead allowed the operator to swing and tilt the cam-era within reasonable limits. Weighing about three hundred pounds and unwieldy to handle on deck, the camera and tripod functioned quite effectively underwater.

Procedures proved cumbersome nonetheless. Once the crew had low-ered the camera to the sea floor, the operator had to set up the shot, then inform the crew by microphone when to switch the camera on or off. All other adjustments being locked up in the copper casing, the crew had to haul the heavy case up by cable and unscrew numerous bolts in order to change the diaphragm of the lens or – using four-hundred-foot magazines – reload the camera. Despite these time-consuming methods, we obtained some good footage, making *The Sea God* one of the first feature films to include underwater sequences.

Of course, films had been made underwater even before that. Camera-men using a type of diving bell had previously shot sequences of exotic sea life off the coast of Florida. These had awakened the interest of pro-ducers seeking new backgrounds for their films. *The Sea God* seemed an answer to prayers. A spicy mix of sabotage, superstition, and underwater derring-do, it had exploited underwater footage to the full. Now, some thirty years later, I anticipated that underwater sequences would immea-surably enrich *The Marriage of Loti*.

While Duvivier left to look for locations in Tahiti, I remained in London to select the equipment I needed to do a first-class job. This pleasant occu-pation ended abruptly when Alex informed me that the proposed film had been postponed and was in danger of being cancelled altogether. Financial considerations had dictated that the production be a joint ven-ture between London Films and 20th Century Fox, but, once in Tahiti, the

20th Century Fox representative had disagreed with Duvivier's plan to film the story in its authentic location. He argued that production would be more efficient and less expensive in Hawaii. Once again the familiar discord between commercial and artistic interests aborted a motion picture of great promise. Had *The Marriage of Loti* been filmed, its authentic underwater sequences would have foreshadowed Jacques Cousteau's highly successful popularization of undersea life in *The Silent World* of 1956.[1] Instead, my hopes of filming in the South Pacific – so close to realization – never materialized.

Instead of Tahiti, the summer of 1948 found me in Ireland shooting a charming little low-budget film called *Saints and Sinners*. Directed by Leslie Arliss, it lightheartedly told of an ex-convict returning to his village to prove his innocence before those who had accused him. To capture the essence of Irish village life we filmed the exterior sequences in Carlingford, County Louth, where the entire population of 500 turned out for crowd scenes and bit parts. Although actors from Dublin's famous Abbey Theatre led the cast, Carlingford and its inhabitants stole the show. This ancient village with its narrow, winding lanes, picturesque square, antique ruins and miniature port provided a perfect backdrop for our whimsical tale. Indeed, the contagious warmth and good-humour of the villagers infected the spirit of the production. Although prior commitments among the stars imposed severe time constraints on location shooting, the unit worked hard and cheerfully to capture on film a slice of authentic Irish life. Among the villagers themselves all other responsibilities gave way to observing and taking part in the production whenever possible. Even the postman loitered for hours, the mail undelivered in his bag.

One sequence called for a village pilgrimage to the top of Slievefoy Mountain behind Carlingford. Labouring all night, the studio carpenter fashioned a twenty-two-foot cross that a work team dragged to the summit to erect at daybreak. Fixing it in place with tackle and ropes, they buried its base deep in the ground behind a pile of large boulders. They then moved off to assess their handiwork. Meanwhile a shepherd passing with his flock looked up and beheld the astonishing sight. Convinced he was witnessing a divine manifestation, he ran back to rouse the village. But by the time they returned, the crew had lowered the cross to make adjustments. Vainly scouring the mountaintop, the poor visionary was hard put to convince anyone that he really had witnessed a miracle. Only our lovely footage of barefoot pilgrims struggling up the mountain with

1 Jacques Cousteau's feature film *The Silent World* (1956) won the Palme d'Or at the Cannes film festival that year.

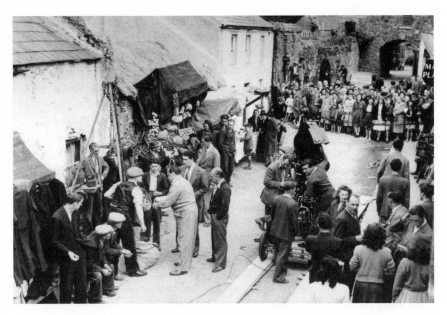

I stand behind Leslie Arliss as he directs villagers of Carlingford on the fine art of washing potatoes for *Saints and Sinners*.

the cross under changing skies eventually attested to what he had seen.

Perhaps the atmosphere of goodwill between inhabitants and film unit was best captured the day we set the camera up in the village graveyard. Concerned that our clambering over the graves might give offense, we moved about our business as circumspectly as possible. We need not have worried. The villagers' unbridled delight with the whole production was expressed in the lilting concern of an old woman. Climbing onto a nearby gravestone for a better view, she exclaimed: "And there's poor Patrick lying there missing all the fun!" The interior scenes in London knew no such levity.

I shot my last feature film in England for 20th Century Fox. When Alex asked me to take over the British sequences of *I Was a Male War Bride*, I found myself working with people I had known in my Hollywood days: Howard Hawks, the director, and Russell Harlan, who had photographed the film's European scenes. A lighthearted comedy situated in Europe at the end of the war, *I Was a Male War Bride* poked fun at military red tape. It starred Cary Grant in the unlikely role of a French officer whose only hope of entering the United States with his American spouse was to disguise himself as a war bride. I liked working with Grant, admiring his

serious professional approach and excellent physical condition. Improbable and frivolous though the film was, it reminded me of my happy associations with Hollywood in its early days. In completing *I Was a Male War Bride*, I sensed my career coming full circle.

We moved to Canada towards the end of 1949. I went on ahead to buy a home, leaving Christiane to sell our house and arrange for the move. Having once again fallen in love with British Columbia's Fraser Valley, I found Cheam Farm at Chilliwack, where Lilla had been born. With its eighty acres of rich soil, its large, comfortable house, fine barns, equipment sheds, and forty head of purebred Jersey cattle, it seemed the perfect home for my young family. When Christiane and the children arrived in the midst of one of the harshest winters in memory, the farm lay hidden under a blanket of snow. Undeterred by so harsh a welcome, the family soon settled into our new way of life.

While the children adapted quickly to new schools and friends, it was Christiane whose life was changed the most. She plunged into her new role as farmer's wife with her usual drive and capacity for hard work. Becoming the farm's bookkeeper and genealogist, she kept her finger on the pulse of production and oversaw the expansion of the herd. Working closely with the herdsman in planning the sowing of crops and the breeding of cattle, she became a farmer in her own right. The success of our perhaps madcap enterprise ultimately owed much to her organizational skills.

Despite the long, strenuous hours – I often saw myself as tied to the tail of a cow every day of the week – the beauty and rhythm of the farm year enchanted me. Each season brought its own demands and satisfactions. From sowing, to nurturing, to harvesting, we worked closely with nature to reap bountiful harvests and raise healthy livestock.

Yet at times all our efforts seemed in vain. Whereas overall production increased by more than fifty percent, rising costs and unpredictable weather and market conditions ate away at our profits. Although at Cheam Farm we had the joy of seeing our children grow up in a beautiful, healthy setting, at the end of each year we struggled to break even. Realizing after ten years that we no longer had sufficient energy, we sold the farm and moved away from the Fraser Valley. But the friends and memories of those years continue to enrich our lives.

While my return to Canada marked the end of my work with major production companies, I did continue to make films in my native country. The National Film Board, which defined Canada's film industry in the 1950s, called on me from time to time to carry out assignments. One of these took me to the Arctic in the summer of 1950 for a short documentary entitled *Canada's Awakening North*.

A beaming return to the National Film Board under its
welcoming new Commissioner, Arthur Irwin. (1951)

The contrast between the South and North polar regions during the summer months of continuous daytime amazed me. Whereas Antarctica enjoyed very limited flora and fauna, corresponding latitudes of the Arctic seemed rich with mosses, grasses, flowers, berries, birds, bears, caribou, musk oxen, foxes, rabbits, and lemurs. Moreover the human population consisting of Inuit, Indians, and whites was increasing as the region opened up to economic development.

I saw a kitchen garden at the Hudson Bay post at Arctic Red River that would be the envy of gardeners living far to the South. With good soil and twenty-four hours of warm daylight, plants shot up quickly during the short growing season. Local lore claimed that there was little point in planting radishes, for they would go to seed by the following day. Remembering Commander Bingham's carefully nurtured miniature greenhouse in Antarctica, I marvelled at the comparative fertility of the Arctic.

On leaving the Arctic, I saw for myself the vital service provided by bush pilots who criss-crossed that huge region in all weathers. We were loading the plane when a young Inuit father arrived, carrying his sick three-year-old son. The local doctor had arranged for the child to be transported to the Charles Camsell Hospital in Edmonton. Bundled up in a beautifully made fur parka, the young patient gazed at us in passive acceptance, his dark eyes huge in a wasted face. In a poignant moment the

young father handed his son over to strangers. I can only imagine his feelings of hope and fear on watching the plane lift off with its precious cargo.

At the hospital in Edmonton I met a doctor recently arrived from Europe who was recognized as an authority in the surgical treatment of advanced pulmonary tuberculosis. His technique involved surgically opening the chest cavity, cutting through the chest wall muscles and the underlying breastbone, and retracting the ribs to expose the lungs. He then isolated the infected lobe by tying off its main airway, thereby preventing the infection from spreading to adjacent areas of the lung. Of course, effective treatment with combinations of antibiotics would eventually replace this dramatically invasive procedure. But at the time it attracted international attention and the doctor was invited to speak at the Mayo Clinic in Rochester, Minnesota. To illustrate his presentation, he asked me to make a film of the operation.

I found it difficult to position the camera without getting in the way of the medical team. By fixing my tripod and a ladder to the operating table, I could point the lens straight down to the scene of action. Smothered in white garments, my face covered with a surgical mask, my head within inches of the reflectors of a large dome lamp, I soon felt rivulets of sweat trickling down my back and legs. Yet despite my discomfort and the gruesome details of the operation – the cutting into flesh and sawing of ribs made even a seasoned veteran like me wince – the surgeon's speed and decisiveness impressed me and I felt confident that the patient was in competent hands. An Indian woman flown down for treatment from the Arctic, she startled me about half way through the ordeal by repeating, despite the anaesthesia, "It hurts. It hurts." To which the surgeon would reply in his heavy accent: "No, Mary, it doesn't hurt. It doesn't hurt at all!" I could only hope he was right.

In making a photographic record of the operation, I knew it would have been more effective had I been able to record it in colour. Yet I had to make do with the black-and-white stock available to me at the time. For some, that was graphic enough. I had arranged with the National Film Board theatre to view the rushes of both *Canada's Awakening North* and the hospital sequence covering the lung operation. As it happened, the operation footage ran during the lunch hour when NFB employees customarily gathered to eat their sandwiches while viewing the latest prints. That particular day the lunch-hour attendance dispersed after only a few minutes. I never heard whether the footage was more appreciated at the Mayo Clinic.

In October 1951, a phone call from Ottawa pulled me away from the farm once again to head a team of photographers for *Royal Journey*, a feature-length film on the visit to Canada of Princess Elizabeth, the future

Elizabeth II, and her husband, the Duke of Edinburgh. Although this was to be Canada's official record of the gruelling five-week journey, those of us involved with its production enjoyed no particular status that would have made our task easier. Security measures added to our restrictions. Until the special bodyguards knew us, even our identity cards and special permits afforded us little access to the protected area surrounding the duke and princess. Jostling for place with other cameramen and journalists, we had to shoot our scenes as best we could. Of course there could be neither retakes nor special positioning of the "stars." Moreover, protocol demanded that we remain silent until spoken to by the royal couple, and that in replying we not change the topic of conversation.

All these limitations made for a strenuous assignment. Not once during that long five weeks did I enjoy more than four hours of sleep a night. Crossing the country by royal train and plane, I witnessed at first hand the stress endured by the royal couple, who found themselves continuously in the public eye. At times I also flew with the Royal Canadian Air Force, arriving early at the next day's stop to arrange for camera positions.

My overriding concern throughout the filming was the monotonous similarity of each day's events. Although producer Tom Daly and director David Bairstow intended each major sequence to stress regional themes – the colour and pageantry of Quebec City, the Royal Winnipeg Ballet, the RCMP and wheat of Saskatchewan, Calgary's Stampede, and so on – the reality was that one civic reception much resembled another. At each town local officials bowed and curtsied, while Scouts, Guides, and Brownies presented bouquets. In desperation I looked for the common touch that would infuse interest into what was rapidly becoming in my mind a penguin parade from coast to coast. Sometimes I was lucky. Waiting for the ceremonies to begin in Regina, for example, I caught a disgruntled army private dutifully touching up the shine on the boots of the navy guard of honour. This cameo shot said more about our national character than the official presentation that followed.

Having heard that the mayor of Montreal, Camillien Houde, had a colourful personality, I wangled my way into his office to request his assistance in breaking the monotony of yet another civic welcome. Sympathetic to my cause, his worship agreed to do his best. Smiling broadly throughout the ceremony, he spoke animatedly with the princess and applauded her speech enthusiastically. His warm touch did much to liven up the ceremony and I thanked him for his efforts. Generously, he reciprocated. Shortly after the conclusion of the film, I received a document bearing the seal of the city of Montreal and expressing the Mayor's appreciation for my services to the city during the royal visit.

From Montreal I flew ahead to Washington to photograph the American leg of the tour. When the royal plane touched down, I found myself well placed to capture President Truman's easy, friendly welcome. So began a tumultuous reception, American style. As the president, princess, and duke took their seats in an open car, the press broke ranks and swarmed around the car. Oblivious to the strict protocol imposed in Canada, journalists and photographers clamoured brashly for attention: "Hey Harry, this is Bill. Have the Princess look this way!" "Hey Dook ... Dook ... smile." And so on. Seeing his guests' bewilderment, Harry Truman reassured them: "Don't worry. They're all friends of mine!" Relieved, the princess and duke relaxed.

On returning to Canada the royal couple enjoyed a brief respite at a secluded lodge near the village of Ste-Agathe in the Laurentian Hills. In this quiet retreat following the lively Washington visit I finally broke protocol, risking censure in a desperate attempt to inject a personal touch in an otherwise formal tour. On arriving at the lodge, I discovered that the princess and duke had left their escorts behind and gone for a sleigh ride in the woods. Grabbing my camera, I jumped into another sleigh and asked the driver to set off in pursuit. We had gone about a mile when we saw the royal party heading back towards the lodge on another trail. By the time we had turned around, they had disappeared into a snowy wonderland. But we caught up with them in the small glade where the two trails met. They had stopped so that Princess Elizabeth could take some pictures of the duke in the sleigh. When she saw me, the princess came over to ask for advice on exposure, for the light had become poor. On the way she stopped to pat the horses. Remembering the American press offensive, I broke the rules by speaking first. I asked if she would permit me to photograph her patting and speaking to the horses. She laughed and said that of course she would and asked where she should stand. After shooting this lovely, personal scene, we had a short conversation about photography. Then the duke signalled to her. As she made her way back to their sleigh, she playfully aimed her camera at him, calling out in a raspy voice reminiscent of the Washington press corps: "Hey Dook ... Dook ... Look this way. Come on Dook, smile!"

Another personal incident sparks my memory of the tour. At the end of the visit to Niagara Falls, I slipped out of my drenched slicker and, without looking around, tossed it to my assistant behind me. "What did you get?" I called back to him. "I got bloody wet," came the reply in a voice that made me spin around in surprise. It was the duke of Edinburgh.

In the course of that five-week journey, I admired the royal couple for their endurance. Few could stand up to such an ordeal for that length of

time. If at first the princess seemed less sure of herself while the duke appeared more relaxed, towards the end of the trip those roles had reversed. Once in stride, the princess began to enjoy the functions in a gracious, easy manner, remembering the names of all she met and personally addressing those of us who travelled across the country with her entourage. On the other hand, the duke showed signs of fatigue, irritation, boredom, and dislike of the press. I sympathized with him. No official tour should last that long – either for the principals or for those accompanying them. With immense relief, all concerned with the journey waved "Bon voyage" to our royal guests as they boarded the *Duchess of Scotland* at Portugal Cove, Newfoundland, on 12 November 1951.

Laboratory technicians worked overtime to complete *Royal Journey* in time for Christmas distribution across Canada. To the satisfaction of all who worked on it, the film was hailed as one of the National Film Board's best productions to date. Despite the grim weather conditions of the tour, critics particularly praised the soft, natural tones obtained with Eastman Kodak's new Ecta Colour process. By eliminating the need for bright sunshine, this all-weather colour stock achieved outstanding clarity and distinctiveness amid otherwise disastrous rain, sleet, and heavy overcast. With no booster lighting we were able to extend the day's shooting time a couple of hours beyond what any other type of colour film would have allowed. From my perspective this flawless system brought to *Royal Journey* outstanding visual impact.

Both at home and abroad critics also praised Leslie McFarlane's lively script and Lou Appelbaum's musical score. In competition with films from other countries, *Royal Journey* won the British Film Academy Award as the best documentary for 1952. But for me, the highest accolade came in a letter from Michael Parker, the Duke of Edinburgh's Equerry-in-Waiting:

> The Princess Elizabeth and The Duke of Edinburgh thought that the film you took during the Tour was simply splendid. All of us are full of praise for the magnificence of the shots, human interest and the story you managed to put across so faithfully. We all agree without exception that it is the best colour film of its type that we have seen.

In 1953, three years after leaving England to become a farmer in British Columbia, I received a cable from Sir Alexander Korda asking me to go to India to photograph the exterior scenes for his latest film. Letters and phone calls followed as Alex explored the possibility of paying me in Canadian dollars – an important consideration at the time. Although it would mean leaving my family and farm for a period of six months, I was

The last day of the Royal Visit with Their Royal Highnesses Princess
Elizabeth and the Duke of Edinburgh, at Government House,
St John's, Newfoundland.

flattered by the offer and felt the familiar sense of excitement at the
prospect of taking up the old game once again. Yet it all came to naught.
Financial restrictions confounded Alex's plans and the production never
took place.

To my sorrow, that was my last direct communication with Sir Alexan-
der Korda. Three years later, at the age of sixty-two, he died of a heart
attack at his London home. A giant of the British film industry, he had
produced over a hundred films, including *The Private Life of Henry VIII*,
The Scarlet Pimpernel, *That Hamilton Woman*, *The Third Man*, and, his last,
Sir Laurence Olivier's *Richard III*. My own career owed much to his genius
for bringing stories from across the British Empire to the screen. Without
Elephant Boy, *The Drum*, *The Four Feathers*, or even the whimsical *Thief of*

Baghdad, my life's work would have been the poorer. In the course of our long association we had had our differences, but with his passing I lost a mentor and friend.

Royal Journey was my last full-length film. Yet from time to time I turned from farming to take up my camera and make short films which helped to bring the face of Canada to the screen. Robert Anderson directed two of them. *Breakdown* (1951) sensitively documented the treatment of a young woman suffering a schizophrenic breakdown. Shot in Chilliwack and at Essondale Mental Hospital, the film attempted to remove the stigma surrounding mental illness at the time. It also marked a turning point for one of our young amateur actors. I discovered him in the hallway of Chilliwack High School where I had gone looking for a bright young fellow to play the role of the patient's brother. Years later he wrote that my decision to cast him, together with his modest pay from the NFB, enabled him to finish his senior matriculation and follow his teachers' advice to go to university. Subsequently lured from one new horizon to another, Allan Fotheringham eventually became a highly successful journalist and television personality.

The modest film *Country Magistrate* (1953) also enjoyed the performance of a celebrated Canadian with unsuspected acting abilities. Directed by Robert Anderson and featuring author, conservationist, and justice of the peace Roderick Haig-Brown, the film explored the simple yet effective administration of justice in small rural communities. Filmed around Campbell River on Vancouver Island, it also introduced me to the world-renowned salmon fishing of the area. Between scenes Rod and I would steal away to cast our fishing lines into clear, swftly flowing rivers and streams. Not even from the mighty Fraser River near Chilliwack have I tasted firmer, more flavourful salmon than the fish we caught during that location. Our shared passion for fishing, together with our mutual respect for the outdoors, marked the beginning of a long and cherished friendship.

On a more ambitious scale, the government of British Columbia commissioned *The Tall Country* to commemorate the province's centennial in 1958. Although produced on a small budget and only twenty minutes long, the film captured some of the beauty and fascination of Canada's westernmost province. Written by Keith Cutler for Parry films, *The Tall Country* won the Canadian Cinematography Award and enjoyed wide distribution overseas by the National Film Board. Keith too became a good friend, sharing not only my vision for the growing film industry of British Columbia but also a common birthday – though he was much younger than I. Over the years we have exchanged many an anecdote over wine and cake marking our day.

Although most of my career was spent abroad, my sense of pride in being Canadian never left me. Perhaps that explained my deep desire to see a strong film industry established in this country. Having crossed and recrossed this land from coast to coast, I never ceased to marvel at the depth of human endeavour that had wrested a modern, progressive state from an unforgiving land in the span of a few short centuries. Stories cried out to be told and brought to the screen. Convinced that Canadians had the skills and talents to establish their own film industry, I found it offensive that we depended so much on foreign productions for our entertainment.

Willing to do what I could to help, I agreed to act as a consultant to a new motion picture organization being established in Vancouver. I then spent a frustrating year during which my professional advice on building good studio facilities was thwarted by the promoters' financial constraints. To this day, I regret my inability to help bring about a viable production unit in my own province. But my talents lay behind the camera, not in balancing the books. Approaching retirement age, I realized I must leave the challenge to a younger generation.

When the time came, I made a conscious decision to pack away my camera. In the ten years we spent on the farm, I had received several requests to make feature films. Yet after reading the scripts, I had declined them all. Although I had been in on the wild early stages of the film industry, I could never accept that the motion picture screen be used for sensational scenes of sex, nudity, or filthy language. To me these bore the stamp of immaturity, degenerate thinking, and greed. I wanted films to tell of the decency of the human endeavour and to do so naturally and honestly. I wanted families to be able to go to the movies without embarrassment. In many ways, I suppose the industry had passed me by.

On selling the farm, we moved to Vancouver where we eventually built a home of cedar and glass on a cliff overlooking a quiet cove on the North Shore. Although the film industry receded in my memory, I discovered one day that it had not entirely forgotten me. Anthony Collins, an authority on the art of making motion pictures, knew of my achievements abroad and wanted me to receive recognition in my native land. Without my knowledge, he proposed my name for one of the highest honours the country can bestow. On 20 December 1982, I became an Officer of the Order of Canada, an honour I accepted with both pride and humility.

Illness prevented my attending the investiture ceremony at Rideau Hall, Ottawa. Yet during my convalescence I received a letter informing me that the governor general would confer the insignia on me during his brief visit to Vancouver on 24 July 1983. On that memorable day, with my dear wife Christiane at my side, we celebrated a career that had spanned

At home in my den surrounded by souvenirs of my globetrotting days.

forty years of motion pictures and seen many changes. Amid reminiscences and congratulations their excellencies, the Right Honourable Edward Schreyer and Mrs Schreyer, graciously hosted a joyful gathering of family and friends.

As the governor general slipped the red and white ribbon of the insignia over my head, I breathed silent thanks to the motion picture industry that had given me so much. My career had taken me to the farthest reaches of the planet, and brought me into contact with people from all walks of life who had deeply enriched my own experience. Now, surrounded by my children and grandchildren, honoured by my country, I remembered distant boyhood dreams and knew them more than fulfilled. If, like Tennyson's Ulysses, "I am a part of all that I have met," I face old age blessed with richness beyond measure.

Selected Filmography

Many of Osmond Borradaile's films are not mentioned in his memoirs. There would have been too many to recall from his early Hollywood days, but even much later productions such as *The Green Cockatoo* (London Films, 1940), find no place in *Life through a Lens*. Only those films whose location had appealed to his sense of adventure delighted his memory when he began to write in his old age. The films listed below are therefore those which meant the most to him and for which he is best remembered.

The dates indicate the year the films were released.

1933 *Men of Tomorrow*, London Film Productions. Producer: Alexander Korda; director: Leontine Sagan, Zoltan Korda; photography: Bernard Browne; exterior photography: Osmond Borradaile.

1933 *The Private Life of Henry VIII*, London Film Productions. Director and producer: Alexander Korda; photography: Georges Périnal; exterior photography: Osmond Borradaile.

1934 *The Private Life of Don Juan*, London Film Productions. Producer and director: Alexander Korda; photography: Georges Périnal, Robert Krasker; exterior photography: Osmond Borradaile.

1934 *The Scarlet Pimpernel*, London Film Productions. Producer: Alexander Korda; director: Harold Young; photography: Harold Rosson, Osmond Borradaile, Bernard Browne.

1934 *The Private Life of the Gannets*, London Film Productions. Producer and director: Julian Huxley; photography: Osmond Borradaile, John Grierson. Academy Award for best short subject.

1935 *Sanders of the River*, London Film Productions. Producer: Alexander Korda; director: Zoltan Korda; photography: Georges Périnal; exterior photography: Osmond Borradaile.

1937 *Elephant Boy*, London Film Productions. Producer: Alexander Korda; director: Robert Flaherty, Zoltan Korda; photography: Osmond Borradaile.

1938 *The Drum*, London Film Productions. Producer: Alexander Korda; director: Zoltan Korda; production manager: Geoffrey Boothby; photography: Georges Périnal; exterior photography: Osmond Borradaile.

1939 *The Four Feathers*, London Film Productions. Producer: Alexander Korda; director: Zoltan Korda; photography: Georges Périnal; exterior photography: Osmond Borradaile, Jack Cardiff. Nomination for Academy Award for colour cinematography.

1939 *The Lion Has Wings*, London Film Productions. Producer: Alexander Korda; director: Michael Powell, Brian Desmond Hurst, Adrian Brunel; photography: Harry Stradling; exterior photography: Osmond Borradaile.

1940 *The Thief of Bagdad*, London Film Productions. Producer: Alexander Korda; director: Ludwig Berger, Michael Powell, Tim Whelan, Zoltan Korda; photography: Georges Périnal; exterior photography: Osmond Borradaile. Academy Awards for colour cinematography, colour art direction, special effects.

1940 *Foreign Correspondent*, Walter Wanger Inc. Producer: Walter Wanger; director: Alfred Hitchcock; photography: Rudolph Maté; exterior photography (Holland): Osmond Borradaile.

1941 *Forty-Ninth Parallel*, (*The Invaders* in the u.s.a), GFD/ORTUS. Producer: John Sutro; director: Michael Powell; photography: F.A. Young; exterior photography: Osmond Borradaile.

1941 *The Lion of Judah*, Imperial Army Film Unit (Middle East Command). Director: Geoffrey Boothby; photography: Osmond Borradaile.

1946 *The Overlanders*, Ealing Studios. Producer: Michael Balcon; director: Harry Watt; photography: Osmond Borradaile.

1947 *The Macomber Affair*, United Artists. Producer: Benedict Bogeaus; director: Zoltan Korda; photography: Karl Struss; exterior photography (Africa): Osmond Borradaile.

1948 *Bonnie Prince Charlie*, London Film Productions. Producer: Edward Black, director: Anthony Kimmins; photographer: Robert Krasker; exterior photography: Osmond Borradaile.

1948 *Scott of the Antarctic*, Ealing Studios. Producer: Sidney Cole; director: Charles Frend; photography: Jack Cardiff, Geoffrey Unsworth; exterior photography (Antarctica and Switzerland) Osmond Borradaile.

1948 *The Winslow Boy*, London Film Productions. Producer: Anatole de Grunwald; director: Anthony Asquith; photography: Freddie Young and Osmond Borradaile.

1949 *Saints and Sinners*, London Film Productions. Producer and director: Leslie Arliss; photography: Osmond Borradaile.

1949 *I Was a Male War Bride*, 20th Century Fox. Producer: Sol C. Siegel; director: Howard Hawks; photography: Norbert Brodine; exterior photography: Russell Harlan (Europe), Osmond Borradaile (England).

1949 *Lady Windermere's Fan*, (*The Fan* in the u.s.a), TCF. Producer and director: Otto Preminger; photography: Joseph LaShelle; exterior photography: Osmond Borradaile.

1951 *Canada's Awakening North*, National Film Board of Canada. Producer: Tom Daly; director: Ronald Dick; photography: Osmond Borradaile.

1951 *Royal Journey*, National Film Board of Canada. Producer: Tom Daly; director: David Bairstow; director of photography: Osmond Borradaile. British Film Academy Award for best documentary for 1952.

1951 *Breakdown*, National Film Board of Canada. Producers: Robert Anderson, Tom Daly; director: Robert Anderson; photography: Osmond Borradaile.

1953 *Country Magistrate*, National Film Board of Canada. Producer: Guy Glover; director: Robert Anderson; photography: Osmond Borradaile.

1958 *The Tall Country*, Parry Films. Producer: Lou Parry; director: Osmond Borradaile; photography: Osmond Borradaile. Canadian Cinematography Award.

Index

Aba, Belgian Congo (now Democratic Republic of Congo), 61
Abu Simbel, Egypt, 167
Academy award. *See* awards
Acworth, Richard, 149
Addis Ababa, Ethiopia, 122, 124, 125–6, 127
Afghanistan, 97
Africa, Central, 61–4; East, 55–8, 161–4; North, 129–40; North-East, 58–60, 103–8, 121–8
African People, 64; Acholi, 55–8; canoe, 62–4; Dinka (Stork), 60; Masai, 163; Ndorobo, 163; Pygmy, 61
Afridis tribesmen, 91
aircraft: Consolidated flying boat, 153; Empire flying boat, 167; Gloster Gladiator, 148–50, 151; Hannibal biplane, 167; Imperial Airways flying boat *Canopus*, 89; Junker, 122; Martin Maryland bomber, 135; Messerschmidt, 137; Mosquito, 148; Pacific Standard, 31; Stranraer flying boat, 53; Tiger Moth, 150; Wellington bomber, 149–50, 151
Airmail, 31
Alaska Highway, 145, 148
Aldridge, James, 132, 148

Aletsch Glacier, Switzerland, 190–1
Alexander Island, Antarctica, 184
Alexandria, Egypt, 90, 138, 140
Algeciras, Spain, 46
Amba Alage, Ethiopia, 129
Amsterdam, Netherlands, 116, 117
Amundsen, Roald, 179, 180
Anderson, Robert, 205
Antarctic, ss. *See* Captain Larsen
Antarctica, 170–89, 199
Antarctic Ocean, 184
Antarctic Peninsula, 173
Applebaum, Lou, 203
Arabian Nights, 111
Aragai, Ras Ababa, 122–4
Arbuckle, Roscoe (Fatty), 27
Arctic, 69, 198–9
Arctic Red River, NWT, 199
Argentina Island, Antarctica, 183
Arliss, Leslie, 196, 197
Armstrong, John, 50
army. *See* British army
Ar Rutbah, Iraq, 90
Ashret Post, India (now Pakistan), 94
Asmara, Ethiopia (now in Eritrea), 129
Asquith, Anthony, 194
atomic bomb, 148, 159
Auchinleck, Claude, 132

Australia, 154–9
Australian Bush Battery, 130–1
awards; Academy award, 50, 53, 109, 111, 120; British Film Academy award, 203; Canadian Cinematography Award, 205; Légion d'honneur, x; Order of Canada, x, 206

Baalbek, Lebanon, 132
Babe (assistant), 161–2
Badger, Clarence, 26
Badoglio, Pietro, 126
Baghdad, Iraq, 90
Bahrain, 90
Bain, George, 150
Bairstow, David, 201
Balcon, Michael, 150, 152, 168, 170, 171, 190
Banff, Alberta, 120
Banks, Leslie, 54, 66
Barrier, Antarctica. *See* Ross Barrier
Battle of the Atlantic, 147
Beaconsfield, England, 85
Beardmore Glacier, 180, 184, 191
Beckwith, Reginald, 192
Beery, Noah, 27
Beery, Wally, 27, 28
Belfast, N. Ireland, 121
Belgian Congo (now Democratic Republic of Congo), 58, 60, 61–4
Bell, Monta, 81–2
Bennett, Joan, 160
Beyond the Rocks, 22, 23, 24
Bidmead, C.D.M., 147
Bingham, Commander, 181, 184, 185, 186
Bland, Bill, 74
Blue Nile. *See* Nile.
Bombay, India, 72, 78
Bomo, 79

Bond, Derek, 192
Bonnie Prince Charlie, 164–7, 171
Boothby, Geoffrey, 88, 90, 100, 122, 124, 126, 129, 132, 165
Borge Bay, Antarctica, 174
Borradaile, Anita Lippens (daughter). *See* Hadley
Borradaile, Christiane Berthe, née Lippens (wife), 44–8, 74, 85, 119, 145, 148, 160, 178, 198, 206
Borradaile, Dick (brother), 9, 10
Borradaile, George Betts (father), 4–8
Borradaile, George Lippens (son), 194
Borradaile, Harry Ben (cousin), 96
Borradaile, Jack (cousin), 55
Borradaile, Lilla Amy, née Hudson (mother), 7–10, 101
Borradaile, Lilla Lippens (daughter). *See* Pedersen
Borradaile, Osmond Hudson (Bordie): birth, 4; childhood and youth, 1–10; first experience of movies, 3–4; projectionist, 12–13; Hollywood years, 13–40; apprentice technician, 13, 15–16; soldier (ww I), 14; assistant cameraman, 16–39; cameraman, 40; marriage, 45; director of photography, 49; war photographer (ww II), 121–42; death, x.
Borradaile, Paul (brother), 9
Bosio, Dr, 109–10
Bow, Clara, 23–4
Breakdown, 205
Bridgeman Island, Antarctica, 176
Brindisi, Italy, 90
British Army, 121,144; and Film Unit, Middle East Command,121, 133–4; and 7th Armoured Division, 133
British Empire. *See* empire, British
British Film Academy award. *See* awards

Brook, Clive, 82
Brown Bay, Antarctica, 174
Browne, Bernard (Brownie), 55, 60–1, 115, 144
Brownlow, Kevin, 26n1, 35
Brunel, Adrian, 115
Burden, Captain, 170, 186–7
Burden Channel, 177

Cairo, Egypt, 121, 129, 131–2, 133, 138
Calgary Stampede, 201
Callaghan, Morley, 147
cameras: Arriflex, 162, 171; Bell and Howell, 17, 20, 195; and climatic conditions, 136, 150, 155, 171, 179; Mitchell, 17, 152, 171; Newman Sinclair, 71, 119, 171; Pathé, 17; Technicolor three-strip, 89, 93, 104, 109; Vinten, 71
Campbell, Daphne, 156
Campbell River, British Columbia, 205
Camp Volant. See Marco le Clown
Canada's Awakening North, 198–9, 200
Canadian Cinematography Award, 205
Canadian Expeditionary Force, 14
Canadian Pacific Railway, 126
Cantor, Eddie, 26
Cape, George, 74
Capetown, South Africa, 141
Caprice, 11
Cardiff, Jack, 104, 192, 193
Caribbean Sea, 101
Caribou, ss. See Battle of the Atlantic
Carlingford, Ireland, 196–97
Cauvery River, India, 73, 87
Cave Store, 11, 12
Ceuta, Spain, 46
Chalfont-St-Peter, England, 111, 168
Challis, Christopher, 88, 89, 90, 100
Chaney, Lon, 27

Chaplin, Charlie, 20
Chechaouene, Morocco, 46, 47
Chevalier, Maurice, 27, 37
Chilliwack, British Columbia, 153, 198, 205
Chitral, India (now Pakistan), 93, 94–100
Chitralian Scouts, 97
Churchill, Manitoba, 119
Churchill, Randolph, 133
Cirque d'Hiver, 43–4
Clair, René, 49
Clarence Island, Antarctica, 175
Clayton, Ethel, 27
Clements, John, 104
Clifford, Governor, 172, 186
Collins, Anthony, 206
colour: and dye tanks, 15; and Eastman Kodak Ecta Colour, 203; and Technicolor (Monopack), 164, 171, 190; (three-strip), 89, 98–9, 104. See also film, processing of
Combo, Clive, 157
Congo (Democratic Republic of Congo). See Belgian Congo
Congo River, 58, 62
Conklin, Chester, 24
Conquest of the Air, 68
Coogan, Jackie, 20, 21
Copper Mountain, Antarctica, 183, 188
Coptic Church: and Emperor Menelik, 126
coronation: of George VI, 89
Coronation Island, Antarctica, 174, 175
Cornwall, England, 111
County Louth, Ireland, 196
Country Magistrate, 205
Cousteau, Jacques-Yves, 195, 196
Coward, Noël, 144
Creer, Henty, 144
critics: Dehn, Paul, x; Garret, Gerald,

167; Haestier, Richard, 103; Hobson, Harold, 71; LeJeune, C.A., 103, 108; Majdalany, Fred, 193; Moran, Noel F., 193; Newnham, John K., ix; Perry, George, x; Rayns, Tony, 120; Trevor, Richard, 157; Wright, Basil,118; and *Bonnie Prince Charlie*, 166–67; and *Elephant Boy*, 87; and *The Drum*, 100–1; and *Foreign Correspondent*, 118; and *49th Parallel*, x, 120; and *The Four Feathers*, 103, 108; and and *The Overlanders*, x, 157–8; and *Sanders of the River*, 66–7, and *Scott of the Antarctic*, x, 192–3

Culloden, Scotland, 65

Cunard Line, 141

Cunningham, Alan, 122

Cunynghame, David, 50

Curaçao, Lesser Antilles, 142

Cutler, Keith, 205

Czechoslovakia, 103

Dalrymple, Ian, 115

Daly, Tom, 201

Damascus, Syria, 126, 132

Daniels, Bebe, 19

Dasara Festival, 78

Dastagir. *See* Sabu

Davenport, Dorothy, 27

Death Valley, California, 31–2

Debre Mark'os, Ethiopia, 124, 125

Deception Harbour, Antarctica. *See* Deception Island.

Deception Island, Antarctica, 182–3, 188, 189

Delhi, 90

De Mille, Cecil B., 16, 26–7, 43

de Mille, William, 26, 36–7

Denham Studios, 69, 89, 100, 102, 103, 108, 111, 113, 144, 148–9

Dessie, Ethiopia, 129

Dir, India (now Pakistan), 93, 94, 96

Dire Dawa, Ethiopia, 122

distributors, 44, 76, 82, 87, 156

Doctor's Secret, The, 36

Donat, Robert, 49, 50, 194

doubles, 179, 162

Dove, Billy, 27

Drosh, Pakistan, 96

Drum, The, 89–101, 103, 104, 122, 204

Duke of Edinburgh *See* Philip.

Dundee Island, Antarctica, 177

Durban, South Africa, 141

d'Urville Island, Antarctica, 177

Duvivier, Julien, 194–6

Dyer, Elmer, 33

Ealing Studios, 150, 168, 170, 171, 172, 185, 191

Eaton, Mary, 24

Edith Ronne Land, Antarctica. *See* Ronne Antarctic Research Expedition

Edmonton, Alberta, 199–200

Eldorado Mines, Canada, 146

Elephant Boy, 68–87, 88, 89, 153, 155, 204

elephant hunt (keddah), 80, 81

Elephant Island, Antarctica, 175

El Fasher, Sudan, 122

Ellis, Fred, 74

Elizabeth, Princess, 144, 200–3, 204

Ellsworth, Lincoln, 177

empire: attitude to British, 66–7; and "Empire films," 54, 88, 101, 158

Endurance, ss. *See* Shackleton

Entebbe, Uganda, 55, 161

equipment. *See* cameras, film, lighting, projection, sound, sweat boxes

Ethiopia, 121–8

Etna, Mount, Italy, 109

Everest, Mount, Nepal, 97

Excuse My Dust, 17, 19
exterior (location) photography, and back (rear) projection, 66–5; and cameras, 119, 136, 150, 155, 162–3, 171, 179; and crews, 51–2, 55, 74, 88, 100, 104, 154, 161–2, 165–6, 170–1, 177–8, 182, 190; and film, 54–5, 89–90, 98–9, 104, 164, 171, 203; and processing, 54,69, 71, 72, 100, 172, 190. *See also* transportation

Fairbanks, Douglas, Sr., 24, 50–1
Falkland Islands Dependencies Expedition Force (FID), 170, 171; bases, 176, 180, 183, 184, 185, 187–8; film on, 171, 179, 183
Famous Players-Lasky (Paramount), 25
Famous Players-Lasky Production Corporation, 15
Fan, The. See Lady Windermere's Fan
Fernside, John, 157
film: and climate, 54–5, 89–90, 104, 171; orthochromatic, 15; panchromatic, 15; processing of, 11, 13, 15, 54, 69, 71, 72, 100, 172, 190; Super X, 43. *See also* colour, critics, music
Film Board. *See* National Film Board
filming: approach to, 39, 40, 66, 155, 158–9, 162, 165–6, 206
Fireman, Save My Child, 28–30
Flaherty, David, 74
Flaherty, Frances, 74
Flaherty, Robert, 68, 69–72, 73–4, 75, 79–80, 87, 152–3
Flora, Mount, Antarctica, 178
Foreign Correspondent, 116–18
Forman, Tom, 26
Fort William, Scotland, 165
49th Parallel, 119–20, 155
Fotheringham, Allan, 205

Four Feathers, The, 66, 102, 103–9, 164, 204
Francis, Freddie, 161
Fraser River, British Columbia, 205
Freetown, Sierra Leone, 141
Fremlin, Captain, 75–6, 77, 82
Frenchman's Passage, Antarctica, 187
Frend, Charles, 190

Gardner, Joan (Mrs Zoltan Korda), 49, 50, 145, 153
Gay, Charley, 20
Général, Le, 41–2
Genoa, Italy,
Germain (electrician), 43–4
Gibraltar, 46, 47
Gilks, Al, 13–14, 16, 17, 19, 20–2, 25, 27, 190
glacier. *See* Aletsch, Beardmore
Glyn, Elinor, 22, 23–4
Goebbels, Joseph, 118
Gombari, Belgian Congo (now Democratic Republic of Congo), 61
Goodall, Ruth, 153
Gordon, Charles George, 103
Graham Land, Antarctica, 176, 184, 188, 189
Grant, Cary, 197–8
Grassholm Island, Wales, 51–2
Graziani, Rodolfo, 126
Great Moment, The, 22
Greenock, Scotland, 142
Grierson, John, 53, 145–6, 148
Grieve, Helen, 157
Gujar Post, India (now Pakistan), 93–4
Gulf of Aden, 124
Gulu, Uganda, 55, 57, 60

Hadley, Anita, née Borradaile, 49, 101, 119, 145
Hague, The, Netherlands, 116

Haig-Brown, Roderick, 205
Haile Selassie, 121, 124, 125–8
Halifax, Nova Scotia, 121
Halton, Matthew, 132
Hampton Court, 50
Happy Hooligan, 4
Harlan, Russell, 197
Hassin, Syed, 90
Hatchard (assistant), 52, 144
Hawaii, 196
Haw Haw, Lord. See Joyce, William
Hawks, Howard, 197
Hawley, Wanda, 19
Hell's Angels, 33, 34
Hemingway, Ernest, 160, 162, 164
High and Dizzy, 57
Himalaya Mountains, Asia, 92
Hippopotamus Parade, 19
His Children's Children, 24–5
Hitchcock, Alfred, 116
Hitler, Adolf, 102, 103
Hobson, Valerie, 88
Holland, 115–17
Hollywood, California, 13, 14, 19, 25,
 26, 39–40, 100, 111, 153, 160, 162,
 164, 172, 194, 197, 198
Holt, Jack, 27, 33
Holy Land, 132
honours. *See* awards
Hope Bay, Antarctica, 171, 173, 175,
 176, 177–81, 182, 184, 185, 187, 188
Hôtel Georges V, Paris, 86
Houde, Camillien, 201
Houdini, Harry, 27
Howard, Leslie, 51, 120
Hudd, Walter, 82
Hudson, Henry, 7
Hudson Bay, Canada, 119
Hudson's Bay Company, 6, 9, 126
Hughes, Howard, 33, 34
Hurst, Brian Desmond, 115

Hutton, Ray, 28
Huxley, Julian, 51–2, 53

Imus, Henry, 88, 89, 99, 100
India, Mysore State, 71–82; Northern
 India (now generally Pakistan),
 88–100
Interlaken, Switzerland, 190
In Which We Serve, 144
Invaders, The. See 49th Parallel
Irwin, Arthur, 199
It, 24
Italy, 109–10
Ivens, Joris, 146–7, 153
I Was a Male War Bride, 197–8

James, David, 170, 171, 172, 176,
 178–80, 182, 188, 190
Jazz Singer, The, 34
Jesse Lasky Company, 15. *See also*
 Famous Players-Lasky (Para-
 mount), Famous Players-Lasky
 Production Corporation, Jesse L.
 Lasky Feature Plays, Vine Street
 laboratory
Jesse L. Lasky Feature Plays, 13.
Jolson, Al, 34
Joyce, William, 130
Juba, Sudan, 60, 61
Jungfraujoch, Switzerland, 190, 191
Justice, James Robertson, 192

Kabul River, Afghanistan, 95, 96
Kafir People, 95
Kampala, Uganda, 55, 57, 58, 60, 61
Kano, Nigeria, 122
Karachi, India (now Pakistan), 90
Karapur forest, India, 73
Kashmir, 92, 93
Kayser, Karl, 155
keddah. *See* elephant hunt

Kenya, 161–4
Kenya, Mount, Kenya, 122
Kelber, Michel, 41
Keren, Ethiopia (now Eritrea), 129
Kew Gardens, 82
Khartoum, Sudan 104, 108, 121, 122, 129
Khyber Pass, 90, 100, 101
Kid, The, 20
Kikuyu tribe, 58
King, Sidney, 74
Kinlock Anderson, 165
Kipling, Rudyard, 69, 72
Kirkhani Post, India (now Pakistan), 94, 95
Kisangani. *See* Stanleyville
Kitchener, Horatio Herbert, 103, 107
Kohat Pass, India (now Pakistan), 91, 92
Korda, Alexander, 40, 44, 45, 66, 102, 167–8, 194, 195, 197, 203–5; and *Bonnie Prince Charlie,* 164, 165; and *The Drum,* 88, 100; and *Elephant Boy,* 68, 69, 81, 82, 83, 87; founds London Film Productions, 48, 49; and *Four Feathers,* 103; and *Lion Has Wings,* 115; and *Macomber Affair,* 160, 161; and *Men of Tomorrow,* 49; and *Private Life of Don Juan,* 50; and *Private Life of the Gannets,* 51, 53; and *Private Life of Henry VIII,* 50; and quota films, 49; and *Sanders of the River,* 54; and *Thief of Baghdad,* 110
Korda, Joan. *See* Gardner.
Korda, Vincent, 44, 49, 50, 101, 111
Korda, Zoltan, 49, 55, 57, 58, 60, 61–2, 145; and *The Drum,* 100, 101; and *Elephant Boy,* 71, 82; and *Four Feathers,* 103, 108; and *Macomber Affair,* 160, 164; and *Sanders of the River,*

54, 55, 57, 58, 60, 61–2
Krasker, Robert, 166
Kuwait, 90

Lady Windermere's Fan, 194
Lagos, Nigeria, 122
La Jolla, 11–13
Lake Edward, Uganda, 58, 60
Lanchester, Elsa, 50
Landi Kotal, Pakistan (formerly in India) 100
Larsen, Captain, 177
Larsen Straits, Antarctica, 176
Lasky. *See* Jesse Lasky Company
Laughton, Charles, 50
Laurie Island, Antarctica, 174
Lawrence, T.E. 102
Lawrence, Ted, 45
Lawrence of Arabia, 102–3
Lean, David, 103
Lebanon, 32
Légion d'honneur. *See* awards
Le Havre, France, 101
Leighton, Margaret, 167
Lemon, "Squash," 55, 161
Leopard Society, 61
Lesser, Sol, 20
lighting, 16, 19–20, 35, 38, 40, 43–4
Lindbergh, Charles, 28–30
Lion Has Wings, The, 115
Lion of Judah. *See* Haile Selassie
Lion of Judah, The, 121–6, 129, 132
Livesay, Robert, 88, 101
Lloyd, Harold, 57
location photography. *See* exterior photography
Loch Shiel, Scotland, 165
Lockheed, Allan, 30
Lockley, Ronald, 52
Lockroy Base, Antarctica. *See* Port Lockroy

London, England, 45, 47, 48, 54–5, 58, 60, 121, 143, 166, 190
London Film Productions, 48, 49, 50–1, 54, 55, 68, 102, 164; and 20th Century Fox, 195
London Films. *See* London Film Productions
London zoo, 51, 52
Long, Louise, 21
Los Angeles, California, 190
Loti, Pierre, 194
Louisiana Story, 152–53
Louka (bearer), 57–8, 59, 60
Love Parade, The, 37
Lowari Pass, India (now Pakistan), 93, 94
Lower Fort Garry, Manitoba, 9

MacDonald, Jeannette, 27, 37
Macomber Affair, The, 160–4, 165
Magellan, Straits of, 172
Maharaja, of Mysore, 69, 71, 72, 78
Mahdi uprising, 103
Malaga, Spain, 46
Man of Aran, 68
Manslaughter, 43
Marco le Clown, 43–4
Margaret, Princess, 144
Marguerite Bay, Antarctica, 182, 183, 184–6, 187
Mariage of Loti, The, 194–6
Marius, 44
Marseilles, France, 108
Martin, Glenn, 30
Mason, A.E.W., 88, 103
Mason, Herbert, 165
Massey, Raymond, x, 51, 88, 101, 120
Mayo Clinic, 200
McFarlane, Leslie, 203
McKaille, Dorothy, 24
McKinney, Nina Mae, 54

McLellan, M.W., 147
Medicine Hat, Alberta, 3, 4
Melkote, India, 73
Men of Tomorrow, 49–50
Men Without Wings, 147
Mexico, 38, 164
Middle East. *See* Syrian Campaign
Mills, John, 192
Minter, Mary Miles, 27
Mirkhani Post, India (now Pakistan), 95
Monopack. *See* film
Montevideo, Uruguay, 172, 190
Montreal, Quebec, 201
Moorehead, Alan, 132
Morgan, Byron, 19
Moss, Bob, 170, 171, 172, 178–80, 182, 183, 190
Mount Hooper depot, Antarctica, 180
Mulholland, Don, 148
music: for films, 13, 66. *See also* Appelbaum; Spoliansky; Vaughn Williams; Wimperis
Mysore, State of, India, 71, 87,
Mysore City, India, 72, 78

Nairobi, Kenya, 122, 161
Nanook of the North, 68, 69
Nany Fjord, Antarctica, 186
Napier, Robert, 125
National Film Board of Canada, 144–8, 153, 198, 199, 200, 203, 205
Negri, Pola, 27
Neumeyer Channel, Antarctica, 183, 188
New York, NY, 24, 152–3
Niagara Falls, Ontario, 202
Nile River, Egypt, 104, 108, 167–8, 169
Niven, David, 165, 166
Nomis, Leo, 30–3
North of 36, 27–8, 156

Northrop, John, 30
Norway, 191

Oberon, Merle, 49, 50, 115
Ogle, Charles, 27
Oland, Warner, 24
Olivier, Laurence, 119, 120, 204
Omdurman, Sudan, 103, 105–8
Orczy, Baroness, 51
Order of Canada. See awards
Overlanders, The, 150, 154–9, 168
Oxford, England, 49–50

Pagan, Peter, 156
Pagnol, Marcel, 44
Pahl, Ted, 41
Panama Canal, Panama, 101
Panamint Range, California, 32
Parachinar, India, (now Pakistan),
 91, 92
Paramount Pictures: British and
 Dominion studios, 45; Hollywood
 studios, 27; Joinville studios, 38, 41,
 42, 45; multi-national productions,
 42–3, 44; New York studios, 24;
 quota films, 49
Parker, Michael, 203
Parry Films, 205
Patricia Bay, British Columbia, 147
Paulet Island, Antarctica, 177
Peck, Gregory, 160
Peck's Bad Boy, 20–2
Pedersen, Lilla, née Borradaile, 153,
 198
Peltier Channel, Antarctica, 183, 187
Périnal, Georges, 49, 50, 54, 100, 108,
 111
Perry, George, x
Perry, Harry, 33
Peshawar, India, (now Pakistan), 90,
 91, 92, 100, 101

Philip, Prince. Duke of Edinburgh,
 201, 202–3, 204
photography, underwater, 195; war,
 142. See also exterior photography
Pickford, Mary, 12, 24
pope: Pius XI, 109; Pius XII, 110
Ponting, Herbert, 189
Port Lockroy, Antarctica, 183, 187
Port of Beaumont, ss. See Ronne
 Antarctic Research Expedition
Port-of-Spain, Trinidad, 141
Port Said, Egypt, 103
Port Stanley, Falkland Islands, 172,
 173, 186
Port Sudan, Sudan, 108
Portugal Cove, Newfoundland, 203
Powell, Michael, 111, 115, 119
Preminger, Otto, 194
Preston, Robert, 160
Prince Gustav Channel, Antarctica,
 179
Private Life of Don Juan, 50–1
Private Life of Henry VIII, The, 50, 204
Private Life of the Gannets, The, 51–3
projection, 3–4, 12–13; back (back-
 ground, rear), 38, 39, 42, 65–6
Punta Arenas, Chile, 172

Quebec City, Quebec, 202
quota films, 49–50

RAF, 148, 149
Rafferty, Chips, 154, 156
Ranga Rao, 74
Rank, J. Arthur Organization, 148
Rayns, Tony, 120
Redding, Bob, 11, 12
Red River Settlement, Manitoba, 9
Red Sea, 108, 124, 141
Regina, Saskatchewan, 201
Reichman, (Austrian director), 43, 44

Reid, Wallace, 17–19
reviews, film. See critics
Rhyolite, Nevada, 31
Richardson, Ralph, 104–5, 115
Rif Mountains, Morocco, 47
Roberts, Theodore, 27
Robeson, Paul, 54, 65, 66
Rocky Mountains, Canada, 120
Rogers, Will, 26
Rome, Italy, 109–10
Ronda, Spain, 46
Ronne Antarctic Research Expedition, 185
Roper River, Australia, 154, 156
Rosamel Island, Antarctica, 176
Rosen (member Dutch resistance), 116–17
Ross Barrier, Antarctica, 177, 184
Rosson, Harold, 51
Ross Sea, Antarctica, 175
Royal Canadian Air Force, 147, 201
Royal Canadian Navy, 170; and convoys, 146–7
Royal Flying Corps, 14
Royal Journey, 200–3, 204, 205
Russell, Victor, 177–81

Sabolouka Gorge, Sudan, 104, 105
Sabu, 69, 70, 74–5, 76, 77, 82, 84–7, 88, 100, 101, 110–11
Safid Koh, Pakistan, 91
Ste-Agathe, Quebec, 202
St John's, Newfoundland, 204
St Lawrence River, Canada, 147
St Peter's, Rome, Italy, 109–10
Saints and Sinners, 196–7
Samborsky (clown), 44
Sam Wood Unit, 16, 17–25, 26
Sandefjord Bay, Antarctica, 175
Sanders of the River, 38, 54–67, 88, 101, 167

Sandford, Daniel, 125, 126
San Diego, California, 11
San Francisco, California, 153
San Pedro, California, 101
Sargasso Sea, 101
Sayne (lab technician), 72, 74
Scarlet Pimpernel, The, 51, 53, 204
Schreyer, Edward, 207
Scotland, 165–6
Scott, Robert Falcon, 169, 170, 189
Scott of the Antarctic, 170–93, 194
Sea God, The, 195
Sélestat, France, 43
Seligman, Gerald, 190
Selkirk, Manitoba, 9
Seven Pillars of Wisdom, The, 102
Sewell, Vernon, 149
Shackleton, Ernest, 175–6
Shaw, Thomas Edward. *See* Lawrence, T.E.
Sheik, The, 23
Shepperton Studios, 64–5
ships: HMS *Broadway*, 121; SS *Duchess of Richmond*, 119; HMS *Encounter*, 139–40; SS *Ferncourt*, 152; SS *Fitzroy*, 172–6, 183–8, 189–90; SS *Franconia*, 141–2; SS *Ile de France*, 40; SS *Lafonia*, 172; HMS *Lagan*, 121; HMS *Latona*, 138–40, 144; SS *President*, 10; SS *Rijnstroom*, 116, 117; SS *Terra Nova*, 189; SS *Trepassey*, 117, 170, 176–7, 181–3, 185–8, 189–90; HMS *Waterhen*, 139
"Short, Happy Life of Francis Macomber, The." *See Macomber Affair*
Shrewsbury, England, 149, 152
Shulamite, The, 22
Sicily, Italy, 109
Sick-a-Bed, 19
Signed with Their Honour, 148–50, 151, 152

Wallace, Edgar, 54, 66
Wallen, Dick, 178
Wanger, Walter, 115, 118
Warrender, Harold, 192
Washington, DC, 202
Watt, Harry, 154, 158
Weddell Sea, Antarctica, 185
Wellman, Bill, 26
Welsh, Jack, 116–17
Westminster Abbey, 89
What's Your Hurry, 21
White, Freddie, 172
White Nile. See Nile
Wilcox, John, 161
Wilde, Oscar, 194
Wilkie, Guy, 37
Willat, Irvin, 26, 27
Wilmot, Chester, 132

Wilson, Edward, 171
Wilson, Lois, 17, 18, 21, 27
Wimperis, Arthur, 66
Wingate, Orde, 125, 126
Winnipeg, Manitoba, ix, 4
Winslow Boy, The, 194
Winter Circus. See Cirque d'Hiver
Wood, Sam, 16, 17, 19, 20–2, 23, 24–5.
 See also Sam Wood Unit
Wordie, Professor, 175–6
Wordie House, Antarctica, 183, 187
Wrangel, Pyotr, 41
Wycoff, Alvin, 16

Yalavatti, interpreter, 74
Young, Freddie, 119
Yuvaraja, of Mysore, 78, 111–14

Signy Island, Antarctica, 174, 182
Silent World, The, 196
Silverton, Louis, 82
Sind Desert, India, 90
Sky Bride, 33
Slievefoy Mountain, Ireland, 196
Smyth, Jackie, 96
Soskin, Paul, 149, 152
sound: advent of, 33–4; and cameras, 35; and cinematograpy, 35–6, 37 sound recording systems, 36, 58, 72n2, 126
South African Air Force, 122; Twelfth Squadron, 135–8
South African army, 126
South Georgia Island, South Atlantic, 176
South Orkney Islands, Antarctica, 174
South Pacific, 194
South Pole, 170, 191
South Sea islands, 154
South Shetland Islands, Antarctica, 182
Spanish Morocco, 46
special effects, 111. *See also* projection
Spoliansky, Mischa, 66
Srinagar, Kashmir, 92
Stanleyville, Belgian Congo (now Kisangani, Democratic Republic of Congo), 58, 60, 61, 64
Steene, E. Burton, 33
Stone (First Mate), 186
Stradling, Harry, 41, 115
Struss, Karl, 164
Stuart, Charles Edward, Prince, 165, 167
studios. *See* Denham, Ealing, Jesse Lasky, London Film Productions, Paramount; Shepperton
Sudan, 58–60, 103–8
Swanson, Gloria, 22–3, 24

Swat, India (now Pakistan), 93
sweat boxes, 35, 37
Switzerland, 190–2
Syrian campaign, 131–3

Tahiti, 194–5
Tall Country, The, 205
Talmadge, Constance, 27
Tangiers, Morocco, 47
Tanner, Peter, 192
Tannura, Phil, 41
Tester, Desmond, 88
Tétouan, Morocco, 47
Theodore II, 125
Thief of Baghdad, The, 110–11, 204
Thornton, Philip, 149
Three Weeks, 22
Tinsey, Tommy, 149
Tirich Mir, India (now Pakistan), 97
Tobruk, Libya, 129–32, 138, 140
Too Good to Be True, 82
Toomai of the Elephants, 69
transportation, 58, 60–1, 63, 93, 96, 99, 104–5, 133, 155. *See also* aircraft, ships
Tree, David, 88
Tree, Lady, 50
Truman, Harry, 202
20th Century Fox, 195–6, 197

Uganda, 55–8, 161
Unsworth, Geoffrey, 192, 193

Valentino, Rudolph, 22, 23, 24
Vancouver, British Columbia, 206
Vatican, 109–10
Vaughan Williams, Ralph, 190
Victoria, British Columbia, 10
Vine Street laboratory, 13

Wales, 51, 100